Terry

Douglas Coupland

Douglas & McIntyre

Vancouver/Toronto/Berkeley

Douglas & McIntyre Ltd.
2323 Quebec Street, Suite 201
Vancouver, British Columbia
Canada V5T 4S7
www.douglas-mcintyre.com

Library and Archives Canada Cataloguing in Publication
Coupland, Douglas
Terry / Douglas Coupland.
ISBN 1-55365-113-8
1. Fox, Terry, 1958–1981. 2. Cancer—Patients—Canada—
Biography. 3. Runners (Sports)—Canada—Biography. I. Title.
RC265.6.F68C68 2005 362.196'9940092 C2004-906464-9

Library of Congress infomation is available upon request

Editing by Saeko Usukawa
Design by Jen Eby
Printed and bound in Canada by Friesens
Printed on acid-free paper
Distributed in the U.S. by Publishers Group West

The publisher gratefully acknowledges the financial support of the Canada Council for the Arts, the British Columbia Arts Council, and the Government of Canada through the Book Publishing Industry Development Program (BPIDP) for our publishing activities.

All of Douglas Coupland's royalties from this book will be donated directly to the Terry Fox Foundation.

Terry's run was in 1980, just three years after Canada went metric. He thought in miles and dreamed of miles at night—how many had he done that day? How many did he have to go before he got home? In deference to his memory, measurements in this book involving Terry and distance are given in miles. But here are some conversions to keep in mind:
1 mile = 1.6 km
26.2 miles (marathon distance) = 42.2 km
3,339 miles (distance Terry ran) = 5373.5 km
5,300 miles (distance across Canada) = 8529.3 km

Credits

Photos, notes and objects are from the archives of the Fox family and the Terry Fox Foundation, except for the following:
John Ayearst photo 108/109
The Atlas of Canada web site http://atlas.gc.ca © 2004 Her Majesty the Queen in Right of Canada, with permission of Natural Resources Canada, map 32/33
Mary Anne Bailey photo 155 top right
British Columbia government photo 149
Courtesy of The Canadian Press photos 111 (Chuck Stoody), 112, 144 left middle and top right
Courtesy Canadian Space Agency. www.space.gc.ca (Canadarm 2) 34
Diana Coish note 134
Marion Dahlberg photo 148
Michael Dawson note 109
Jamie Delong drawing 113
Betty and George Gilbert note 40, photo 40/41
Darren Hardemann note 131
Alf Lower photos 58, 96, 98/99
Denise McGovern note 136, 137
Dawn McKinley note 120
Tracy Maxwell drawing 125
Ken Mayer Studio © 2005 Douglas Coupland 18 (setup by Douglas Coupland), 19, 20/21, 22/23, 25, 26 right, 30, 31, 35, 36, 42/43, 48/49 , 52, 53, 54/55 (setup by Jen Eby and Ken Mayer, food styling by Jessica Iorio), 68, 69, 80/81, 82, 83, 92, 93, 94, 97, 106, 107, 110, 113, 114/115, 116/117, 118, 119, 120, 122, 123, 125, 126/127, 130, 131, 133, 134, 137, 156, 158, 159, 160 (setup by Douglas Coupland and Darrell Fox)
Mick drawing 100/101
Marnie North photos 72, 73, 74/75, 76/77, 78/79
North Battleford High School signatures 126/127
Sharon A. Reed photo 45
Marti Ryan photo, 66/67
St. Thomas More School (Edmonton) photo 152 bottom left
Borough of Scarborough photos 51, 60, 62/63, 64, 65
Leslie Scrivener 29 and 114 excerpts from Terry Fox: His Story, published by McClelland & Stewart, © 1981, 1983, 2000 by Terry Fox Foundation; 133 transcript
Somerset and District School photo 121
Terry Fox Run volunteers photos 152/153, 154/155
Courtesy Toronto Star photos 88/89 (archives); 86 (Erin Combs); 38/39, 70/71, 102/103, 104, 128/129 (David Cooper); 138/139, 140/141 (Frank Lennon); 84, 85 (Boris Spremo); 87 (Michael Stuparyk)
Vancouver Sun photos 142/143 (Ken Oakes); 144 top, left bottom, right middle, right bottom (George Diack)
Armand and Annette Viau photos 46, 47, 147
Jody Wright note 116/117

The author would like to thank Mac Parry, for being a great friend and inspiration and for showing cancer a thing or two.

Terry Fox coin design © is the property of the Royal Canadian Mint—visit us at www.mint.ca

Counting the Names

Over the past year I've been in and out of Vancouver-area storage lockers, looking through more than a hundred thousand archived items from the Marathon of Hope. There are too many of them to even begin listing, but the two categories I noticed most were the staggering number of get-well cards—floor to ceiling stacks of boxes filled with them—and the equally staggering number of letters and cheques sent in by schoolchildren, most of them postmarked 1980 and 1981. I thought that after I'd spent a few hours of sifting I'd become immune to the sentiments expressed inside them, but no, I never did and I doubt I ever will. Their messages are too pure and too real.

Leeane from Victoria has breast cancer and is worried that soon she'll be too weak to drive, so she won't be able to get her daughter to her violin lessons on time.

Mark from Fredericton had an osteosarcoma in 1975 and wants to tell Terry, *You can make it pal!*

Tracy from Oshawa remembers her grandmother being sick from methotrexate and being unable to eat Thanksgiving dinner.

Greg from Edmonton lost his older brother to leukemia and wants Terry to finish his run—Greg is willing to come along to help!

And then there are cards to Terry from your mother—my mother—so many mothers wrote to Terry, fathers, too, often unbeknownst to their children. All of these mothers and fathers wished Terry safety and health and peace, and they thanked him for his courage and for making our country a better home.

Helen from Toronto had five children who all left home decades ago. *Terry, I think of you as the son who never left.*

But here's what floored me the most and what makes me write these words: the signatures. In the Fox archives, signatures by the tens of thousands faced me from every direction: on jumbo cheques, on homemade cards, on huge rolls of paper sent in by entire schools, on pink floral cards like your grandmother uses—names and names and names of everyday Canadians, walls of them—all of them yearning to count, to mean something. I think I was on my second day in one of the storage lockers when suddenly all of the boxes and all of the paper fell away, and all that remained behind were the constellations of names hanging in the air like stars, like a universe. I don't think I've ever felt as safe as I did for that brief one-minute window on a Vancouver weekday, surrounded by the goodwill of so many Canadians. Collectively, those names testify to something divine—our nation, our home and our soul.

Douglas Coupland, June 2004

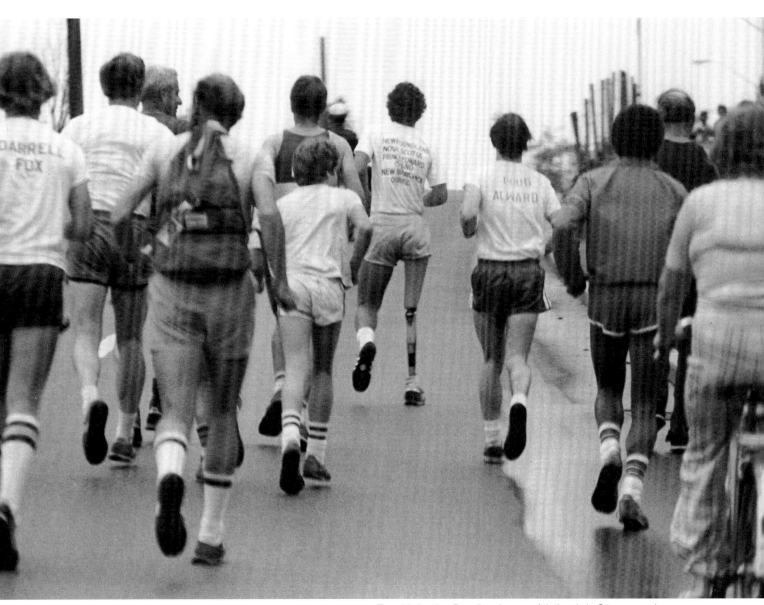

Terry, his brother Darrell and some of their pals in Ottawa, running to meet the governor general at Rideau Hall. Ottawa was mile 2,000 and was definitely one of the highlights of the Marathon of Hope.

My Brother Terry

On behalf of the Fox family—Mom and Dad (Betty and Rolly), brother Fred and sister Judi—I share these words:

Nearly twenty-five years ago I experienced the daily thrill of witnessing Terry run across Canada—and I was doubly thrilled to see everyday Canadians respond to that run. I was there in that smelly Ford van, cutting up oranges, devouring Terry's Joe Louis sugary snack cakes, fighting with Terry's friend Doug Alward over radio station choices, collecting donations and generally trying to be the best brother I could. And while every day I now speak Terry's name, see his face, and both read and hear his words, the thrill of 1980 remains pure and undiluted.

On September 1, 1980, just east of Thunder Bay, the thrill was taken away. It was replaced by feelings of helplessness as cancer returned and moved in on Terry the second time. The greatest five months of our family's lives was followed by ten months of horror. Our world came to revolve around Terry. Me, I wanted only to see him run, to complete his Canadian journey and to inspire us all once again. When he died, we felt, as do many who lose someone to an extended illness, a sense of relief for him mixed in with our pain.

One memory that haunts me is of Terry's determined effort to use the washroom even though a catheter eliminated this need. I mean—he was my brother; we laughed and we cried. And decades later a few things still stick—I don't like to see the sun rise because it reminds me of the silent drive home on June 28. And I know it's ridiculous, but I sometimes find myself avoiding hospitals.

The years after Terry's death were hard on all of the family. For me, there was the nagging worry that there was something I could have done that would have fixed things. I felt empty, powerless and beaten. And because the fifteen-month experience was so intense, I spent years trying to blot it out of my mind. I wanted to run away and be Darrell Fox for a while and not Terry Fox's brother, but I couldn't escape.

However, when I joined the Terry Fox Foundation in 1990, I looked at my life with my brother and did a complete 180. Hey, wait a second—look at how Terry touches and inspires people—now I get to see that every day of my life. How many of us can say that? It dawned on me that I'm blessed—not just with my wonderful wife, children and family—but with the work I get to do daily as National Director of the Terry Fox Foundation.

It was on December 22, 1980, that Terry finally spoke the words that indicated he knew his fate. He said, "Even though I die of cancer my spirit didn't die and that should influence a lot of people." Well, Terry, more than you ever imagined. Terry, you'd enjoy a tour of the TFF twenty-five years later. We spend money on research, Terry, not on bricks, mortar and lavish office furniture. More than $360 million has been raised so far! There are twenty-four great people who work here, and you would like each and every one of them. You look down at me from three of the four office walls, and your favourite T-shirt is always close by. We honour you by trying our best to keep it clean and pure. We continue to persistently pursue your dream, and we recognize and value all who join us.

Our family, Mom in particular, has wanted this book for twenty-five years. We were simply waiting for Doug Coupland to call. I hope you recognize the passion and effort that went into this book. I do. Thanks, Doug. And to you readers, Terry runs on in each person who supports his cause.

Darrell Fox, November 2004

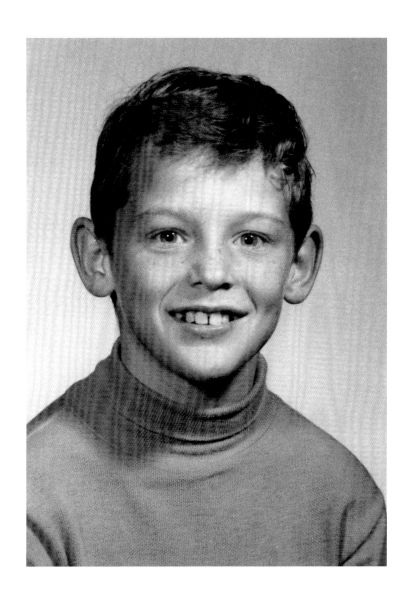

"I remember promising myself that should I live
I would prove myself deserving of life."

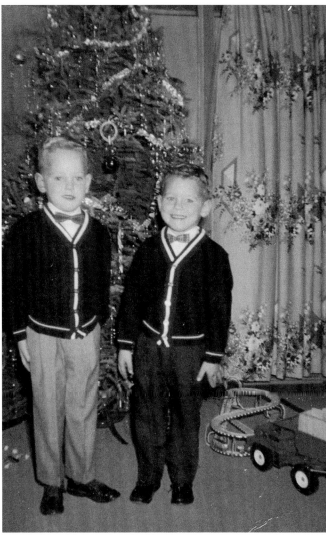

Terry Fox (right), age four, and his brother Fred (left).

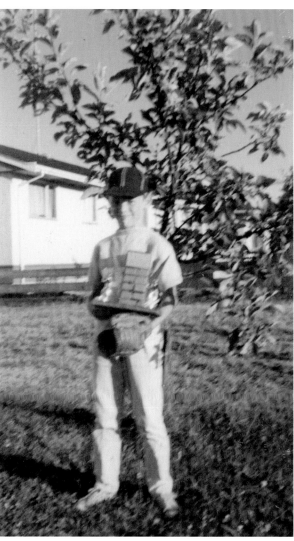

Terry, age nine, in the 1960s.

Beginnings ...

Terry Fox was born in Winnipeg in the summer of 1958. He had an older brother, Fred; younger brother Darrell arrived in 1962, sister Judith in 1965. In 1966 his family moved to British Columbia, settling in the suburban town of Port Coquitlam. Terry's father, Rolland—called Rolly by friends and family—was a quiet man, a switchman for the Canadian National Railway. His mother, Betty, stayed at home to raise the children.

The Foxes were rambunctious, noisy and fun-loving—a typical Canadian family of the era. In terms of size, income, occupation and history, there was really nothing that made them very different. They were living the quiet Canadian middle-class dream, the sort of calm good life that makes us homesick when we're far away.

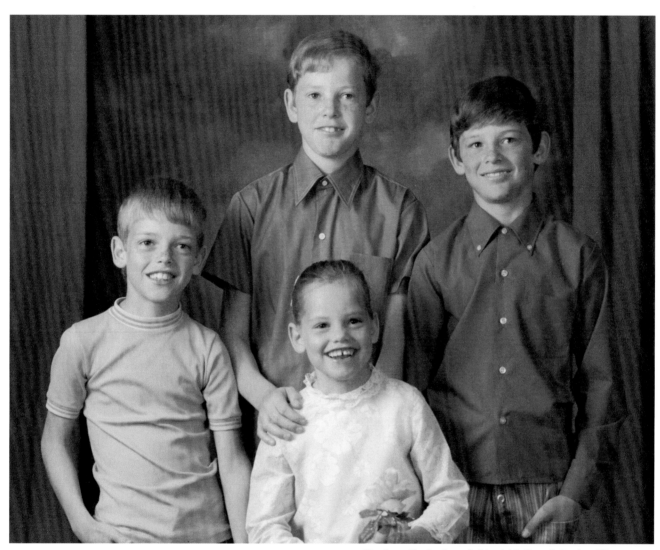

The three Fox brothers (left to right), Darrell, Fred and Terry, with sister Judith in front.

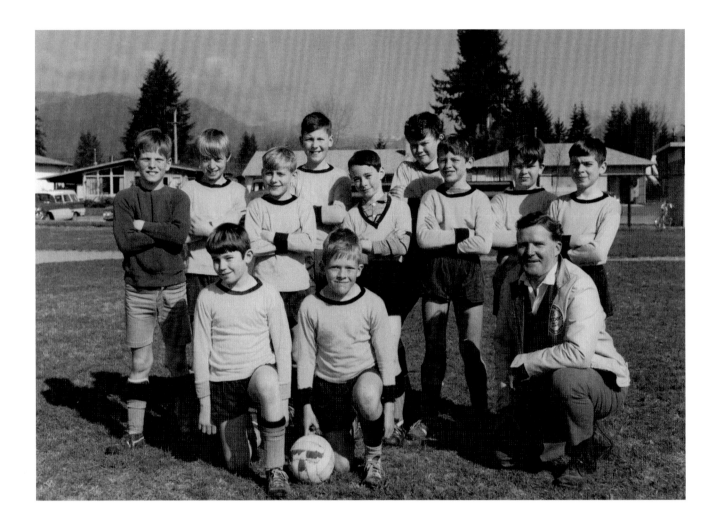

Game Boy

When Terry was young, five things became evident about him. First, he loved sports of any kind—soccer, rugby, baseball and basketball. Second, he wasn't tall or brawny, so he had to work harder than the bigger kids to fully participate in sports he wanted to play. Third, he was extremely competitive. Fourth, he had a remarkable ability to get lost in his own world, often playing complex plastic-soldier games that went on for entire days with rules known only to him. Fifth, he had a marked determination to finish any task he started. Some might say Terry was driven; some might say stubborn. Either way, his intensity was always admired by family and friends.

Here's a quick story that shows all five of Terry's youthful traits. In junior high school, Terry loved basketball and wanted to play guard on the Mary Hill Cobras team. As he was then

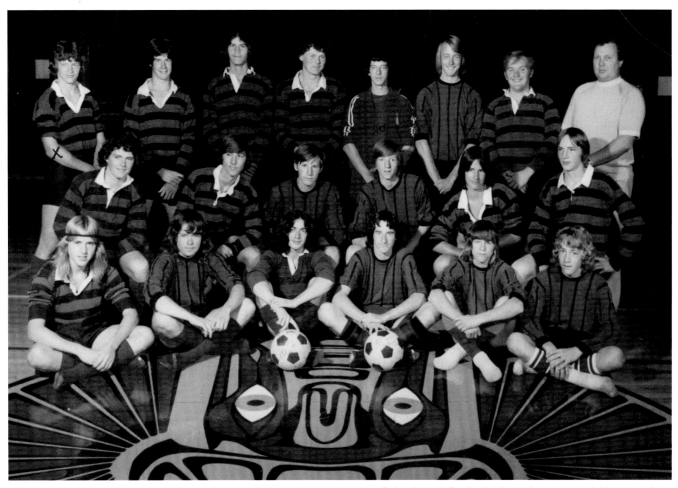

Going through Fox family photo albums, you quickly get used to seeing Terry in just about every sort of team shot possible. On page 10 is a peewee soccer photo that includes Doug Alward, Terry's good friend who accompanied him on the run a decade later. On this page is the 1976–77 Port Coquitlam Ravens soccer team.

only five feet tall and not even very good at the game, Terry had his work cut out for him. He spent every available waking moment practising, practising and practising with his close friend, Doug Alward, who was also in the same situation. They approached basketball with a sheer doggedness and were highly competitive with each other. By grade ten, both boys had become ferocious guards, well respected by other teams, even though by then they were only five-foot six and far shorter than their competitors. In senior high school, Terry was a starting guard on the Port Coquitlam Ravens. He'd achieved what he wanted and loved every minute of it.

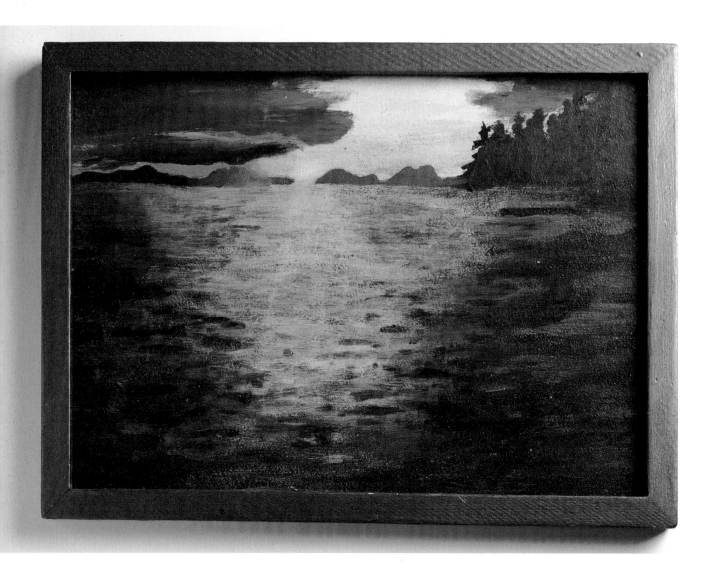

A Hint?

We all look back after the fact and try to locate hints or clues as to why things turned out the way they did in a person's life. Here's one: a painting done by Terry in grade nine art class, showing the sun setting in the west over a Canadian lake. There's no story behind it—he simply wanted to paint it. Perhaps Terry was born with an innate need to go west— a bit of the Canadian pioneer spirit.

MARY HILL
JR. SECONDARY SCHOOL
PORT COQUITLAM, B.C.
STUDENT IDENTIFICATION CARD
1972 – 1973

Terry Fox
NAME GRADE
3337 Morrill, ST.
ADDRESS

MR. ALLAN H. MATHESON
PRINCIPAL

MARY HILL
Junior Secondary
Port Coquitlam,
British Columbia
1973-1974
Student Identification Card

Allan H. Matheson
Principal

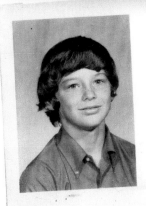

MARY HILL
JR. SECONDARY SCHOOL
PORT COQUITLAM, B.C.
STUDENT IDENTIFICATION CARD
1971 – 1972
1972 - 19

Terry Fox 1959
name birthdate
3337 morril V 8
address grade

MR. ALLAN H. MATHESON
Principal

PORT COQUITLAM
SECONDARY SCHOOL
PORT COQUITLAM, B.C.
STUDENT IDENTIFICATION CARD
1974 - 1975

TERRY FOX 11
NAME GRADE
3337 MORRIL ST
ADDRESS

John R. Gowans.
PRINCIPAL

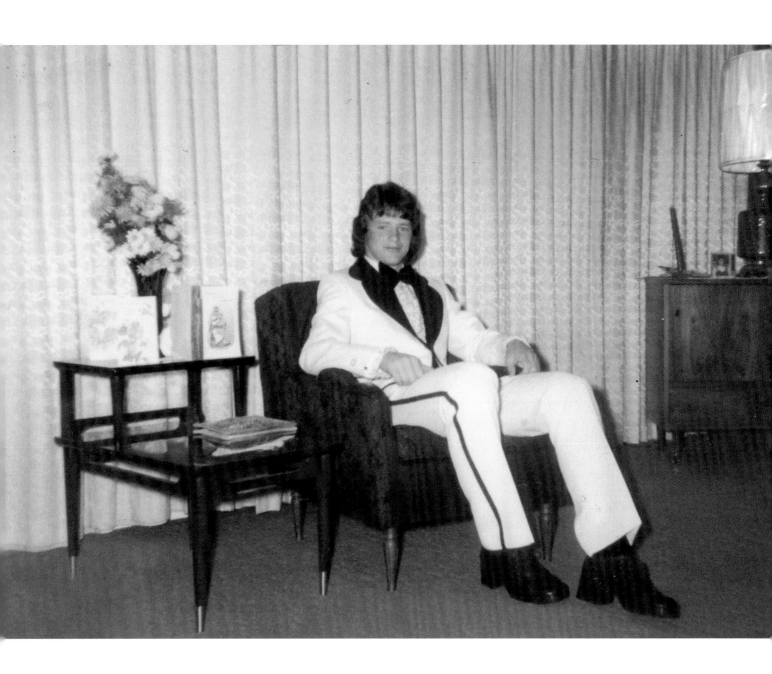

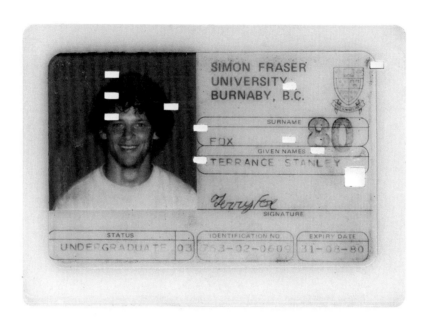

One Cool Dude

Here is Terry in his distinctly 1977 grad outfit, as well as on his ID card from Simon Fraser University—both of which remind us that he was just an ordinary Canadian guy. He'd entered SFU to learn kinesiology (the study of movement), thinking that he might teach physical education down the road.

Looking at these images almost makes you want to enter a time machine and travel back to the 1970s and say, "Hey, Terry, you don't know it, but you've been marked for greatness." On the other hand, there might also be people out there in the future who want to travel back and tell any of us that we too have been marked for greatness.

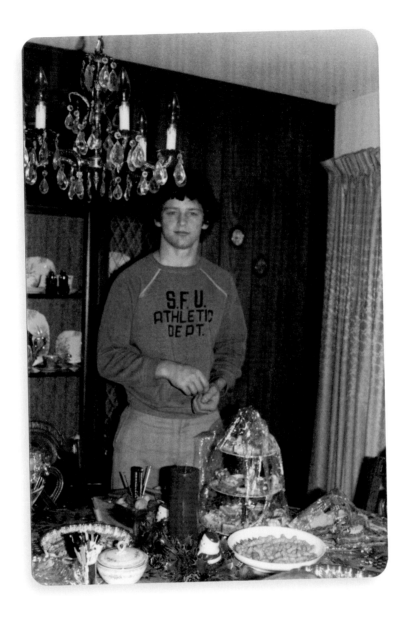

Home Life

The mother of any teenage boy knows that special mixture of boredom, dreaminess and empty fridges that colours the last few years of his time at home. Terry was no exception. He was, by any definition, a jock in a family of jocks.

In the photo above, Terry is snacking from the dining-room table on New Year's Eve *(Don't touch the stuff under the plastic wrap until the guests arrive!)* and just generally loafing about the house.

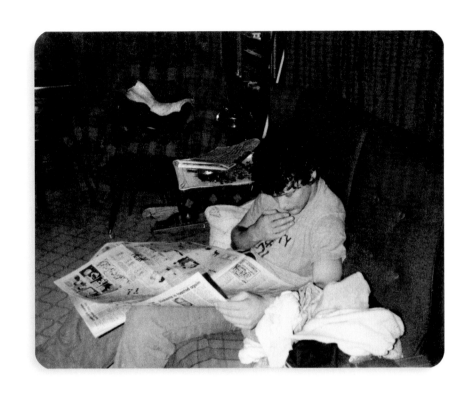

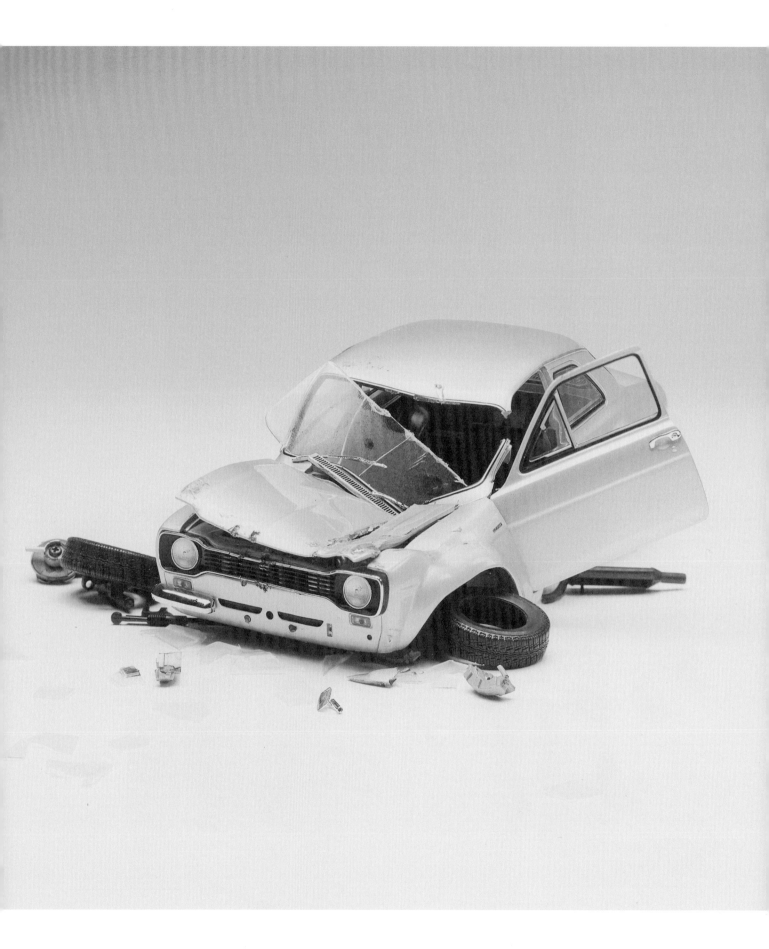

Crash

On November 12, 1976, Terry was driving home along Port Coquitlam's Lougheed Highway in his green 1968 Cortina. His attention was distracted by bridge construction on the Coquitlam River, and his car slammed into a half-ton truck. Fortunately, nothing happened to the truck and its driver, and Terry emerged from the accident unscathed except for a sore right knee.

That soreness continued into December, but Terry paid it little notice. If you're an athlete, pain is a given. But when the knee still hurt in February, he visited his university's medical services and was handed painkillers, which seemed to take care of the problem. Then the knee got worse. In early March, Terry came home after running a few laps at a local field and the pain in his leg was immobilizing. The next day, March 2, Terry visited the family doctor, who suspected something more serious than just water on the knee or bruised cartilage.

On March 3, Terry was sent for X-rays at Royal Columbian Hospital in New Westminster. There, Dr. Piper, an orthopaedic specialist, looked at the shadows on Terry's knee on the X-rays and suspected that it was osteogenic sarcoma (also called osteosarcoma). This is a form of cancer that strikes men more than women, usually between ages ten to twenty-five, at a point in the life cycle when the body is growing most rapidly. It is a cancer of the connective and supportive tissues, and it's the most common primary cancer of the bone. Often the cancer starts in the knee, then works its way outward into surrounding muscles and tendons.

Cancer is a disease that comes in several forms. First is when some cells become abnormal and grow too quickly and out of synch with the body's normal control mechanisms. Second is when some cells become abnormal and don't die when they're supposed to. Third is when a mutation causes some cells to acquire an abnormal function that leads those cells to do things they're not normally programmed for.

Here's an interesting fact: most people acquire mutations in their cells many times in their lives, but these don't automatically lead to cancer because the body's natural defence mechanisms usually win the battle before any problem is even apparent.

Terry's cancer was a type that strikes people during their "growth spurt" or fast period of growth. Healthy and diseased cells are competing against each other, and researchers are trying to learn why one cell multiplies in a good way, and another in a bad way.

Still, the crash begs the question: Did it trigger Terry's sarcoma? The condition is just rare enough that no data can confirm this one way or another, though Terry's father, Rolly, very much believes this to be true in Terry's case.

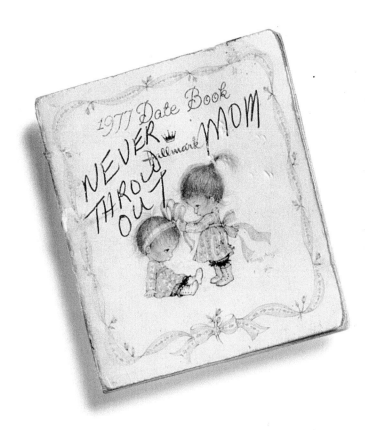

The 1968 Cortina in the photo is a 1/18 scale model. Terry's accident wasn't as serious as this.

Sunday	Monday	Tuesday
Feb 8 – Feb 12 Hospital Feb 15 – Hallmark cheque dated april 11/77	♔ March 11th 500.00	1
6	7	8
13	14	15
20	21 Fitting	22
27	28 Got temporary Plasses	29

Wednesday	Thursday	Friday	Saturday
2	3 *Dr mE McDonald Terry Hospital*	4	5
9 *Terry operation*	10	11	12
16	17 St. Patrick's Day *Tutor 2 hours*	18	19 *Tutor 2 hours*
23 *mE Dr McDonald*	24 *Tutor 3 hours*	25	26
30	31 *Tutor 2 hours*		Have a happy St. Patrick's Day gathering with colourful and carefree Hallmark party sets.

21

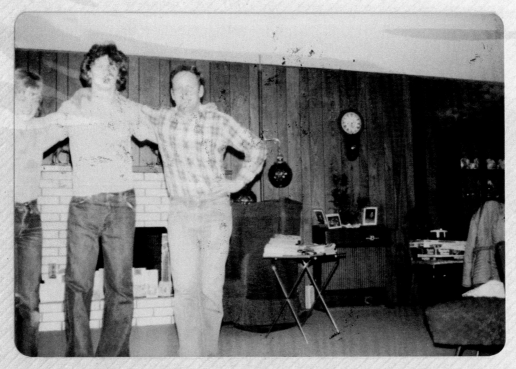 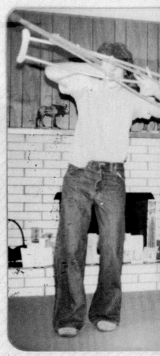

MARCH 1977 MONTH OF AM

3337 MORRILL, ST. PT. COQ.

TATION

Out of the Blue ...

Pages 20 and 21 are from a daybook belonging to Terry's mother, Betty. Alongside reminders for everyday family events is Terry's March 3 trip to the hospital, where a diagnosis was made of a malignant osteosarcoma in his right knee. On March 4, a bone scan confirmed the condition. Days later, early on the morning of March 9, Terry's right leg was amputated six inches above the knee. On the 21st, not even three weeks after getting the bad news, he went in for his first fitting for a prosthetic leg.

On the night before his operation, Terry's senior high school coach, Terri Fleming, visited him in the hospital. Not quite knowing what to say, he showed Terry a magazine article about an above-the-knee amputee who had run in the New York Marathon. The coach doesn't remember the article making a big impression, but it planted the seed for Terry's idea to run across Canada.

Crutches

About three weeks after receiving his first prosthesis, Terry was already playing pitch-and-putt golf with his dad. Terry's attitude to cancer was never "Why me?" but rather, "Why not me?" Here, Terry is just back home minus one leg and plus a temporary prosthetic leg. He was a fun-loving teenage guy trying to joke about the bad hand fate had dealt him. Terry's family knew him for the joker he was, but there's a universe of experience that's not evident in these family photos. What we're not seeing is the effect on Terry of the things he witnessed in the children's orthopaedic ward of the hospital where he had his operation and at the cancer clinic in Vancouver where he went for his chemotherapy sessions.

During his chemotherapy treatments, Terry experienced the harsh realities of cancer—endless vomiting, crying families, strange crashes in the middle of the night—people of all ages stripped of hope, liveliness, personality and a future.

Terry's doctor told him that his specific cancer treatment was new and that in the three years since it was developed, the chance of survival had increased 20 to 50 per cent. In a flash, Terry realized the value of cancer research.

Friends and family agree that Terry's hospital stays deeply changed him, made him grow up beyond his years. And it was in the hospital that Terry understood that miracles are fine, but cancer research is what actually changes the world and what gives hope to the hopeless.

The Cap

Using chemotherapy, doctors hoped to destroy any stray malignant cancer cells remaining in Terry's body. Terry went in for treatment every three weeks for sixteen months. He was given two drugs in rotation: adriamycin and methotrexate. Chemotherapy is a harsh process, and both drugs had extreme side effects, inducing profound nausea that could often debilitate him for up to a week at a time.

Most chemotherapy patients quickly lose their hair, as did Terry. Also, many people undergoing cancer-related amputations are initially more upset about hair loss than the loss of a limb. Terry was no different in this regard.

Early in his treatments, Terry visited a shop near Vancouver General Hospital and bought what his mother, Betty, called, "an awful, awful wig." Curiously, Terry's hair was wavy before the cancer. His hair only became truly curly—the way most people remember him—when it grew back after his chemotherapy. Betty also remembers Terry wearing his SFU cap at all times when he went outside the house.

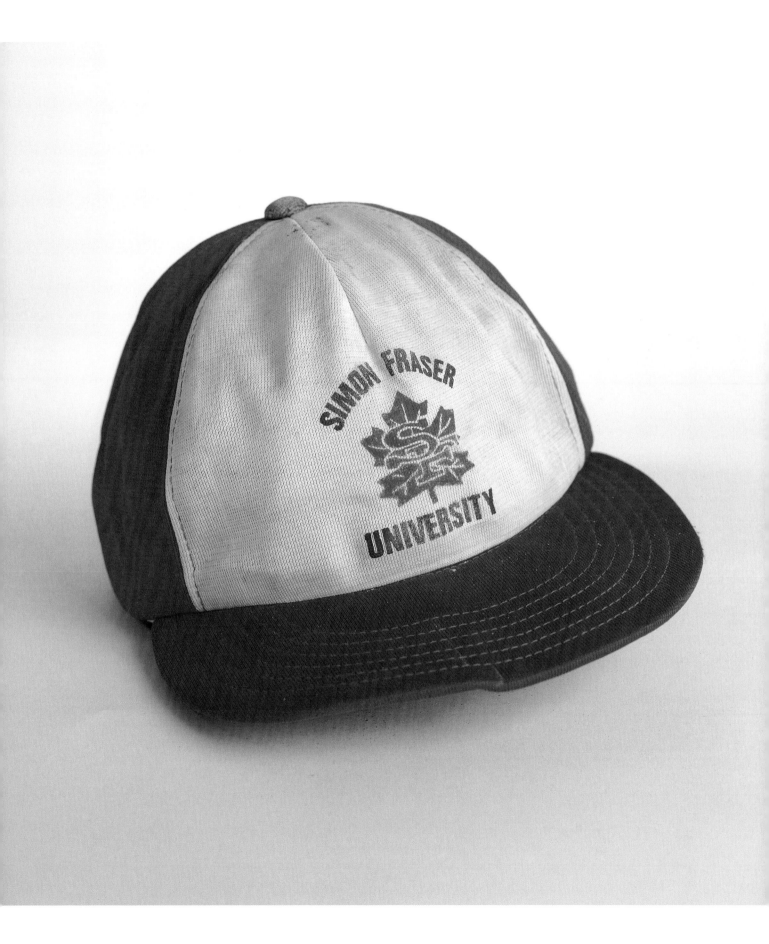

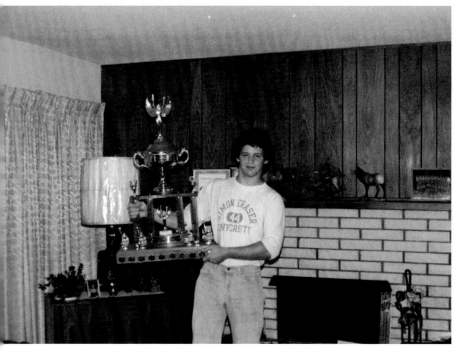

Hoops

Most people don't know that after Terry lost his right leg, he became a championship wheelchair basketball player. A few months after Terry's 1977 operation, fellow athlete Rick Hansen phoned to ask if he wanted to play on his team, the Cablecars. Terry was unsure: he was still undergoing chemotherapy treatment and his hair hadn't yet grown back. But being athletic, competitive and curious, he quickly bonded with the sport and the team. His father's co-workers at the Canadian National Railway yard bought Terry a wheelchair, and after practising, Terry was quickly able to "rewire his neural pathways"—a complicated way of saying that he honed his reflexes for this new sport to the point of excellence. Sometimes he would show up for games looking pale, haggard and exhausted after his chemotherapy, and at one practice, Terry's wig flew off, freaking out players on both teams, but Terry said, "What could I do? I just laughed, and then everyone else did."

The Cablecars won the 1978 Canadian championship. A year later, the team was rated sixth in North America. Sports experts hope that wheelchair basketball may someday become an official Olympic event.

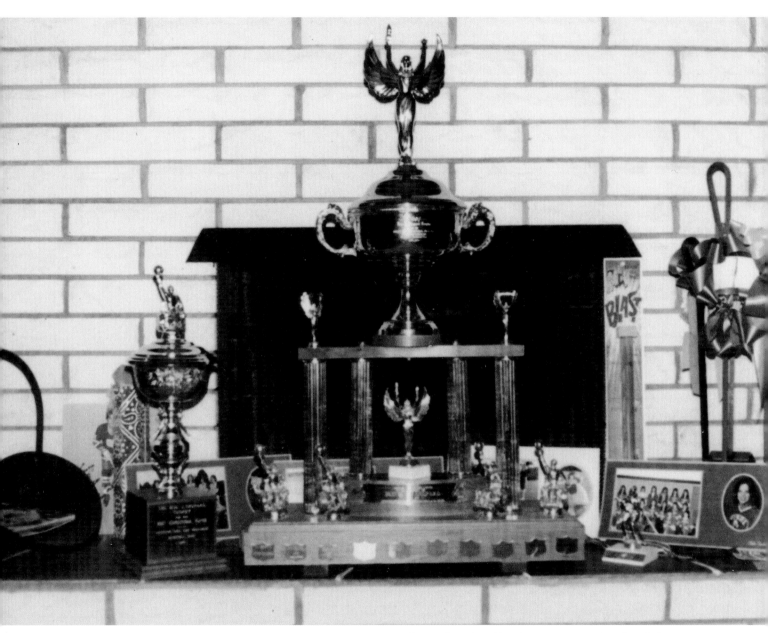

Terry collected trophies the way most people collect their spare change. Also visible in this photo of Terry's trophy farm is sister Judith's ringette team photo, and behind it, a yellow plastic toy used to collect … spare change!

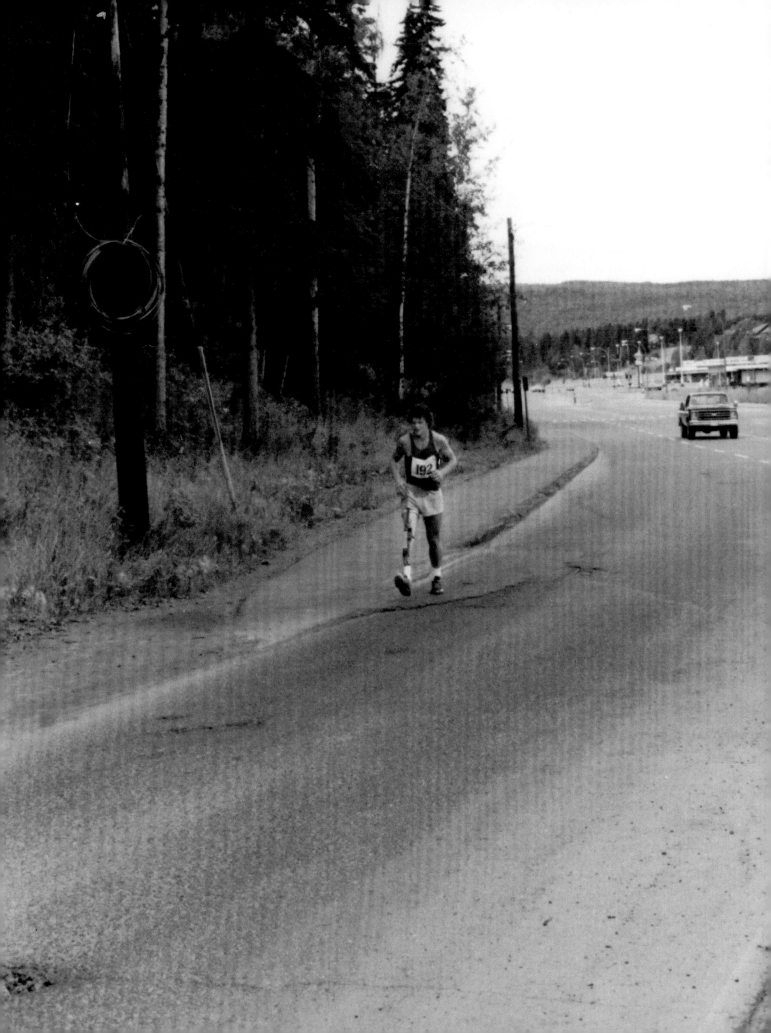

The photo on the left is the first true glimpse of things to come, as Terry runs at the back of the pack in Prince George. Terry finished last by twelve minutes, but Darrell Fox said, "Just look at that smile when he's crossing the finish line. It doesn't matter where you finish—it's only that you finish."

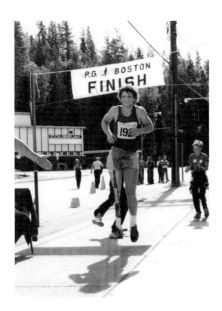

The First Big Run

In early 1979 Terry decided to start training for marathon running, but he had not yet told anybody about his plan to run across Canada. He was a committed diary writer and noted on his second day of working out on February 15: "1/2 mile, weights." After running laps around a dirt track, bulking himself up by weight training and wheeling up local mountains, he began running all around the quiet rainy communities of Port Coquitlam and Port Moody. Six months later, he was running 10 miles a day.

Although modifications were made to Terry's prosthetic leg, he still had to take two steps with his real leg for every step with the prosthesis. Blisters, bleeding and cysts on his stump made it painful to run on, but Terry never complained. Sometimes blood would trickle down to his prosthetic knee, making his family and friends very concerned, yet Terry approached it as if it were simply a part of being an athlete. The following excerpt, from Leslie Scrivener's marvellous book, *Terry Fox: His Story*, eloquently describes Terry's training process:

> One of Terry's secrets was that he set small goals for himself. He didn't think about running ten miles when he set out in the morning. Instead, he ran one mile at a time. "I broke it down. Get that mile down, get to that sign, get past that corner and around that bend. That's all it was. That's all I thought about. I didn't think of anything else."

Terry's route took him through loco, the company town built for employees of the Imperial Oil refinery. He ran past cozy middle-class houses with wood siding and car ports,

past Burrard Inlet and the smoke of the refinery; he ran up hills to Sasamat Lake, which is the same deep blue-green as the mountains reflected in its water. The weather was always damp. Moss crawled over graffiti on the rocks, and the telephone wires always sparkled with raindrops.

On August 30 Terry, his brother Darrell, and his friends Doug Alward and Mitch Fiddick, travelled north to Prince George, British Columbia, to enter the Labour Day weekend 17-mile "Prince George to Boston Marathon." The winner of this race would get a slot in that famous U.S. marathon. Up until then, the farthest Terry had run in one day was 11 miles, but Doug, knowing Terry's competitiveness, encouraged him.

It's important to remember that in 1979, people with disabilities—or people who were merely different in some way—didn't participate in the everyday world the way they do now. For someone with one leg to enter a race of this length was quite shocking.

Terry completed the race in three hours and nine minutes. What he hadn't expected was that almost everybody from the run would wait for him to arrive, and when he crossed the finish line, many of his fellow athletes were so moved that they were unable to speak.

Terry had been planning to run across Canada before this, but he knew he had to be able to run several miles each day before sharing the idea with anyone. The day after he arrived home from Prince George, he told his mother that he was going to run across Canada. As with anybody who knew Terry, she realized that trying to change his mind would be futile; so everybody in Terry's world did what they could to help him prepare. Only on Christmas, as a present to his mother, did he take a rest from training for the first time in 101 days.

From monday Jan 8 to monfeb 11 a minimum
of 10 miles per day
JANUARY 28 MON

Up at 9:15 A.M. - ate Granola + Toast
Ran 15 miles at 10:00 A.M
- had runs for 1st 2½ miles had to
stop and 5 dit.
- the rest of the run was quite good
- Sunny Day, extremely cold
 especially til 12 Am
Ran 8 miles at 2:30 P.M.
Still cold. Very good run.
- using 3rd water bottle
Lunch at 1:30 pm
 3 4 piece toast + Coke
Supper 5 fish, corn, potatoes, icecream

Weight at 6:45 O.K.
5 at night
Basketball at 9:00 pm

Bed at 11:15 pm.

(Finished 2662 miles)

JANUARY 29 Tues

2 Chronicles 24
Up at 9:00 A.M. - Ate Granola + Toast
Ran 10 miles at 9:45 A.M. - very cold.
Sore on end of stump, tired.
Lunch - 4 pieces of bread, coke.
Ran 8 miles at 1:45 pm - dead, sore

Supper 5 chile
 went to Dave B.B. game
Bed at 10:00 pm
 I didn't get to sleep til
after 12:00 p.m.

Eat Run Sleep. Eat Run Sleep.

Terry was a very good student—he had an excellent memory
and graduated from high school with As and Bs. He was
also methodical. In his pocket-sized training diary, he wrote
in detail what he'd eaten that day, what physical activities
he'd done, and when and how he'd slept.

Before leaving for Newfoundland to start his cross-Canada
marathon, Terry had run 3,159 1/2 miles.

Todays leaving for St Johns

Finished 3159½ miles

Distance

Terry planned his run with the same intensity he'd once shown playing complicated games with his toy plastic soldiers. His goal was to cross Canada's 5,300 miles by running roughly two hundred marathons in a row (an Olympic marathon is 26.2 miles) with no rest days in between—all on one real and one prosthetic leg. Along the way, people would see Terry, recognize his cause and donate money for cancer research.

Many critics said the idea was ridiculous, and to be fair, they had good reason to think so. Look at this way: most Canadians know somebody who competes in marathons, so they are aware that entrants train for months, run in the event and then take a week to recuperate. Imagine running two hundred marathons in a *row*—there's no record of anybody ever running even *one* hundred marathons in a row. So it's easy to see why many people were skeptical.

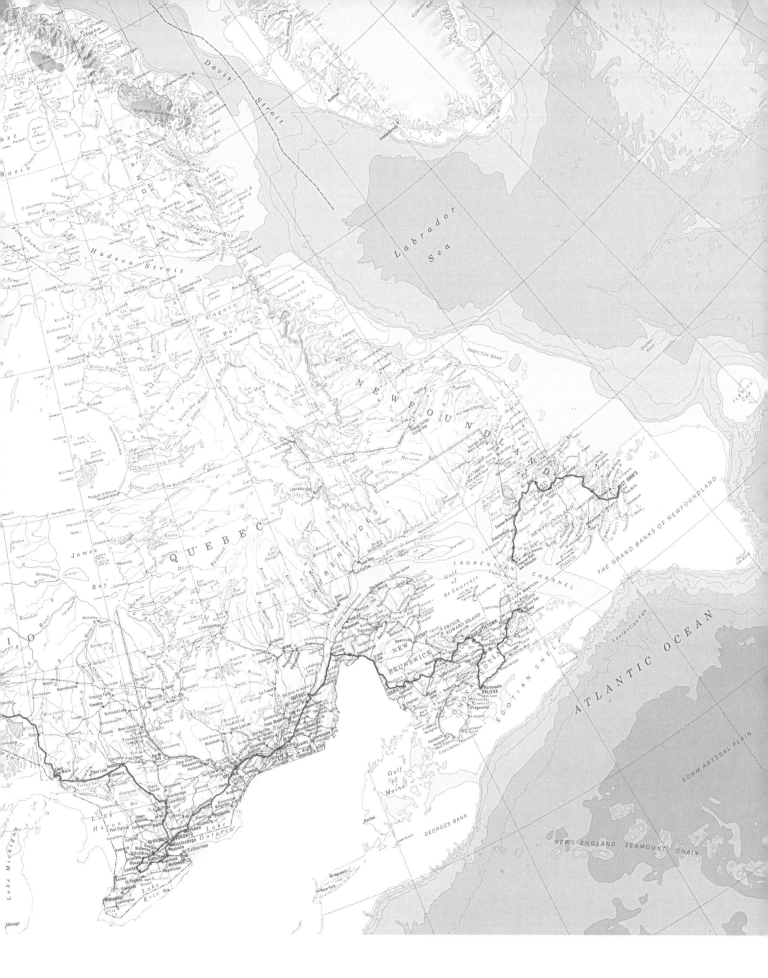

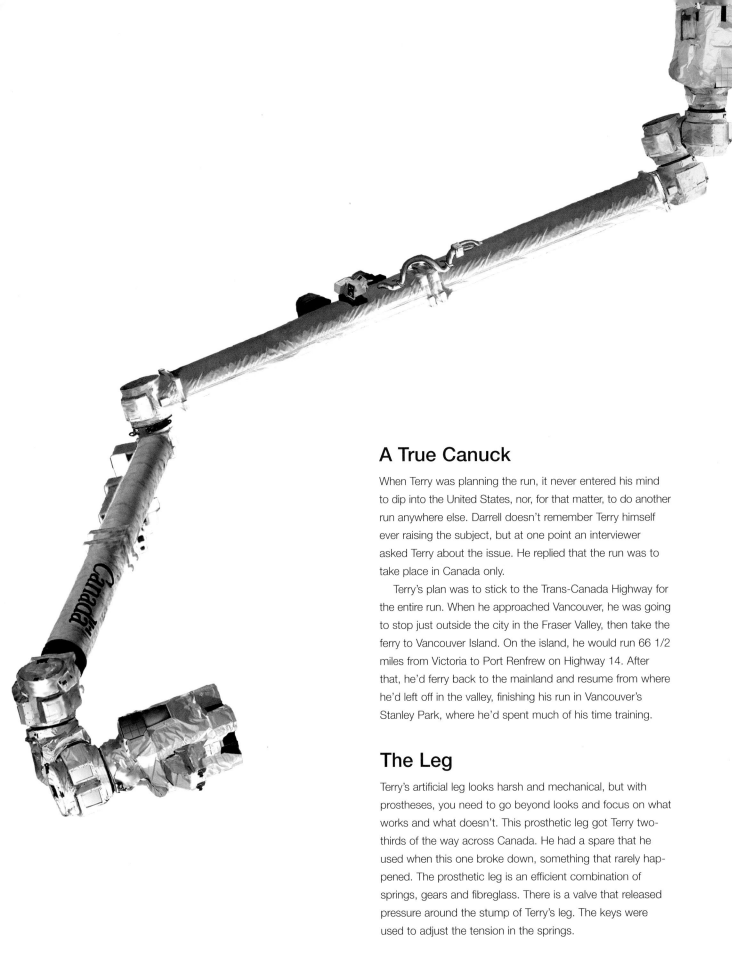

A True Canuck

When Terry was planning the run, it never entered his mind to dip into the United States, nor, for that matter, to do another run anywhere else. Darrell doesn't remember Terry himself ever raising the subject, but at one point an interviewer asked Terry about the issue. He replied that the run was to take place in Canada only.

Terry's plan was to stick to the Trans-Canada Highway for the entire run. When he approached Vancouver, he was going to stop just outside the city in the Fraser Valley, then take the ferry to Vancouver Island. On the island, he would run 66 1/2 miles from Victoria to Port Renfrew on Highway 14. After that, he'd ferry back to the mainland and resume from where he'd left off in the valley, finishing his run in Vancouver's Stanley Park, where he'd spent much of his time training.

The Leg

Terry's artificial leg looks harsh and mechanical, but with prostheses, you need to go beyond looks and focus on what works and what doesn't. This prosthetic leg got Terry two-thirds of the way across Canada. He had a spare that he used when this one broke down, something that rarely happened. The prosthetic leg is an efficient combination of springs, gears and fibreglass. There is a valve that released pressure around the stump of Terry's leg. The keys were used to adjust the tension in the springs.

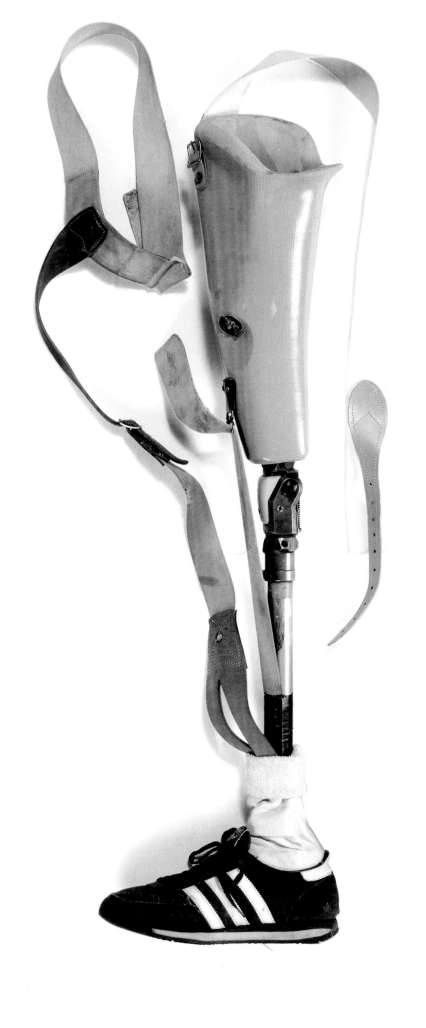

Westward Ho!

On the morning of April 12, 1980, in St. John's, Newfoundland, Terry woke up in a hotel room, had a large breakfast and then dressed warmly. Accompanied by his friend Doug Alward (who drove the van while Terry ran), he went to a rocky shore bordering the Atlantic. He'd brought with him two large clear bottles to fill with water. One was for himself to keep as a souvenir, the other he planned to empty into the Pacific Ocean at Vancouver's Stanley Park once he reached the end of his run.

The weather was rough that day, and one of the jugs fell into the ocean and was lost. The other was filled halfway before angry waves made it too difficult to get more water into it. To this day, Terry's parents keep the jug, shown here, safely stored in their house.

It's now common for people to do cross-Canada events of all kinds, but in 1980, running—or doing anything else—across Canada was a pretty new idea. Although many people in the press thought Terry's idea was too flaky to cover, others were a bit more generous, but a lot of people simply didn't get the idea, it was that new.

When Terry began his run, the mayor of St. John's gave him an honorary send-off, but there was little media fanfare and no cheering crowds. That first day, he ran 11 miles.

The realities of the road came as a bit of a shock to Terry and Doug: sleet, hills, dogs, cold, rain and roaring eighteen-wheel trucks. While these issues were a nuisance, Terry and Doug regarded them simply as obstacles that were actually fun to deal with in their own way. What really did trouble Terry was getting word out about the run so that when he passed through a town, people would know he was coming and he could speak and fundraise. This was long before cell phones, e-mail and faxes. Mostly Terry and Doug used payphones to call local radio stations and newspapers. Sometimes it worked, sometimes it didn't.

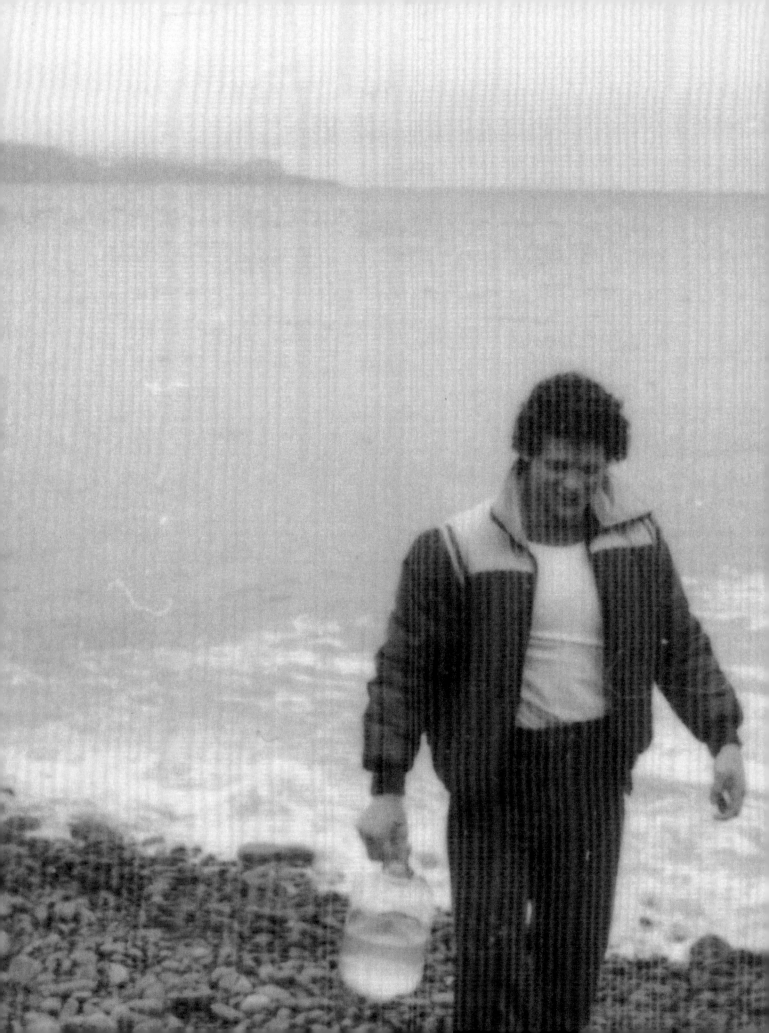

Come by Chance, Newfoundland

In the early and less publicized days of the run, people along the route gave Terry and Doug meals and helped them out in what ways they could. This show of support greatly moved the two young men and gave them a boost during the many times when isolation and a lack of media coverage made the days feel long. The letter below comes from the Gilberts of Come by Chance, Newfoundland. Their generosity is typical of Canada's response to Terry and Doug's passage.

Dear Mr. and Mrs. Fox,

… We were the first ones to go after him [Terry] to stay here. We flagged them down—him and Doug his pal. Brought him in our kitchen, had a chocolate cake made for him. Gave him a souvenir of CBC [Come by Chance] and had people come in, give donations. I dried his clothes in the dryer …

While he was upstairs getting cleaned up I called the Toronto Star and they called back and talked to him by surprise and had an interview with him. We also called the radio station and spoke highly of him and asked he be greeted elsewhere on his route.

And we had the high school girls as seen in the picture come in for his visit …

Pictures enclosed for you of the cake and him and Doug at our kitchen table …

We hope to see you on your next visit to Newfie or on ours to Vancouver.

Betty & George Gilbert
Come by Chance, Nfld.

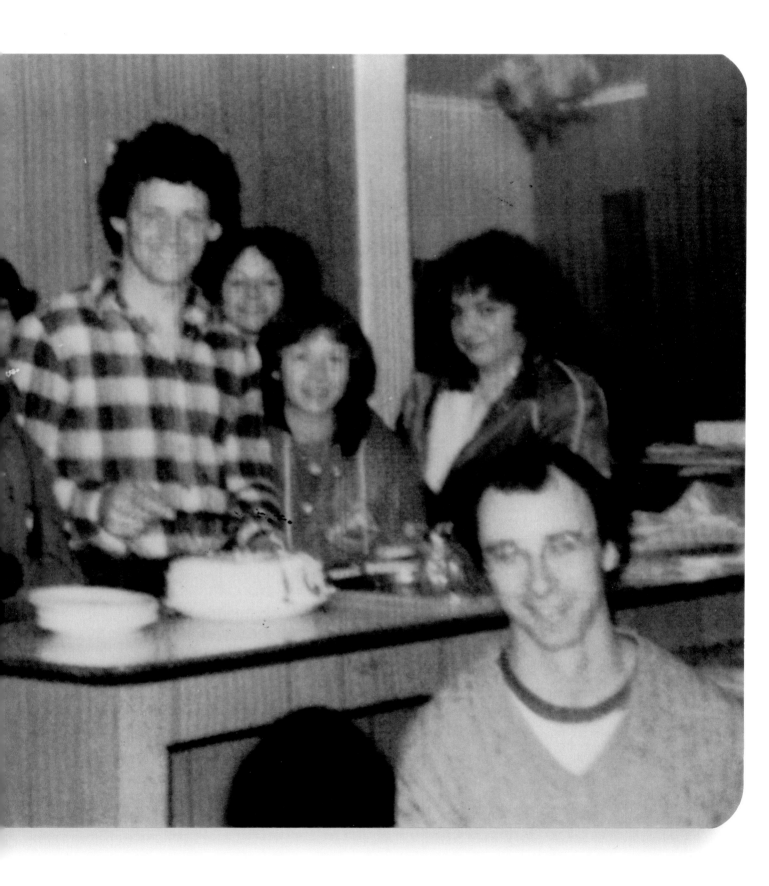

SATURDAY / APRIL 26th / 1980

(DAY 15) 35 miles Total 337 miles

Today we got up at 4:00 A.M. like usual it was tough. We drove the 35 miles back to our starting point and I took off again. This time I had the other leg on with the ordinary knee I had made at the start whether it would be effective or not. However, it did seem to be a bit easier on my body and the leg I had was coming through quicker. It was very foggy this morning, so I ran on the left side of the road. We wanted to cover 14 miles right away, because there was going to be a reception at the Smithbrook Junction. I was feeling pretty good and the first 2½ miles went quite nicely then all of a sudden I was seeing & pictures of everything. I was dizzy and light headed but I made it to the van. It was a frightening experience. Was it all over? Was my running finished? Would I let everybody down? Slowly the seeing double went away, but my eyes were glossy and I was light headed. I told myself it is too late to give up I would keep going no matter what happens. If I died, I would die happy because I was doing what I wanted to do. How many people could or can say that? I went out and did 15 pushups on the road and that took the My head was left but the double sightedness went away. At 5 miles Doug and I talked about it for a while. I cried because I knew I was going to make it or be in a hospital bed or dead. I want to set an example that will never be forgotten. It is courage and not foolishness. It won't a waste. I managed 8 raw miles then we ate lunch while we let time go by, so we could time our arrival at the junction. I ran miles to the Springdale Junction, then drove to the Barr West Junction for another reception, then we drove back where I finished my last 3 miles with a headache. We stayed in the building there, were we were given a meal. After that I drove for about an hour. Drove to Bassville and settled. We love bed at 8:45. I talked with Uncle Doug

Last night there was a band playing all night. It took about an hour to get to sleep. But at around 1:30 Doug and I were both woken up to vibrating drums. At 2:30 A.M. we decided to leave the hotel and drive to the nearby Esso Station. Since time switched I couldn't get up at 4:30 A.M. which was really 3:30 A.M. We finally got up at 6:15 A.M. and took off. It snowed all day long, fortunately it didn't stay on the road. It was very, very cold today. Fortunately, the wind was at my back. The terrain was rolly but not big hills. The first miles were like usual tough, but I felt quite good from there till the end of 10 miles. During our break we drove to a tiny town called Stephenville. Here I talked to a bunch of kids, (cute kids). We rested at the Bair Not Junction, and then I did my next 15 miles in a row. I ate too many chocolate chips and had a cool breeze in my face from the air conditioner we thought might be an heater. I felt very sick for the first 3 to 5 miles. But luckily it went away. We had around 13 miles of road without a single curve. The miles slipped bye way quickly. Some teenagers from Stephenville ran the last 3 miles with me, which I burned up. My sores went away today. We drove back to the Indian River Hotel were our meal and rooms were donated. Bair Not Junction. Here we showered and then I did my phone calls. We still couldn't get hold of the amputee Association, in order to get my leg sent away and repaired. After that we had our meal. Then I came back did some postcards and went to bed.

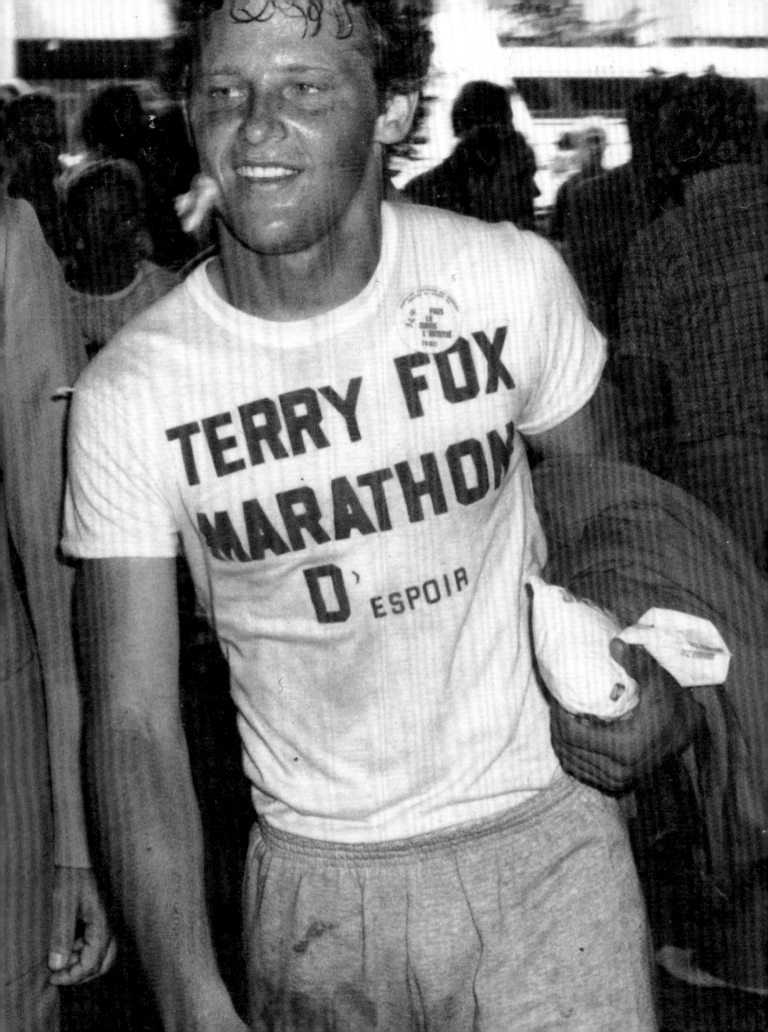

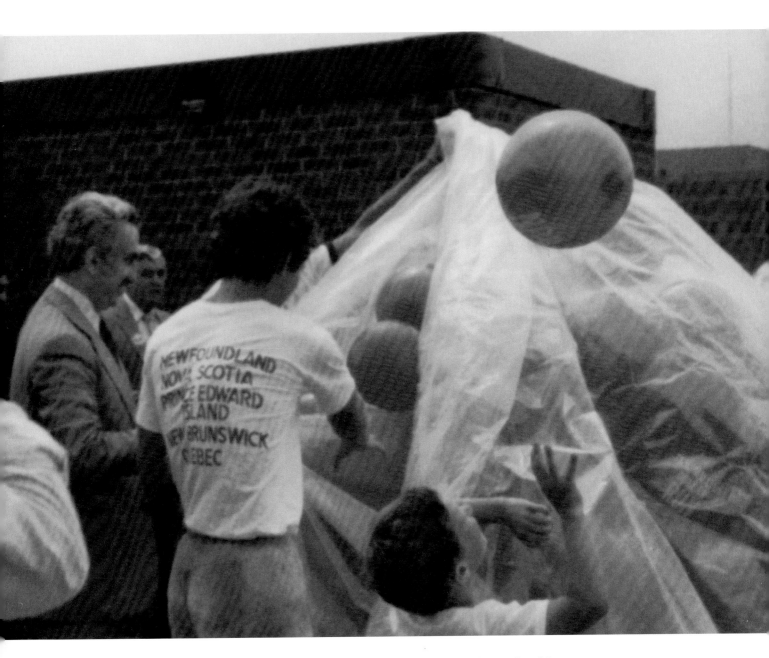

Montréal, Québec

June 23, 1980

Terry releases balloons from the roof of the Four Seasons Hotel in Montréal. This was the first time in seventy-three days that Terry didn't run, and though he enjoyed the break he was distinctly worried about losing a day's progress.

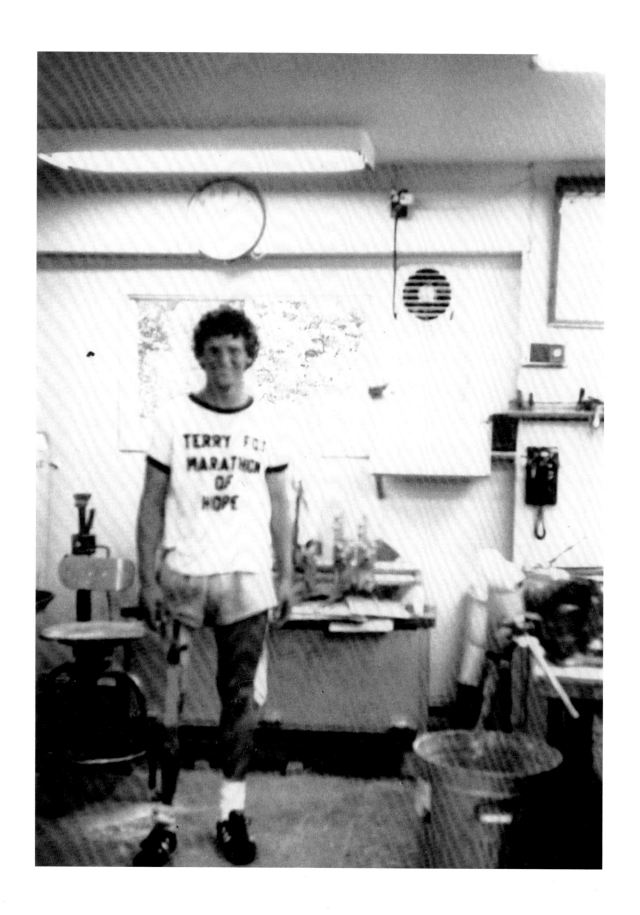

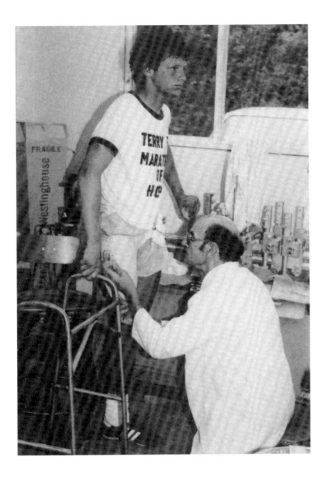

Hull, Québec
July 1, 1980
Left and this page: Terry in the office of Armand Viau. A master
prosthetics craftsman, Viau is fitting Terry for two new artificial legs.

Road Health

Terry's body took an awful beating from the run. Most people don't know that he had a condition called ventricular hypertrophy (an enlarged heart due to inflammation of one of the valves). It's not uncommon among athletes, and in Terry's mind it was far more of a threat to the success of the run than the possible return of cancer. There's no way of knowing if Terry was born with this condition, or whether it was caused by his sports activities or by his chemotherapy drugs. He always said it was the chemotherapy.

He had his heart X-rayed once before the run, and then refused to have it X-rayed again. This reluctance might have been bravado, but it might have been superstition, too. Terry simply didn't want anything to hinder his run.

Nobody—nobody in recorded history—had ever run this many consecutive marathons, so there were no examples to learn from. Terry had shin splints, he lost many of his toenails,

his knee was inflamed, his stump was endlessly bruised and chafed and developed many cysts. He lost weight, got dizzy spells and saw double—but he kept almost all of this to himself, and when people expressed concern, he always said it was really nothing.

As well, the weather for most of Terry's time in Ontario was unusually hot and muggy, which meant he had to drink water constantly and which increased the chafing and the formation of cysts on his stump.

The biggest single injury Terry suffered wasn't physical but emotional. A British Columbia journalist named Doug Collins wrote a story saying that Terry had driven through Québec. That the newspaper was published in the Vancouver area made it all the worse. Darrell says the story so disturbed Terry that the run almost ended there, and afterwards, Terry became more guarded around the media.

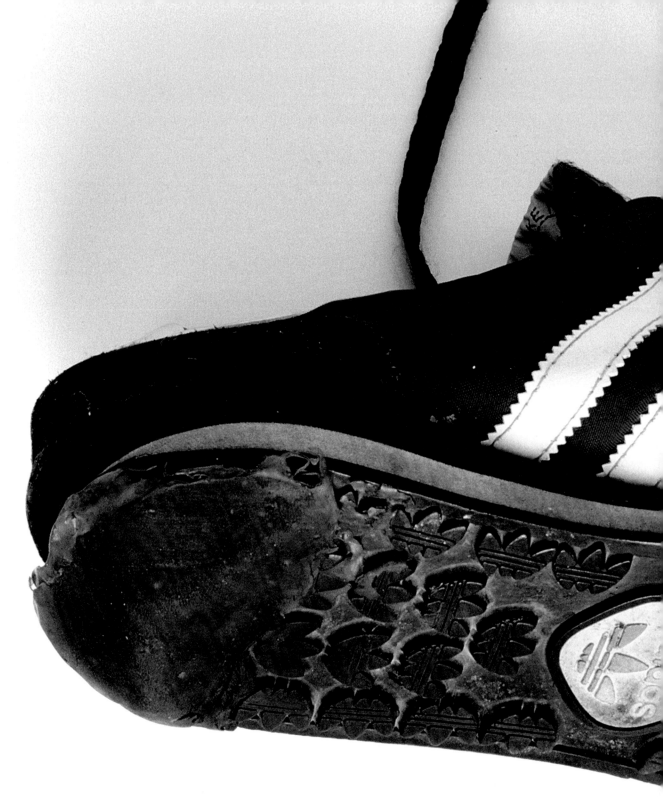

Treads

Running shoes were very primitive in the early 1980s, not at all like the high-tech marvels we see today. The model shown here was one of only a few suitable for Terry's run. He went through nine shoes in all: one shoe only on his prosthetic foot, and eight on his real foot, which took the brunt of the wear. The shoe shown here is a left one that he wore on his real foot. The brown flaky stuff on the sole is from a squeeze-on plastic called Shoo Goo that was used to extend the shoe's wear. In the twenty-four years since 1980, the plastic has turned into the consistency of cornflakes that have gone soggy and dried onto the bowl.

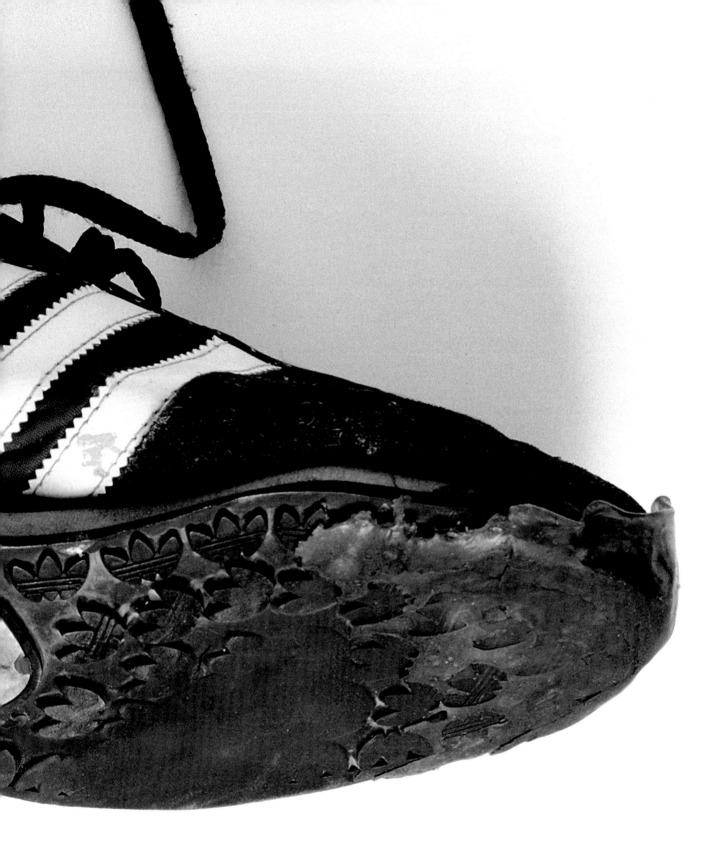

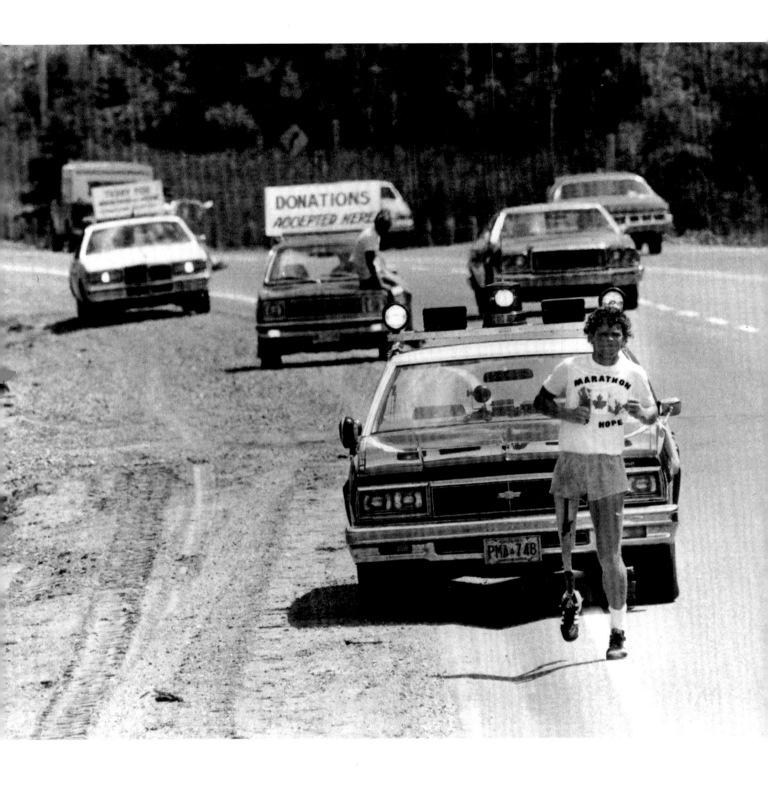

Life on the Road

Early in the run, Terry had a bit of time for himself. After a day of running 26 miles, doing phone and radio interviews, and giving one or more speeches every night, he also kept a detailed journal and wrote scores of postcards and letters.

Sometimes motel owners let Terry and Doug stay for free, but if no motel was available, they camped in their van for the night in church parking lots or out in the country where they were unlikely to be disturbed. Terry occasionally took the van and went for a spin by himself, which must have been an odd experience, driving in a few minutes the distance that it took him a full day to run.

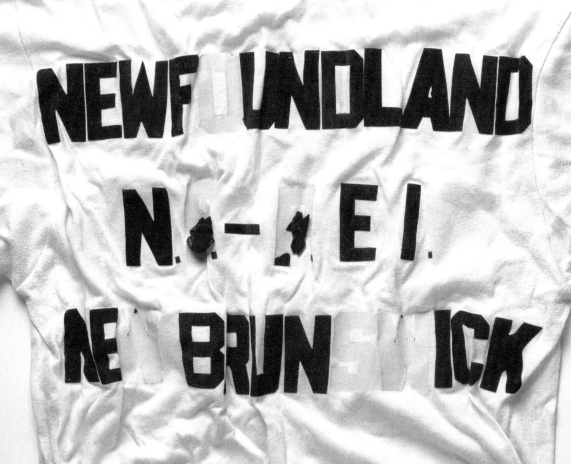

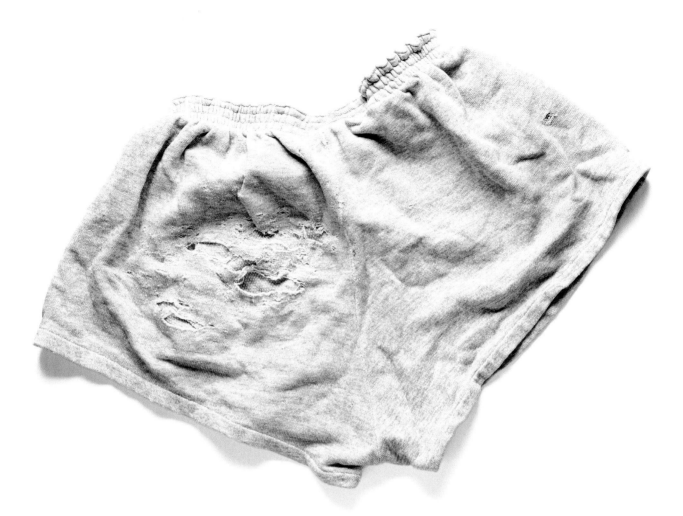

Terry's Marathon Outfit

Terry was inflexible about his wardrobe during the run. He would wear only his white T-shirts with MARATHON OF HOPE lettering and his grey shorts. Decades ahead of his time, he refused to wear clothing that had logos or brand names on them, as they might imply he was endorsing a company's products. On a humorous note, when this shirt was being photographed in the living room of Terry's parents in April of 2004, the red lettering, which was brittle with age, flaked off onto the carpet, and Mrs. Fox said, "It's twenty-five years later and that kid is still messing up my living room."

Food Fight!

When you run across Canada, you need a lot of fuel, and Terry's fuel came from motel restaurants across the land— good simple 1980-style cuisine, and massive amounts of it. Reporters who dined with Terry were pretty speechless when they saw how much he ate. A few hours later, when they saw how far he'd run in a given day, they were even more stunned.

And one thing that gets overlooked in the history of the run is just how much darn *fun* it was for Terry, Darrell, Doug and, later on, the collection of people who became part of the van's team. They were making history. They were doing what they wanted to do. Tempers sometimes flared, but then ten minutes later it was all something to joke about. They ribbed each other mercilessly, and often there were food fights. The guys in the van used food as a means of letting off steam, but their one rule was that "food may never touch the restaurant"—food on the upholstery or walls would have been insulting to the many people who treated them kindly along the way. Instead, a food assault had to be confined solely to the body: soy sauce in the crotch, Black Forest cake down the inside back of the shirt, fries down the back of the pants. Laundry day always came as a relief to all.

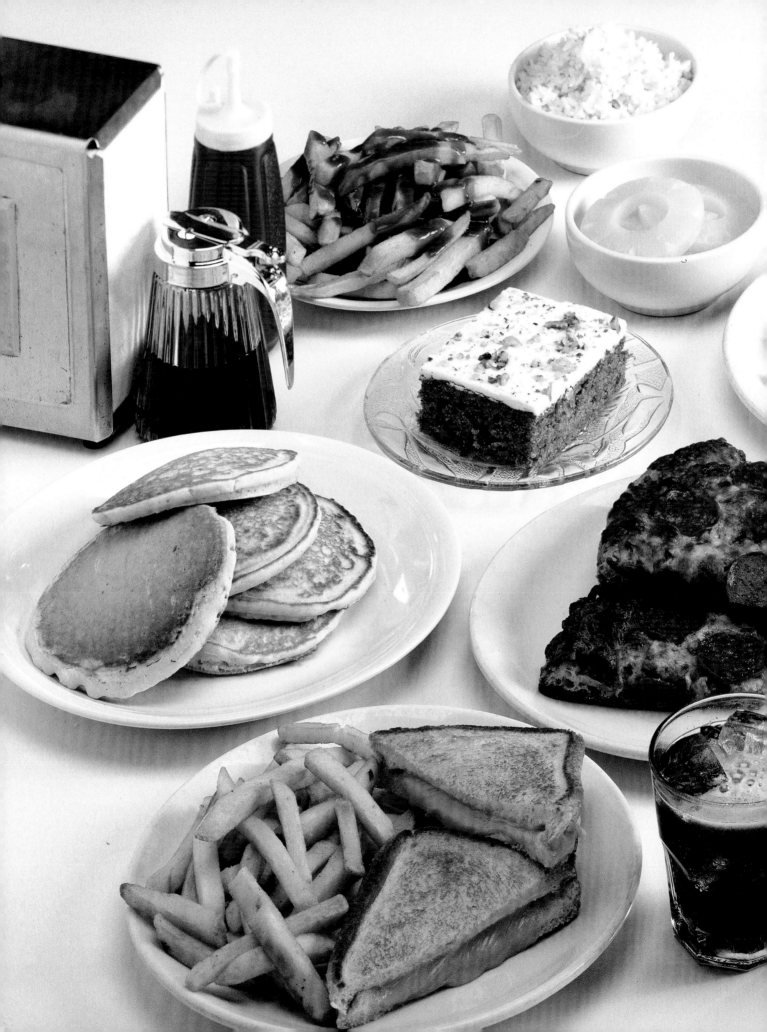

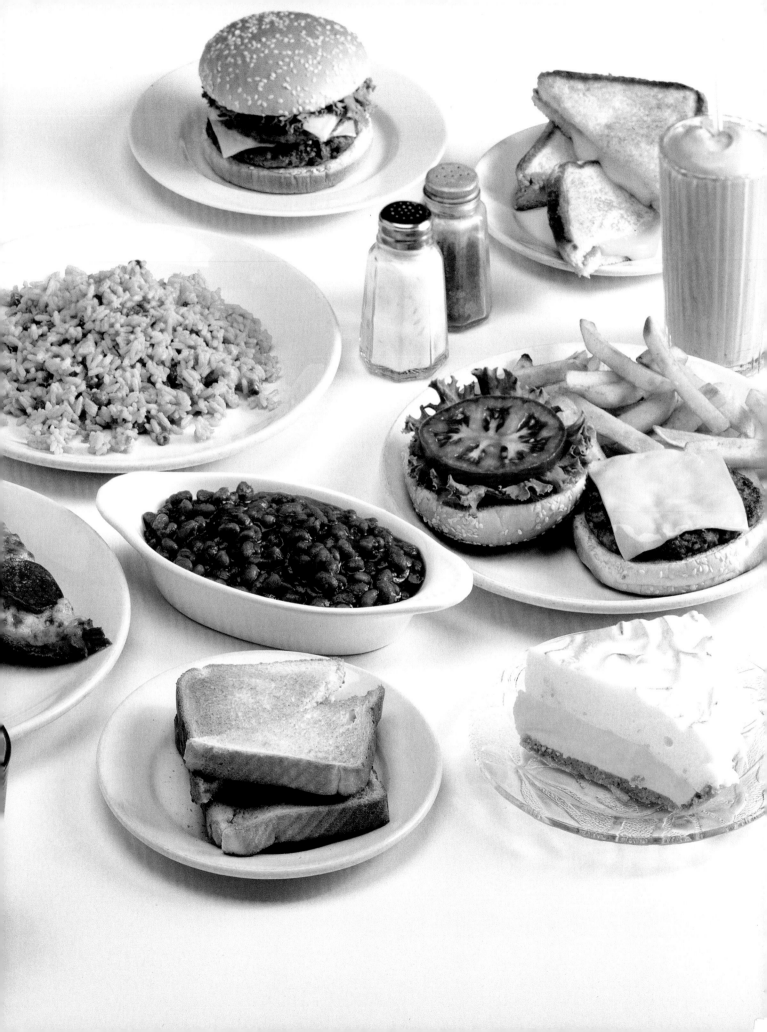

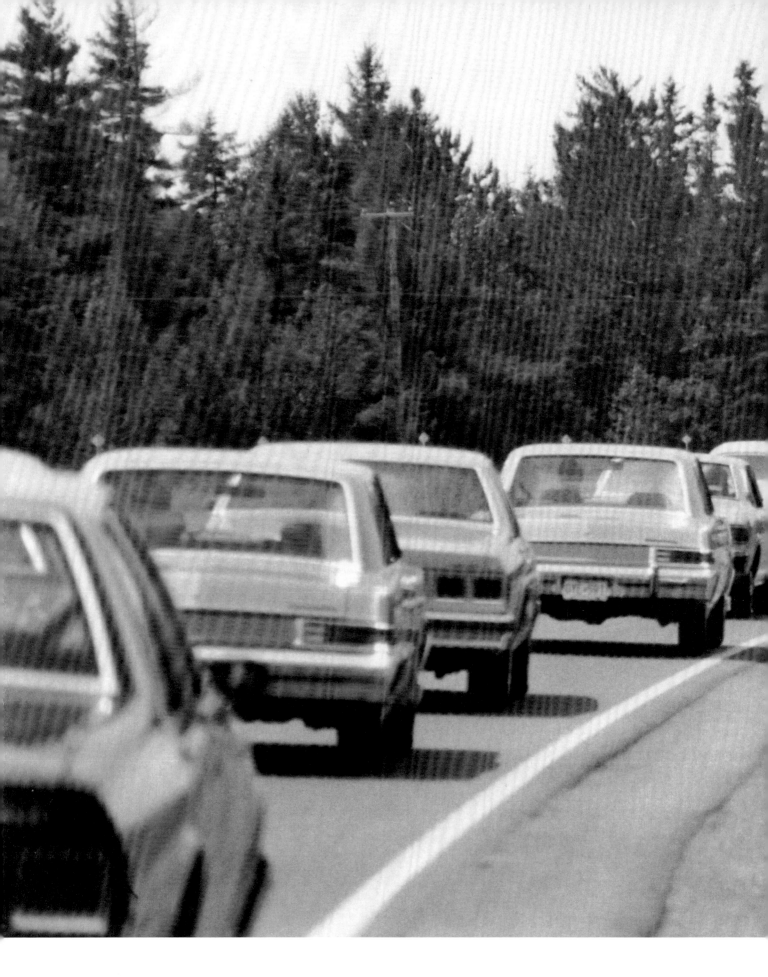

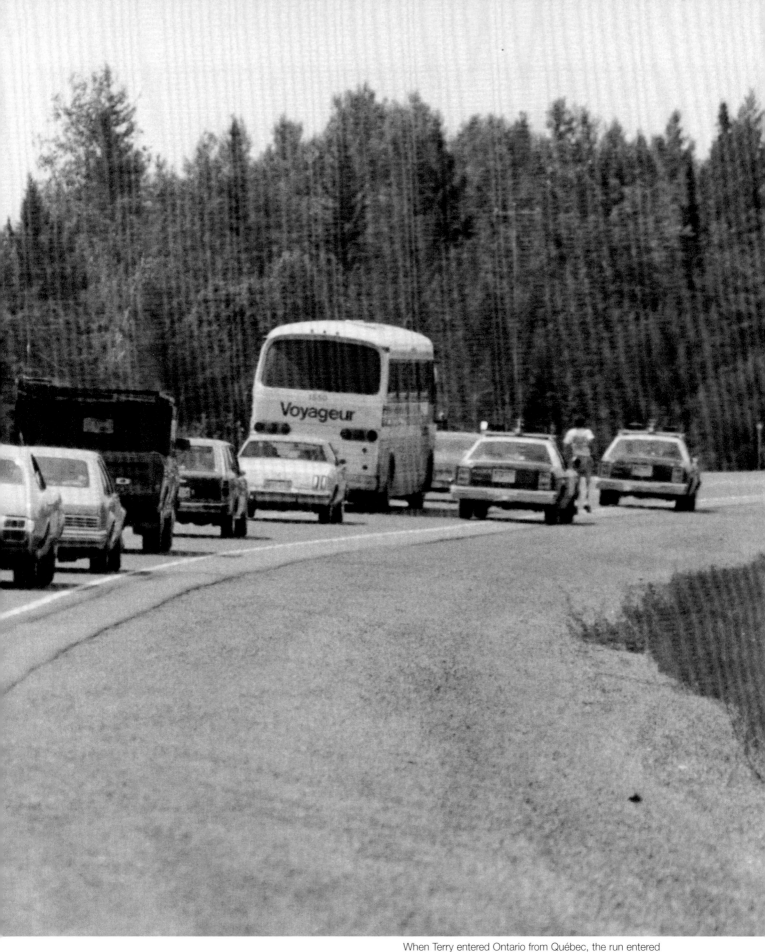

When Terry entered Ontario from Québec, the run entered overdrive and stayed that way until the end.

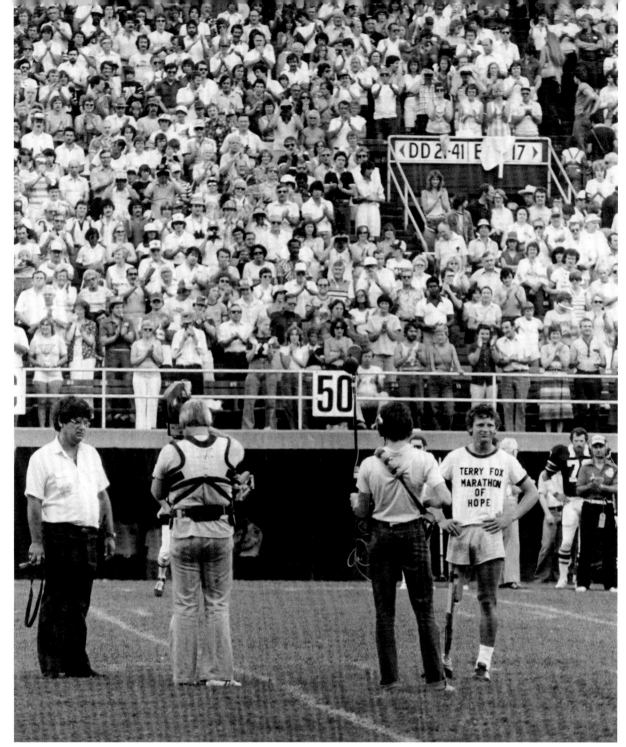

Terry waits for the signal to run onto the football field and kick the ball to start an Ottawa Rough Riders game.

Sunburn

When people look at photos of Terry taken during the marathon, most of them remember that his face was sunburned. What's often overlooked is that it was mostly Terry's *left* cheek—the cheek that faced the sun as he ran westward— that was sunburned, the Canadian landscape burning itself onto his body.

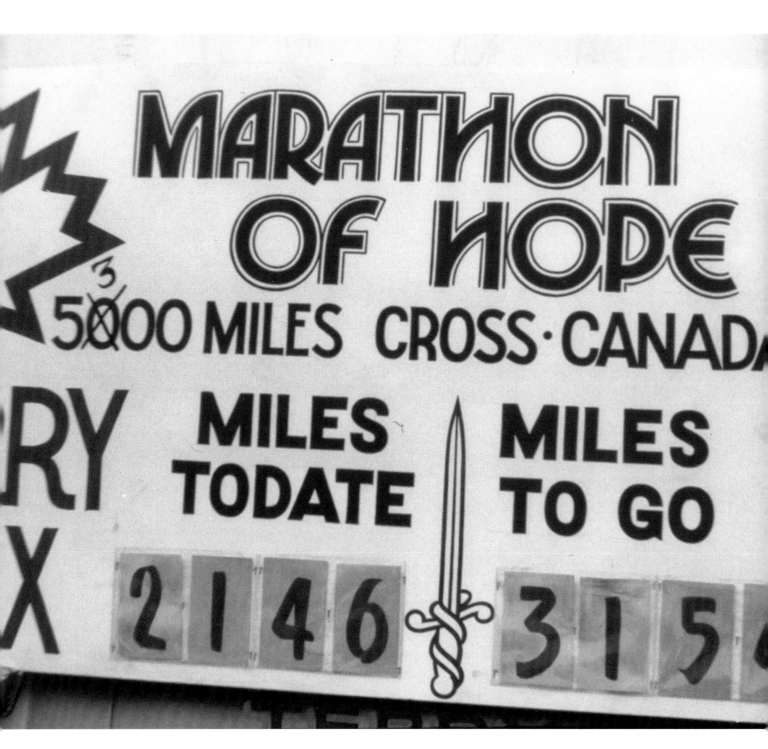

MARATHON OF HOPE
5000 MILES CROSS·CANADA

RY MILES TODATE MILES TO GO

X 2146 315

The Van

The vehicle Terry used for the run was a camper van donated by Ford of Canada. It had air conditioning, a stove, a fridge and a stereo. Technically, the van slept six, but it quickly filled with all of the clutter that surrounds most twenty-year-olds: food, laundry, papers and so on. The van also became notorious among journalists because of its odour—a combination of sweaty clothing and a chemical toilet.

By the time this photo was taken, Terry and the van had travelled 2,146 miles.

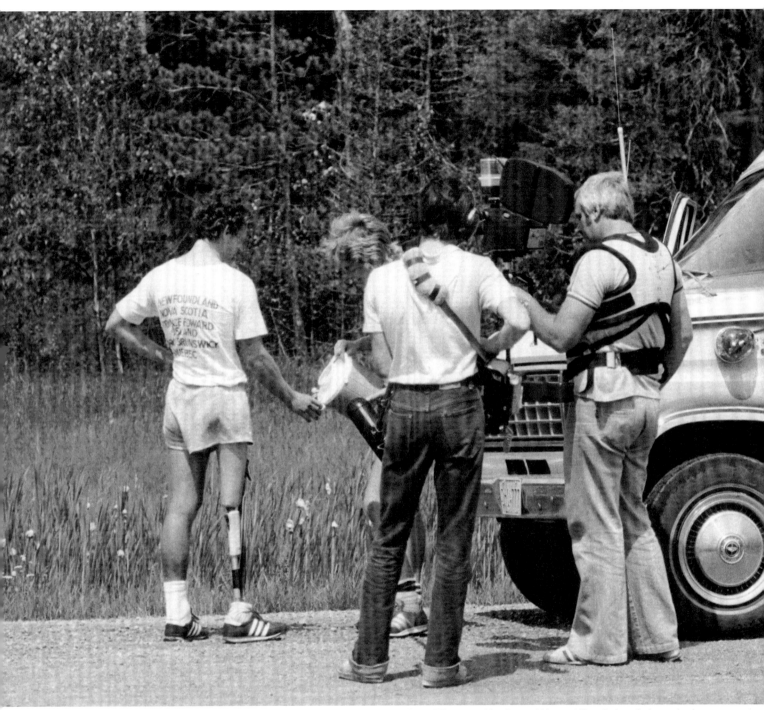

Darrell Fox says this photo of him and Terry being photographed
by a film crew really captures the sense of being on the road.
"Terry had to have water or oranges at precisely every mile along
the way, and there was always a film crew nearby."

Scarborough Civic Centre

Scarborough, Ontario
July 10, 1980

When Terry arrived at Scarborough's Civic Centre building, just east of Toronto, both the media and Canadians realized that Terry and his story were becoming something much larger than just a run to raise money for cancer. The cold lonely days in the rural Maritimes and Québec were long gone. The air in Ontario was charged and muggy. Terry was now mobbed by fans of all ages, and on stage, his presence was electric. Listeners were spellbound by the honesty and realism of his words, spoken in a deep voice—along with his pauses and errors. In 1980 Canada's economy and political future were both on rocky courses. Never before had Canadians been so cynical and jaded about society. And suddenly, there was this young guy in front of a microphone who was everything you wanted the world to be.

"I'm not doing the run to become rich or famous. One of the problems with our world is that people are getting greedy and selfish."

In Scarborough, Terry was presented with a daffodil by a young cancer victim, Anne Marie Von Zuben. Anne Marie had been fighting cancer since the age of three and was thirteen when the photo on page 64 was taken. Terry said of this meeting, "On my run, when I got emotional, it was because I was happy, it was a life-happening, like that girl Anne Marie Von Zuben, who lost her hair three or four times on chemotherapy treatments, and she was still there. She gave me a flower, and boy, that really hit me, that was a great one."

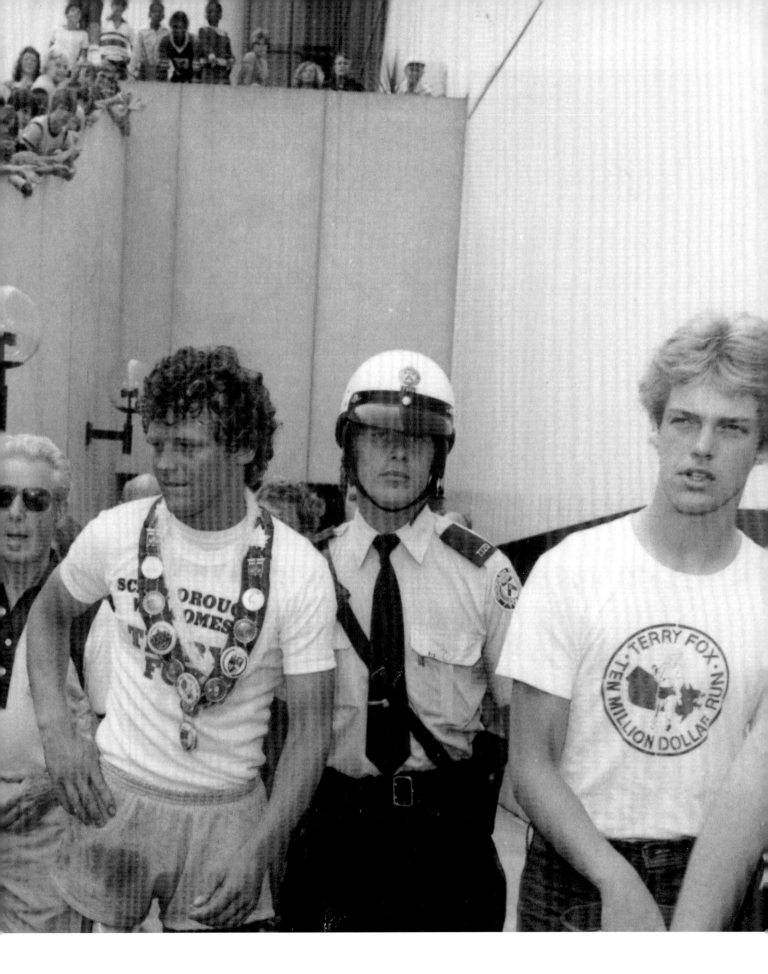

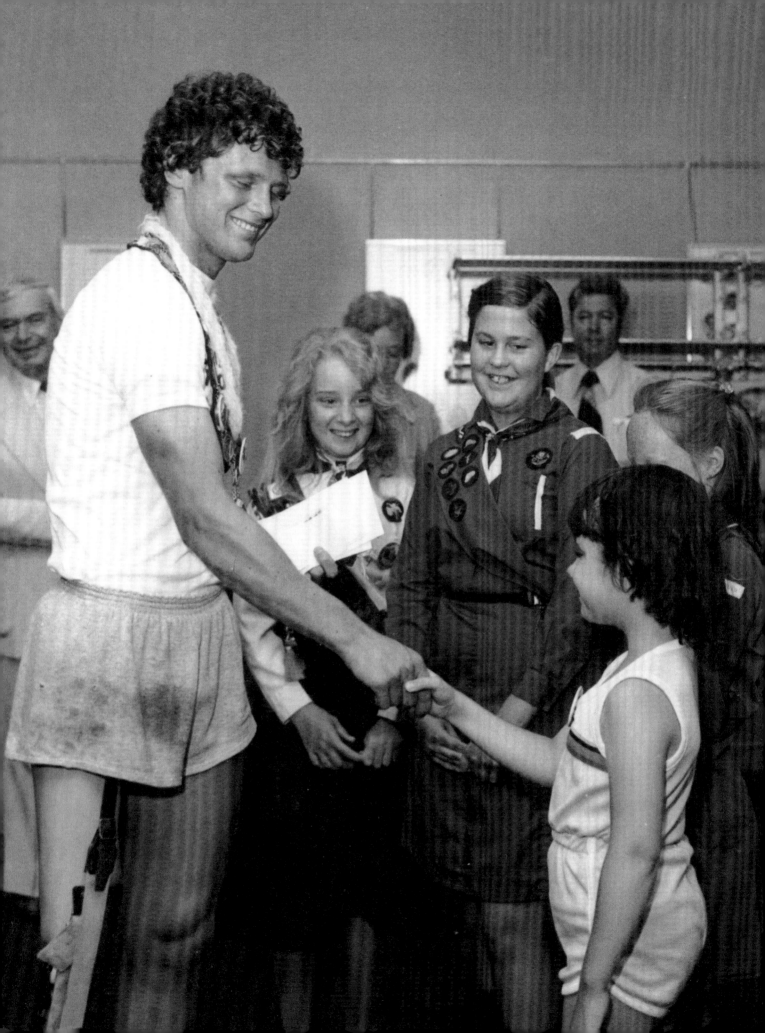

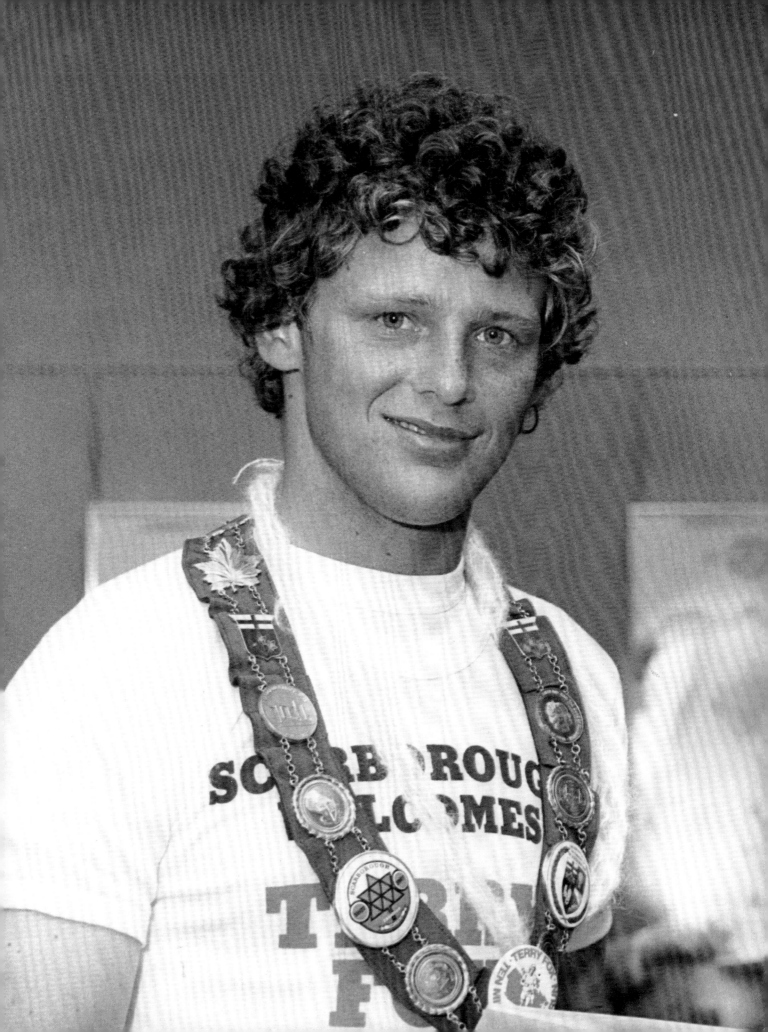

Terry spends the evening at a backyard barbecue in St. Marys, Ontario.

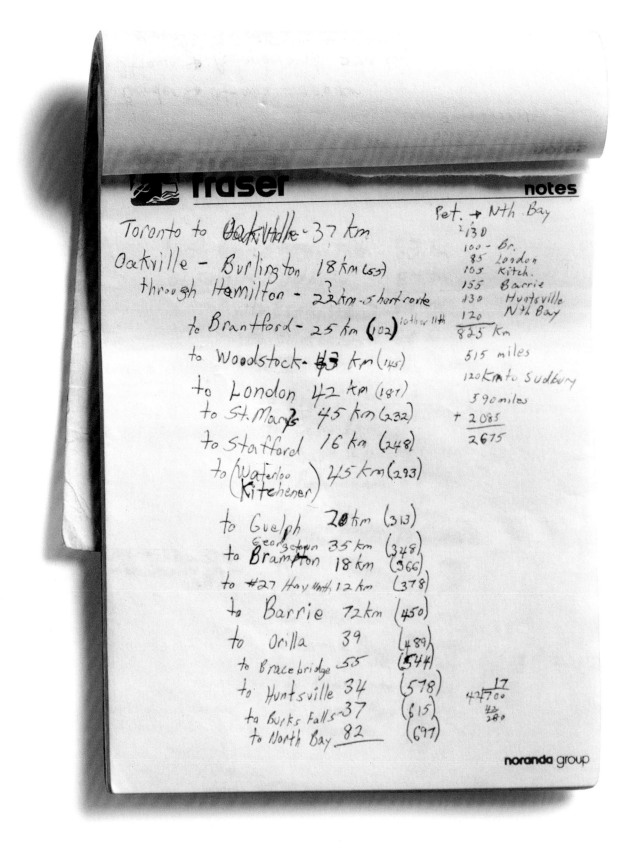

Toronto to Oakville - 37 km

Oakville - Burlington 18 km (55)

through Hamilton - 22 km - short route

to Brantford - 25 km (102) 10th or 11th

to Woodstock - 43 km (145)

to London 42 km (187)

to St. Marys 45 km (232)

to Stafford 16 km (248)

to (Waterloo) 45 km (293)
(Kitchener)

to Guelph 20 km (313)
 Georgetown 35 km (348)
to Brampton 18 km (366)

to #27 Hwy Nth. 12 km (378)

to Barrie 72 km (450)

to Orilla 39 (489)

to Bracebridge 55 (544)

to Huntsville 34 (578)

to Burks Falls 37 (615)

to North Bay 82 (697)

Pet. → Nth. Bay
130
100 - Br.
85 London
105 Kitch.
155 Barrie
130 Huntsville
120 Nth Bay
825 Km

515 miles

120 Km to Sudbury
390 miles
+ 2085
2675

17
42)700
42
280

noranda group

Calories, Miles and Phone Calls

Part of life on the road during the marathon was the endless crunching of mileage numbers—figuring out how far Terry had run during the day and how much farther he had to go. Terry made it two-thirds of the way across Canada before he had to end his run. These are two of many pages from a notebook kept by Terry's friend, Doug Alward, on which he calculated

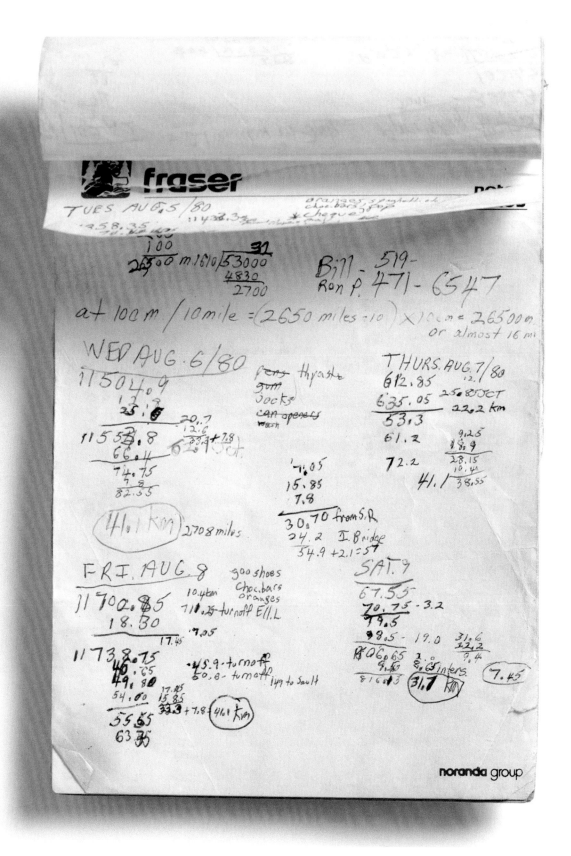

mileages over and over and over. As can be seen, food and
phone calls and mileage were the three big issues—inevitable
and necessary when crossing a country as wide as Canada.

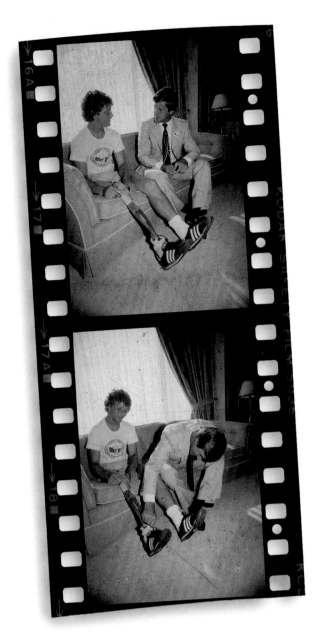

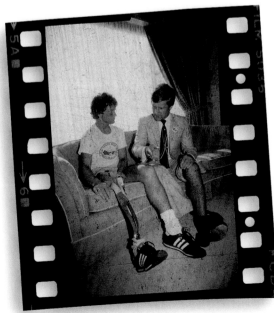

Legend Meets Legend

Terry was a massive hockey fan, and two highlights of the marathon—and of his life—were the meetings with hockey legends Bobby Orr and Darryl Sittler. Here, Terry and Bobby Orr are comparing legs and having a blast in Toronto. These photographs, taken during Terry and Bobby's meeting, give an idea of the high spirits and energy of the encounter.

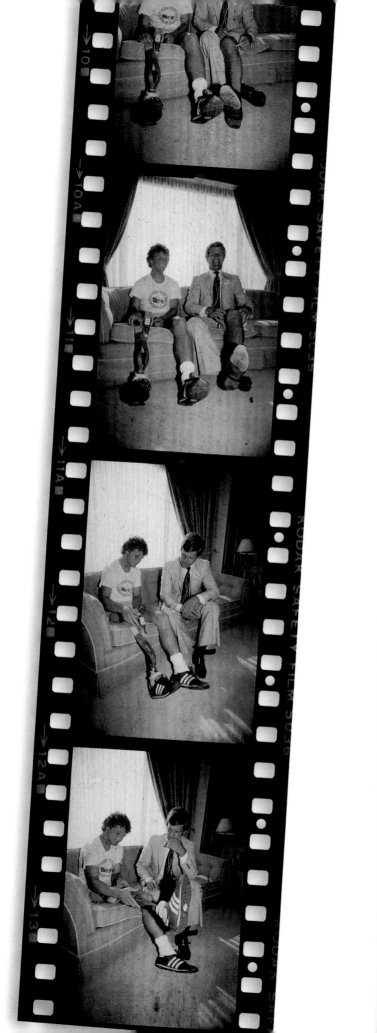
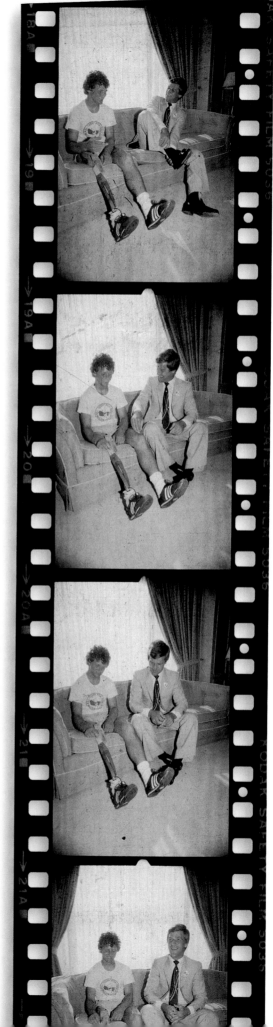

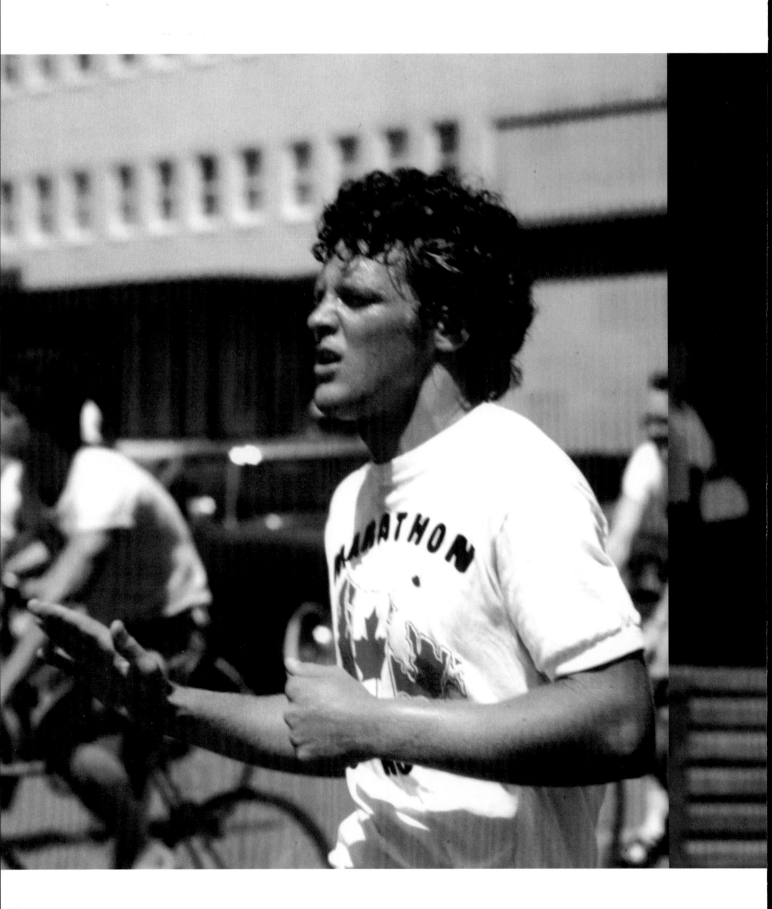

Terry is running down Toronto's University Avenue en route to Nathan Phillips Square. On page 72, Terry gives what his brother Darrell called a "Terry wave"—Terry's way of acknowledging the people who were cheering him on.

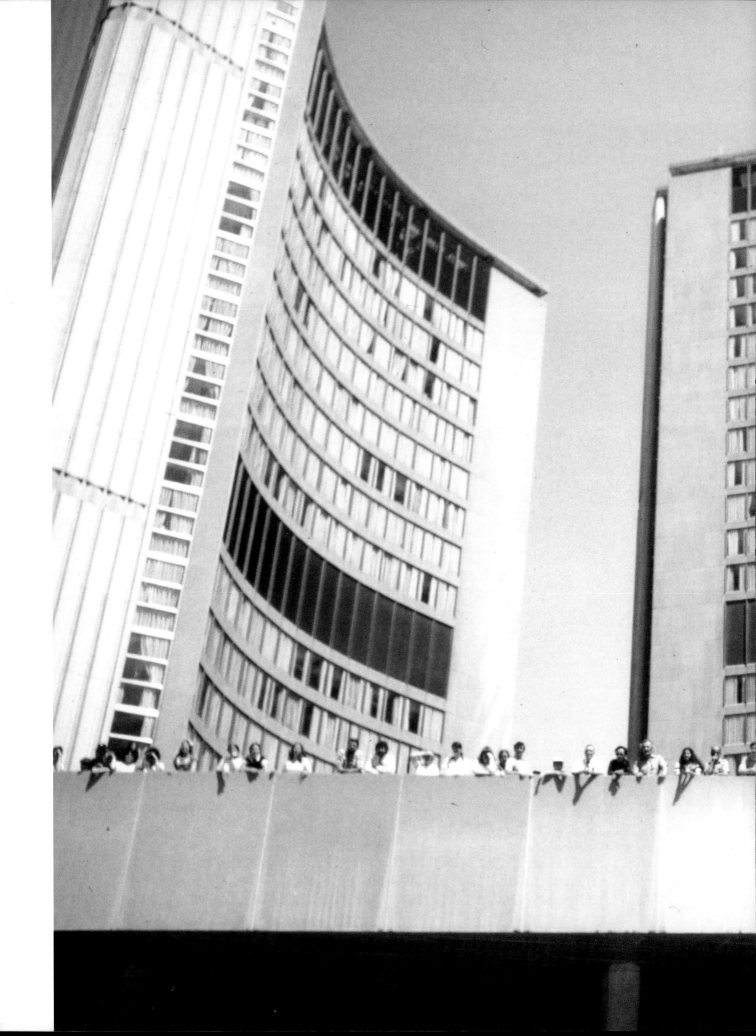

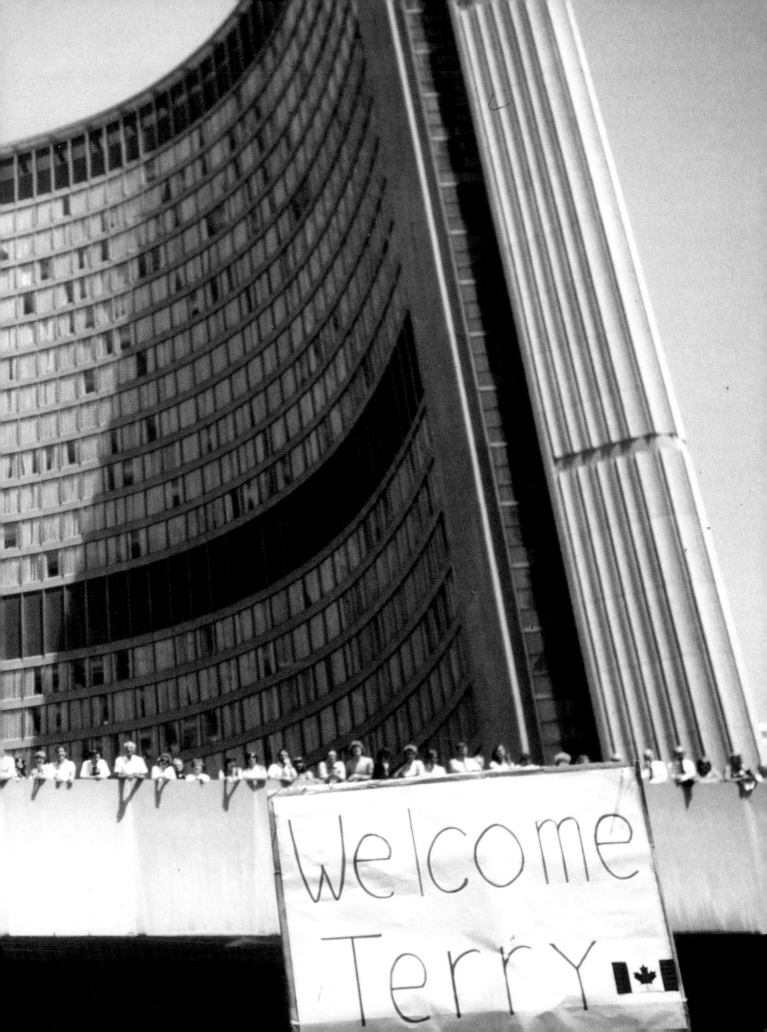

Superstar

Toronto, Ontario
July 11, 1980
30° Celsius

Terry's time in Toronto was brief and dramatic. After meeting with his sports idol Darryl Sittler, the two men, plus friends and family members, ran down University Avenue to Toronto City Hall in Nathan Phillips Square. Ten thousand people watched as Sittler gave Terry his 1980 NHL All-Star team sweater and called Terry a superstar. Terry raised $100,000 that day.

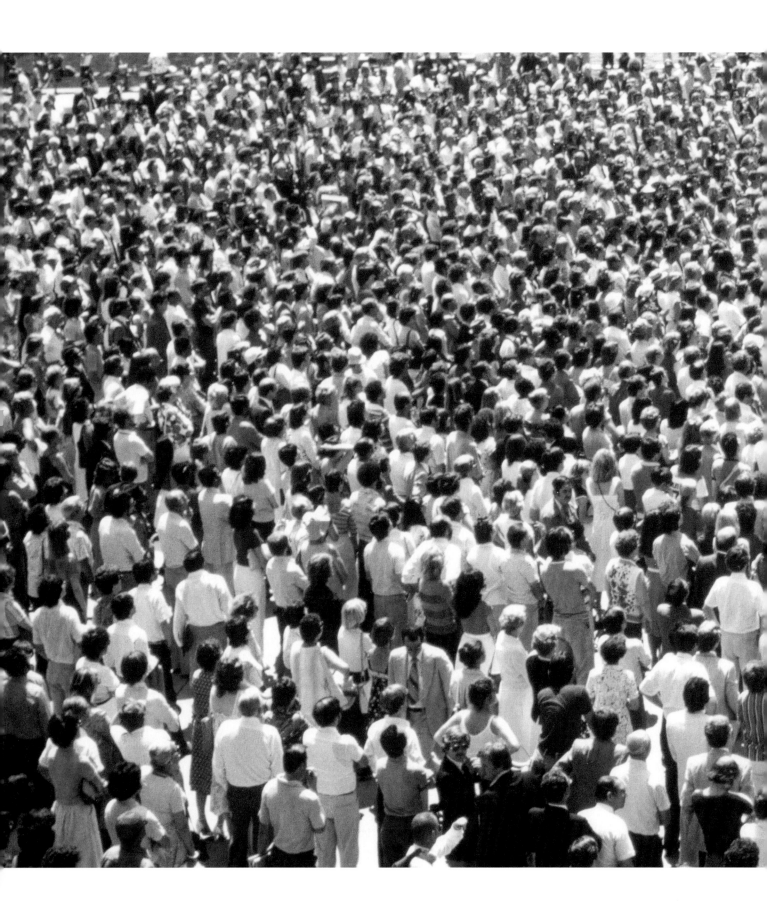

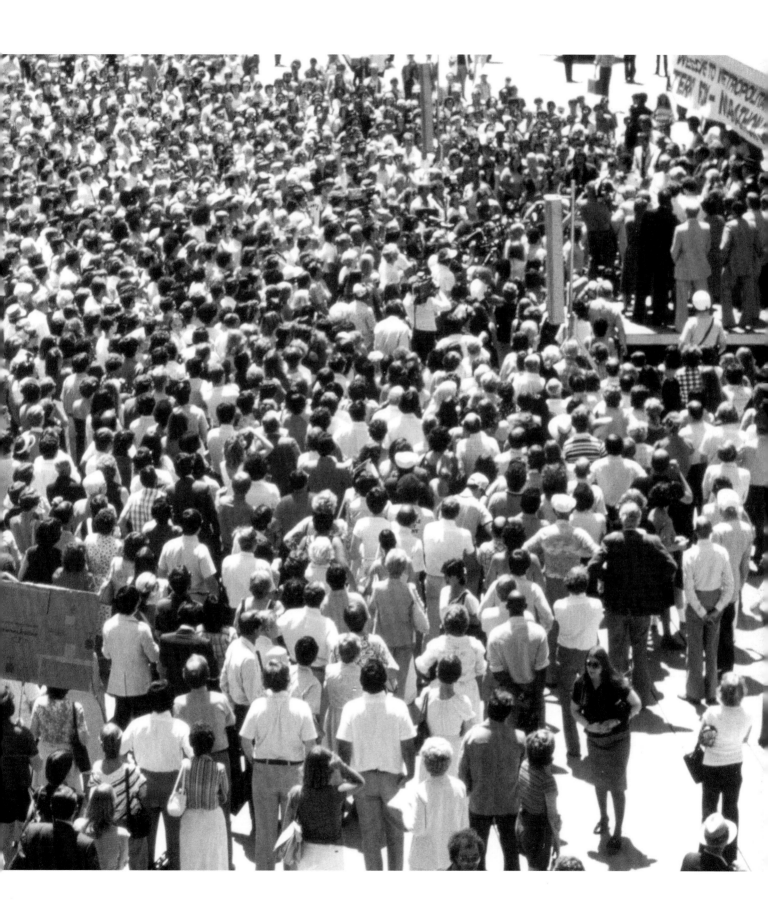

One Leg: $55.00

This is an expense account slip filled out by Bill Vigars of the Canadian Cancer Society's Ontario Division. Bill met with Terry in the Maritimes and was instrumental in arranging press and speaking activities for Terry's time in Ontario.

This expense slip tells a lot about life during the marathon: sunburn lotion, long-distance phone calls, rain gear, a trip to the top of Toronto's CN Tower ... and a $55.00 cab fare to have a replacement leg sent to Hamilton from Toronto!

WEEK OF _____

Date		Place
July	6	Peterborough
	4	"
June	28	L' Orignal
	7	
	12	Toronto
	12	
	14	
	13	
	14	HAMILTON
	14	
	15	
	18	
	17	LONDON
	19	
TOTAL EXPENSES		

Ontario Division, Canadian Cancer Society

EXPENSE ACCOUNT

No.

NAME: W. Vigars

Mileage Allowance		Hotels		Meals		Miscellaneous			Total	
						Food	4	56		
						Sunburn Lotion	12	70		
		20	—			BELL CANADA JUNE 18/80	5	81		
				8	10	CAB	3	—		
						CN TOWER	4	—		
PARTIAL RECEIPTS				43	12	3 CABS return & activate	44	—		
				13	79					
				16	86	~~16 86~~				
				TERRY'S LEGS		CAB FARE - SHIP TORONTO TO HAMILTON	55	—		
				23	24	CASH FOR GAS	10	—		
				10	80					
				17	50		2	75		
				18	00					
				38	67	CAB	3	05		
						RAIN CABY CLOTHES	17	90		
		20	—	172	58		158	85	351	43

Signature _____

Hot and Cold

People sent Terry thousands of gifts, large and small. One of them is a delightful leg warmer (for just one leg!) for when the run was to have continued into the fall and winter. Another is a sun hat, decorated by schoolchildren, for the remainder of Terry's summer.

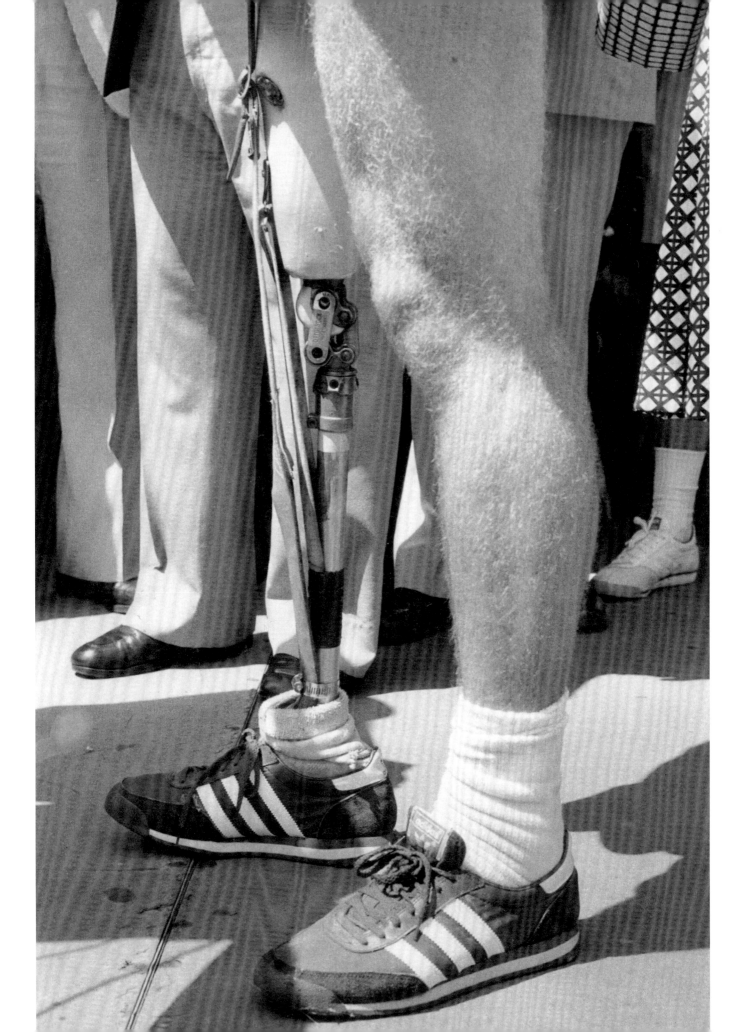

On the road: His face was a grimace, not so much of pain as of concentration. It was the same look children have when they struggle with a difficult math question.

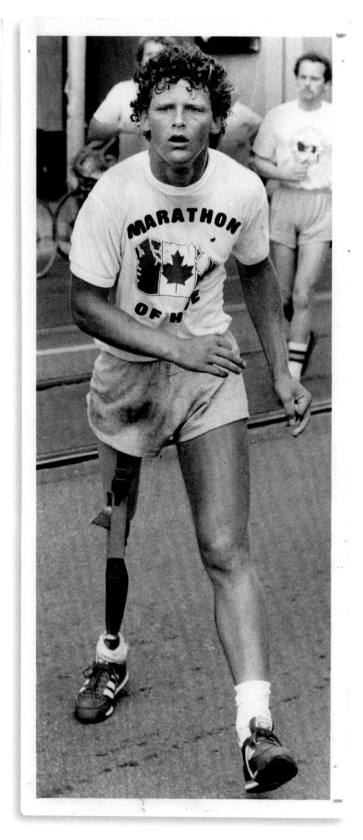

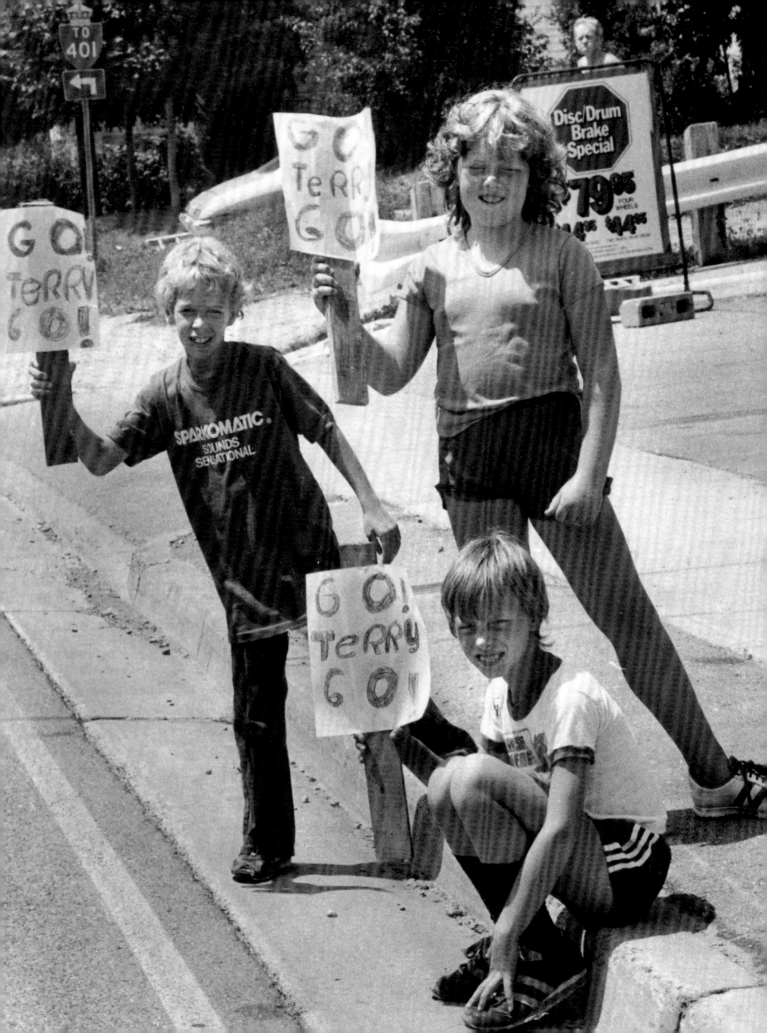

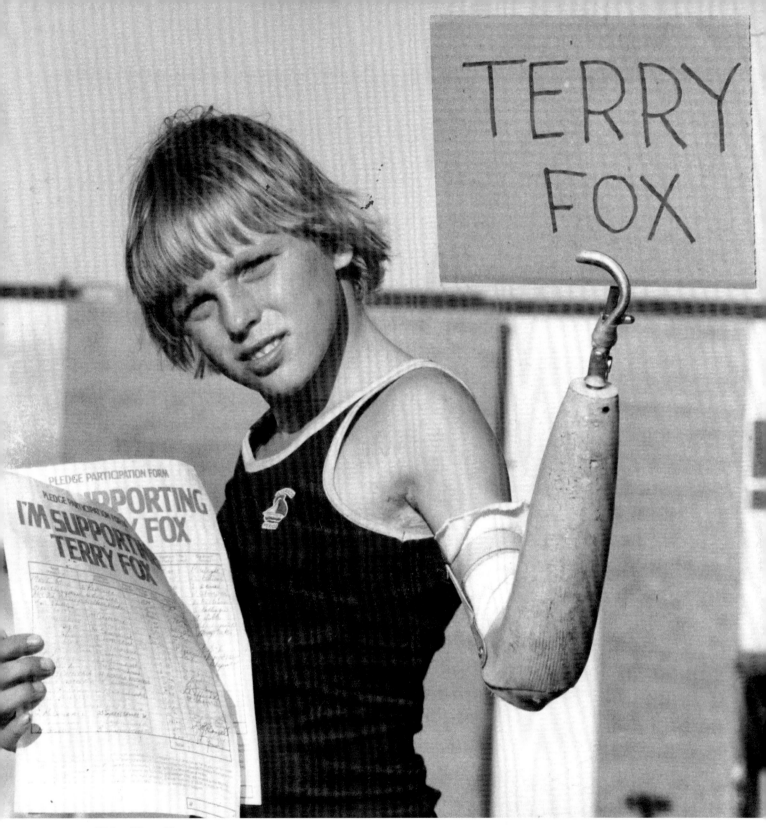

Big Brother

Kids loved Terry, then and now. To them, Terry was a big
brother and a best friend. He made it okay to simply be
yourself, and he loved it when kids ran along with him.
Children taking part in the annual Terry Fox Run have raised
hundreds of millions of dollars for cancer research.

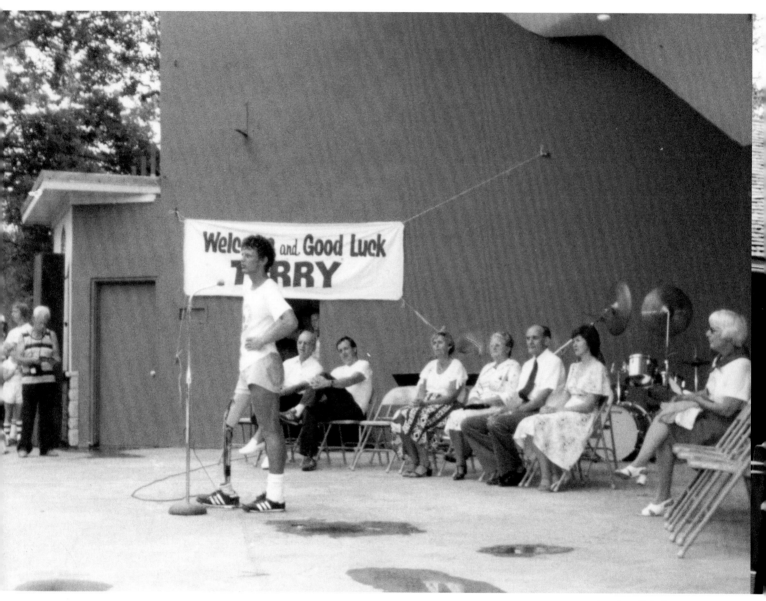

London, Ontario

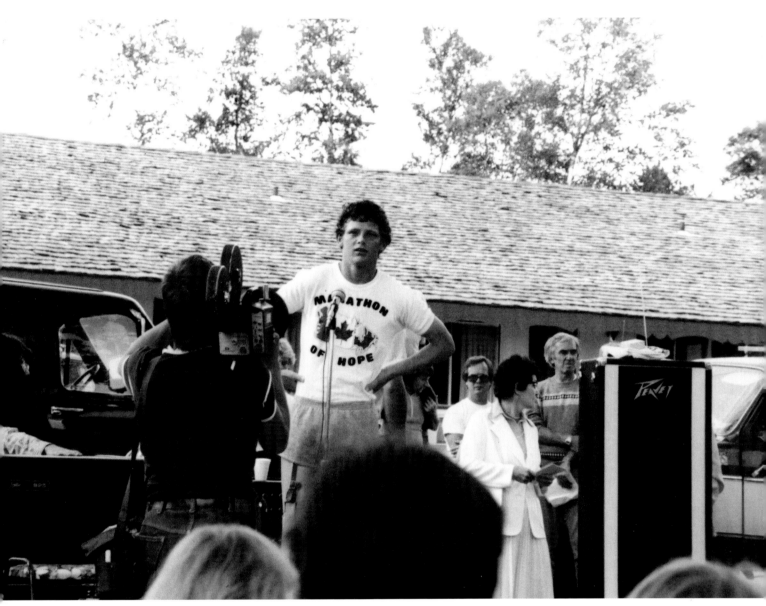

Terrace Bay, Ontario

Always Speaking

When Terry wasn't either sleeping or running a marathon every day, he was usually giving a speech or an interview. Some days he gave several speeches, as well as shaking hundreds of hands. If Terry could raise money by being present for a function, then he'd show up, regardless of how gruelling the extra effort. Most people who work in the media and who look at how Terry dealt with the press say they have no idea how he possibly could have done it all. Even minus his marathon exertions, his press efforts alone would have taxed even the most seasoned politician or movie star.

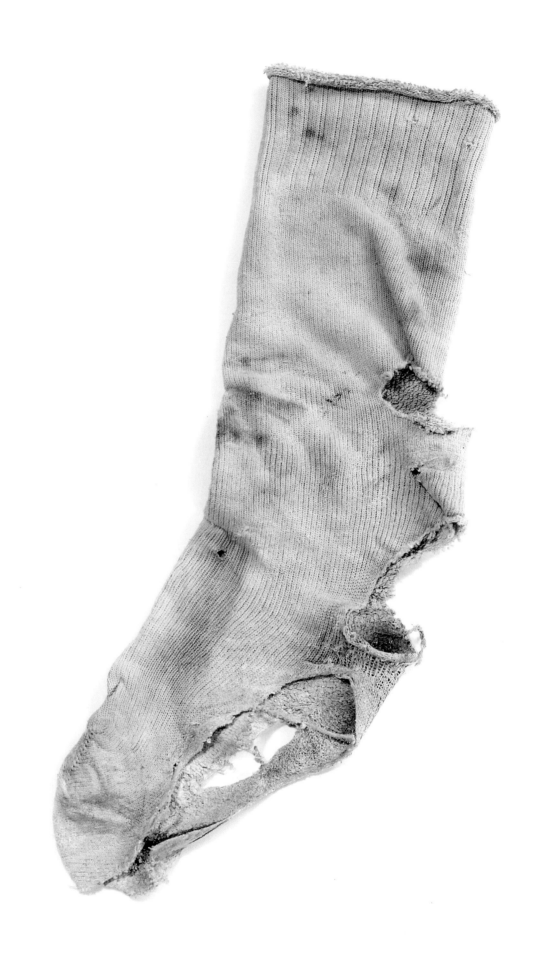

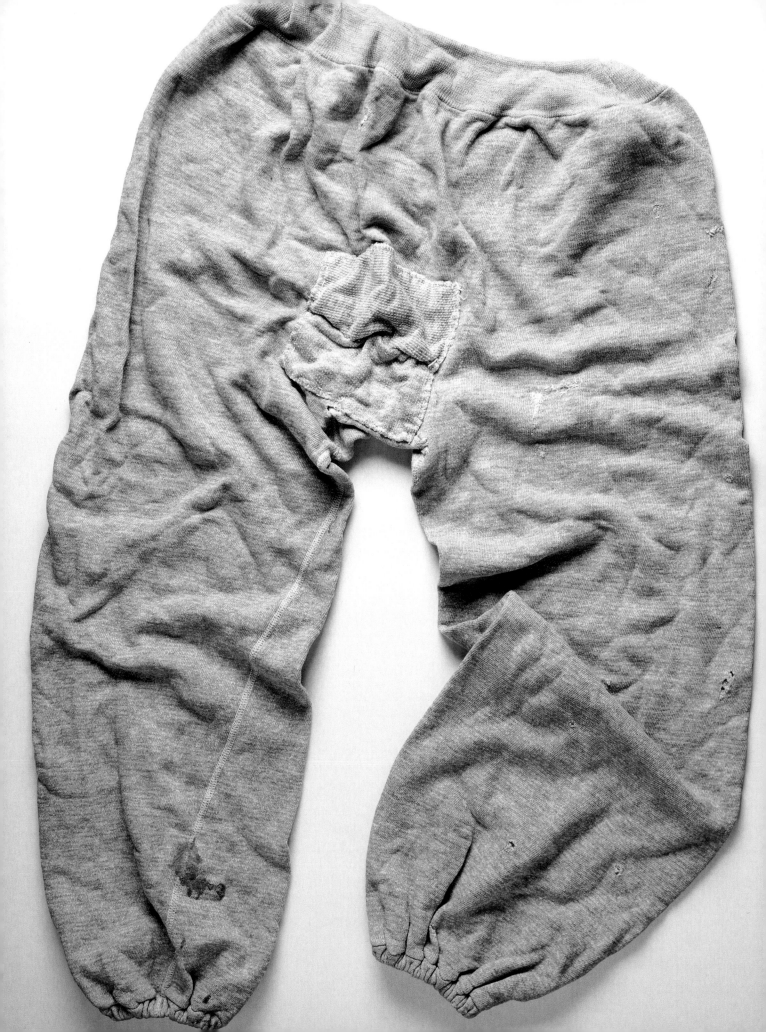

Wear and Tear

Terry had a special attachment to this sock (page 92). He wore it continuously on his prosthesis from the day he left home on April 7, 1980, to begin his run and he kept on wearing it for about three months after the marathon ended. The frayed fabric, shoe dye and rust from his prosthesis present a candid and intimate picture of the run.

There were few comforts on the run, and when Terry's clothing needed mending, brother Darrell or Doug Alward did what they could, but it was Terry's mom, Betty, who came to the rescue and repaired the garments properly. During the run, attempts were made to locate new pants or shorts in this style with no logo, but none could be found, and Darrell says Terry wouldn't have worn them anyway, as he refused to spend any donated money on himself.

Inklings …

At some point during the run, Terry's health began to change for the worse, but just when is hard to say. Some people claim they noticed a shift in his tone of voice during a certain speech in Toronto. Others say that he didn't have a characteristic expression on his face on the morning that the run swung into western Ontario.

The first real indication of a downturn in Terry's health became evident in White River, Ontario. A film crew had been making a documentary of the run, and as they were going through tapes made that day they began to notice a persistent small dry hacking cough on the soundtrack. This was new to them, and the technicians didn't know what to make of it. They assumed that Terry was getting a cold.

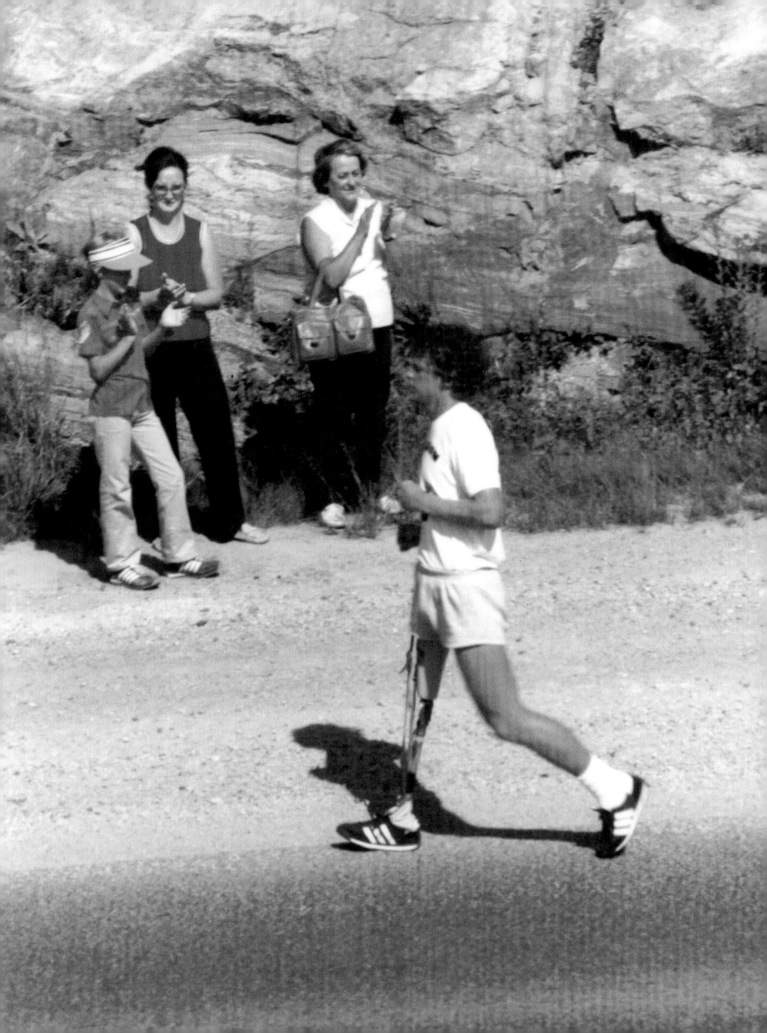

A drawing by an anonymous young girl from Seebe, Alberta, of her as a cat and Terry as a fox.

Saturday, August 30

Day 141

"Today I had a late start because I didn't sleep last night. Incredible thunder and lightning. Did 10 miles that took me to Nipigon and ten more took me to Sturgeon river. Cloudy day."

Sunday, August 31

Day 142

"Today was all right. Started late and it was cold for the entire morning. Twelve, eleven [miles]. Nothing else happened."

Calculations in Terry's journal from days 141 and 142 show that he expected to finish the marathon and arrive home on December 8.

And then there was a storm ...

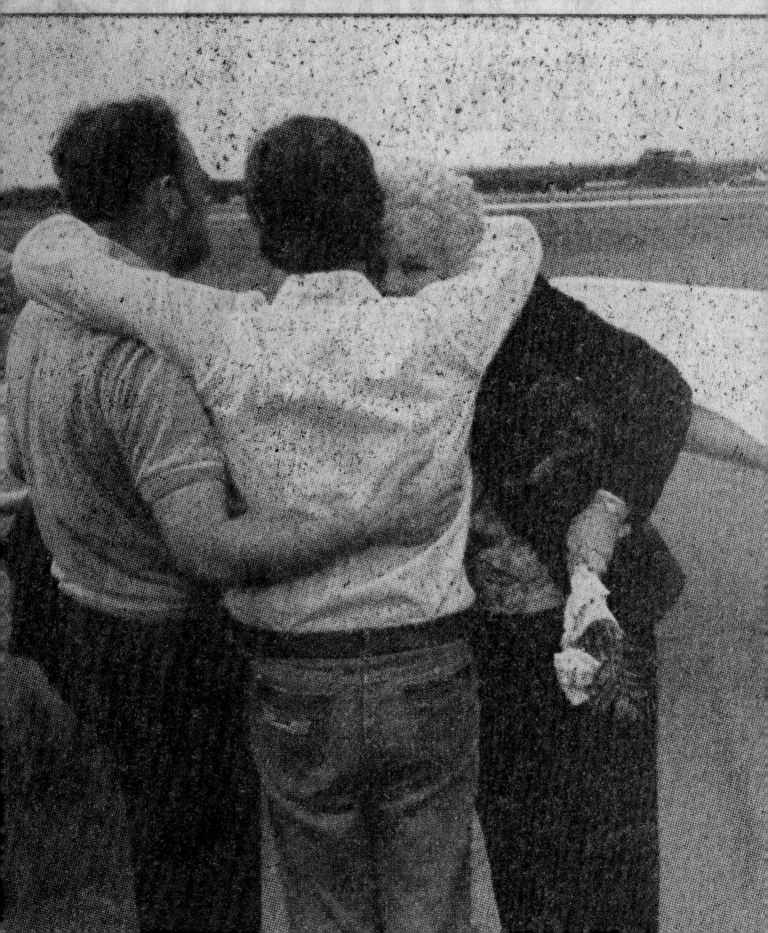

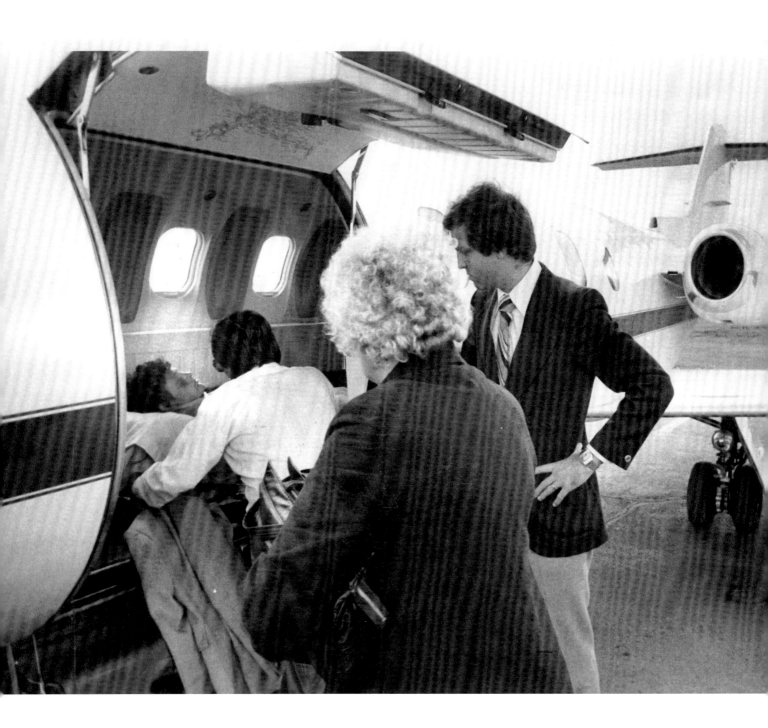

Labour Day
September 1, 1980

12 miles east of Thunder Bay, Ontario

In the morning, Terry ran 13 miles. He ate a little bit, went back to a motel to nap, then returned to where he'd stopped and resumed his run. That afternoon the highway was crowded with supporters and the weather was good.

Five miles into the run, Terry began coughing, and then a bit farther along he developed a "dull, blunt pain" in his upper chest. Whenever he'd had a similar pain in the past, continuing to run had always made it go away, but that tactic didn't work this time. The pain persisted and worsened. Terry climbed into the van and had a brief nap but still didn't feel better. He started running again, surrounded by well-wishers, police and film crews, none of them aware of the realization dawning on Terry that whether it was a heart attack or something else, this might be his last mile. He got into the van and asked Doug to drive him to the hospital, saying, "It's not my ankle, and it isn't my foot." They drove to the hospital in silence.

Left: A wire service image shows Terry being lifted by an ambulance driver into the jet that would take him back to Vancouver. With Terry are his mother and Dr. Geoffrey Davis of Thunder Bay.

Breathe

X-rays quickly revealed that Terry's right lung had a lump in it the size of a golf ball. In his left lung was a less defined growth the size of a lemon. These lumps were not lung cancer—rather, they were actually patches of bone cancer that had spread into his lungs through his bloodstream. The lemon-sized lump was too large and too close to Terry's heart to remove safely. Instead of surgery, Terry was to be given two newly developed chemotherapy drugs called interferon and cis-platinum.

Terry's parents flew in from Vancouver on a red-eye flight and arrived in Thunder Bay the next morning. The news was too big and too bad to be immediately absorbed. Terry went with his parents to eat lunch across the street from the hospital but was unable to walk that short distance. A few hours later

106

he was too weak to brush a fly away from his cheek. By that night he'd been flown home to Vancouver in a small jet. It all ended that quickly.

It's impossible to know how long the growths had been in Terry's lungs, but it is safe to assume that they'd been there for at least the last few weeks or so of his daily marathon run. His fear of being X-rayed was justified.

Both a golf ball and lemon are shown here at actual size. Hold the book up to your chest and look in a mirror to sense the scope of the cancer's re-entry into Terry's life.

3,339
The Last Mile

The following letter was sent to the CBC in 2000:

My name is Michael Dawson. I was 12 years old when I first met Terry Fox in person. As coincidence would have it, my family was taking a cross country trip out west along the Trans Canada Highway at the same time Terry was just about to end his Marathon of Hope. It was a very hot summer, and the section of road we were traveling was full of hills.

I remember vividly how the traffic on both sides of the road came to a standstill. No one was moving, and many cars had pulled off the side of the road … I was amazed that one person could stop traffic for so many miles.

And then I saw him. An OPP cruiser in front of him as the heat rose from the pavement.

Every step for him seemed to be agonizing. The pain on his face and the sweat that covered his entire body was humbling … I was amazed the way he endured. He didn't jog—but instead had a bit of a skip to his step as he would take a step with his artificial leg and a skip with his real leg. People would get out of their cars and watch in amazement. As he ran past them they would be digging into their wallets and purses. I had been saving my money for this trip all year long. When I saw Terry jog by I felt compelled to give some of it to him. I got out of the car and ran to catch up with him. I asked him "Hey Terry, can I run with you? I've got some money for ya." His reply between breaths was, "Sure thing kid, thanks." I gave him a five dollar bill and ran with him for about 3 or 4 minutes.

I turned back and returned to my family. The next day, while we were continuing our drive, we heard on the radio that Terry had discontinued his run. In the weeks following, I watched the news and followed the headlines about Terry.

When I returned to school that September, we were asked by our teacher what we did that summer. I proudly professed that I had ran with Terry Fox. When asked what that meant to me, I replied, "One person can make a difference."

Terry is an inspiration … He makes me proud to be Canadian.

Michael Dawson
Mississauga, Ontario

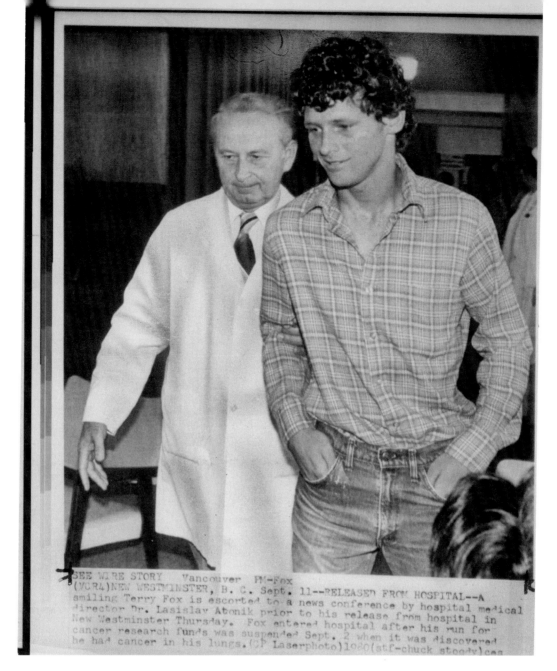

From this yellowing wire photo taken nine days after Terry's marathon ended, it's evident how much weight he had lost during the run. You also have to wonder how odd it must have felt for Terry to be wearing a long-sleeved shirt after so many months in his run uniform. The bluish-white haze above Terry's head is airbrushing applied in 1980 to make it stand out more clearly when the photo was reproduced in newspapers.

Heart-shaped Rock

The rock shown here is about the size of a football. It was deposited atop the muskeg by retreating glaciers thousands of years ago. The rock came from the exact spot on the Trans-Canada Highway where Terry's run ended on the afternoon of September 1, 1980. About 20 metres (66 feet) away from where the rock was found—to the side of the road and across a ditch—stands a small wooden post that marks the end of Terry's run. It was placed there in 1981 by Ontario's Ministry of Transportation. Jim Pope, a local mechanic who mows the weeds and grass between the post and the highway during the growing season, says: "I don't know how to put it. Everything today is to make money. People have to do nice things for each other."

The official monument to Terry's run is 12 kilometres (7 1/2 miles) away—a 3-metre (10-foot) high bronze statue of Terry atop a 45-tonne granite base laid on a foundation of local amethyst. It overlooks Lake Superior and is the most popular tourist destination in the region.

Sick Day

Terry's run ended on Labour Day. The following day was the first day of school, and both students and teachers returned from summer holidays in a state of shock. Normal school activities were eclipsed by the greater need to come to terms with the end of Terry's marathon. Thus began the first massive wave of letter-writing to Terry. From thousands of classrooms across the country, students sent in get-well letters, art projects, cards and dollars raised through in-school runs, bake sales, donation drives—anything that allowed people to feel as if they had somehow helped and participated in Terry's cause.

In general, boys tended to draw Terry running on the road by himself, and thousands of variations on this theme are represented in the Fox archives. Girls, however, tended to draw both themselves and Terry on the road together, each making the other feel safe, and each helping the other to complete the run.

One widely circulated news photo taken that month showed Terry in a hospital bed, watching fundraising activities on TV. As watching TV while at home sick in bed was something most school kids could relate too, it became a popular theme in drawings and sketches sent in that month.

terry and other cancer victims need your prayers.

the Canadian Cancer Society need's your donation.

Give both, now.

Mail your donation to:

terry fox.

you you wouldn't won't to be this way.

miracle

The Nation Reacts

In a masterwork of logistics, Canada's CTV network organized a 48-hour telethon in only a few days. The following description comes directly from Leslie Scrivener's book, *Terry Fox: His Story*:

The first Sunday in September, Terry lay fully dressed watching the fluids drain from the bottles hanging above his hospital bed into his veins. It was the start of his first chemotherapy treatment and he was rooting for the cancer drugs. The television over his bed was turned on. He watched, in disbelief, the popular country singer John Denver sing a song especially for him. He saw other singers—Elton John, Glen Campbell, Anne Murray, and Nana Mouskouri—sing for him. The Canadian ballerina Karen Kain risked her beautiful neck dancing on a concrete floor for him. She slipped once and carried on.

Terry drifted in and out of sleep. He watched Darryl Sittler, Paul Williams, Gordon Lightfoot ... and the whole cast from the Stratford Festival's *Beggar's Opera*. The premiers of the ten provinces all praised him ...

"John Denver's doing this for me?" It seemed that the people of Canada had taken over where Terry had left off ...

By the end of the CTV broadcast, $10.5 million had been raised ...

A couple of teenagers walked through Toronto's wealthy Forest Hill neighbourhood and collected six hundred dollars for Terry in one afternoon. At Simon Fraser University, faculty and staff raised forty-five thousand dollars in one hour ...

Students from Cloverdale Catholic School in Cloverdale, British Columbia, held a boot throw to raise money. In Quebec City, a bank robber–turned–disc jockey organized a twenty-kilometre march for him. In Kelowna, British Columbia, the Woodlake Old Time Fiddlers held a dance. In Newfoundland, a man offered to skate two thousand miles for Terry. A Montreal pianist offered to hold a Chopin recital. There were walk-a-thons, run-a-thons, stitch-a-thons (stitch a quilt in a bank in Oakville, Ontario, and donate one dollar) and cut-a-thons. Toronto businessmen organized a To Terry With Love Day, filled Nathan Phillips Square, and raised forty thousand dollars ... And in Port Coquitlam, two six-year-olds, Tara Binder and Melanie Ward, sold cold drinks behind a little sign that said, HAVE A LEMONADE AND HELP TERRY HELP THE WORLD.

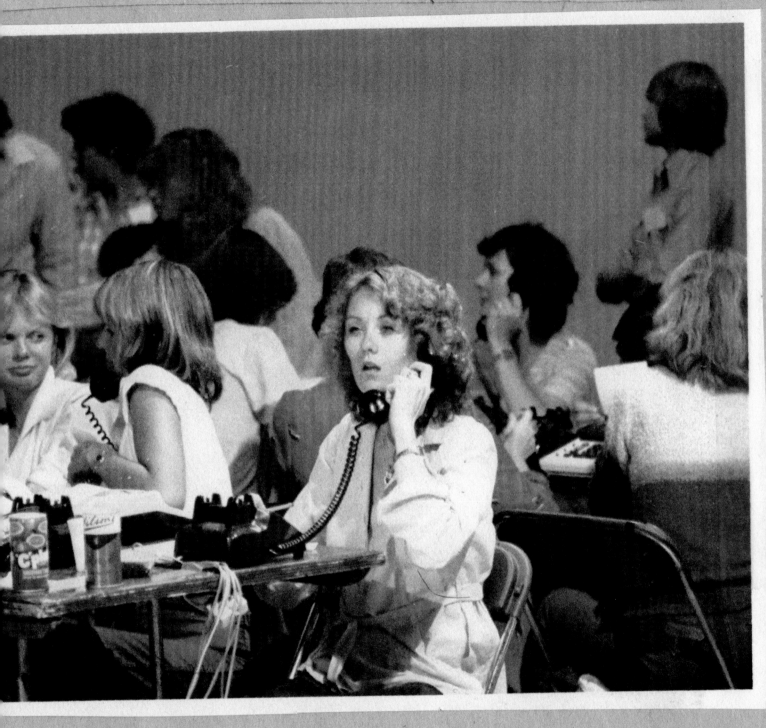

a smile for every mile ♥

3299	✓	love you, Terry. Smile!
3300	✓	love you, Terry. Smile!
3301	✓✓	love you, Terry. Smile!
3302	✓✓✓	love you, Terry. Smile!
3303	✓✓✓✓	love you, Terry. Smile!
3304	✓✓	love you, Terry. Smile!
3305	✓✓	love you, Terry. Smile!
3306	✓✓	love you, Terry. Smile!
3307	✓✓✓	love you, Terry. Smile!
3308	✓✓✓✓	love you, Terry. Smile!
3309	✓✓	love you, Terry. Smile!
3310	✓✓	love you, Terry. Smile!
3311	✓	love you, Terry. Smile!
3312	✓	love you, Terry. Smile!
3313	✓✓	love you, Terry. Smile!
3314	✓✓✓	love you, Terry. Smile!
3315	✓✓	love you, Terry. Smile!
3316	✓✓	love you, Terry. Smile!
3317	✓✓	love you, Terry. Smile!
3318	✓✓	love you, Terry. Smile!
3319	✓	love you, Terry. Smile!
3320	✓✓	love you, Terry. Smile!
3321	✓✓	love you, Terry. Smile!
3322	✓✓	love you, Terry. Smile!
3323	✓✓✓	love you, Terry. Smile!
3324	✓✓	love you, Terry. Smile!
3325	✓✓	love you, Terry. Smile!
3326	✓✓	love you, Terry. Smile!
3327	✓✓	love you, Terry. Smile!
3328	✓✓✓	love you, Terry. Smile!
3329	✓✓	love you, Terry. Smile!
3330	✓✓	love you, Terry. Smile!
3331	✓✓	love you, Terry. Smile!
3332	✓	love you, Terry. Smile!

A smile for every mile! ♡

3333	✓ I love you, Terry. Smile!
3334	✓ I love you, Terry. Smile!
3335	✓ I love you, Terry. Smile!
3336	✓ I love you, Terry. Smile!
3337	✓ I love you, Terry. Smile!
3338	✓ I love you, Terry. Smile!
3339	✓ I love you, Terry. Smile!

IF I'VE SAID IT ONCE I'VE SAID IT THREE THOUSAND THREE HUNDRED AND THIRTY-NINE TIMES!

✓ I love you, Terry!

Smile! and be happy! ♡

Let Me In

Some of the letters sent to Terry were scented with perfume, and some of the letters were scented with music—more than two hundred people wrote songs for Terry. Some were recorded on tape and some were pressed into vinyl. Most came with elaborate cards and boxes, and some, like the one shown here, arrived only with an air of absolute urgency—pacts between Terry and the sender: *Terry, listen to me. I can help you. I understand you. Let me be a part of your life. I'm the one who can help you.*

Spirit of Radio

Artists from around the world were moved by Terry's story. Canada's rock band supremo, Rush, sent Terry the gold record for their album that was on the charts that month.

Thinking of You

One delightful—and very long—letter (pages 116/117) sent in to Terry was from Jody Wright of Ancaster, Ontario, who wrote the words *I love you, Terry. Smile!* 3,339 times. Also included in the letter were a photo and a phone number. ;)

anthem

PERMANENT WAVES
R U S H

SIDE 1 ANR-1-1021

SPIRIT OF RADIO 4:54
FREEWILL 5:23
JACOB'S LADDER 7:50

All Lyrics by NEIL PEART except
"Different Strings" By GEDDY LEE
Music by GEDDY LEE/ALEX LIFESON
Produced by RUSH and Terry Brown
℗ 1979 Cat Productions Ltd.
Published by Core Music Publishing

	Presented to	
RUSH	TERRY FOX	CERTIFIED GOLD
	to commemorate the sale of over 50,000 units of the	
	ANTHEM RECORDS	
	album	
	" PERMANENT WAVES "	Canadian Recording
	SEPTEMBER 1980	Industry Association

Dear Terry Fox
we have been praying
for you. my Dad has
Cancer in the lung
too. My mother had
it but the got it
all. I'm always thin
of you. And praying king
for you. I know you
can do it.
Our shcool rised
a lot of money 152$
From Dawn McKinley Grade 4.

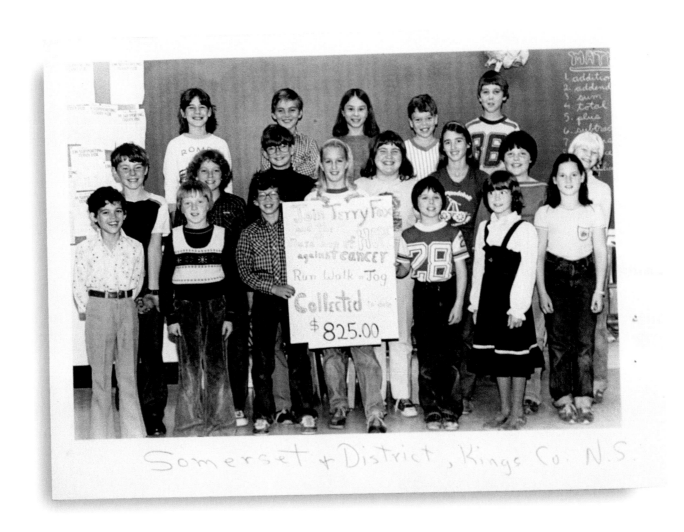

Somerset + District, Kings Co. N.S.

A Call to Arms

Students across the country—not just elementary school students, but high school students, university students and people taking classes in community colleges—sent hundreds of thousands of cards to Terry and the Fox family. Almost all of them came with donations big and small.

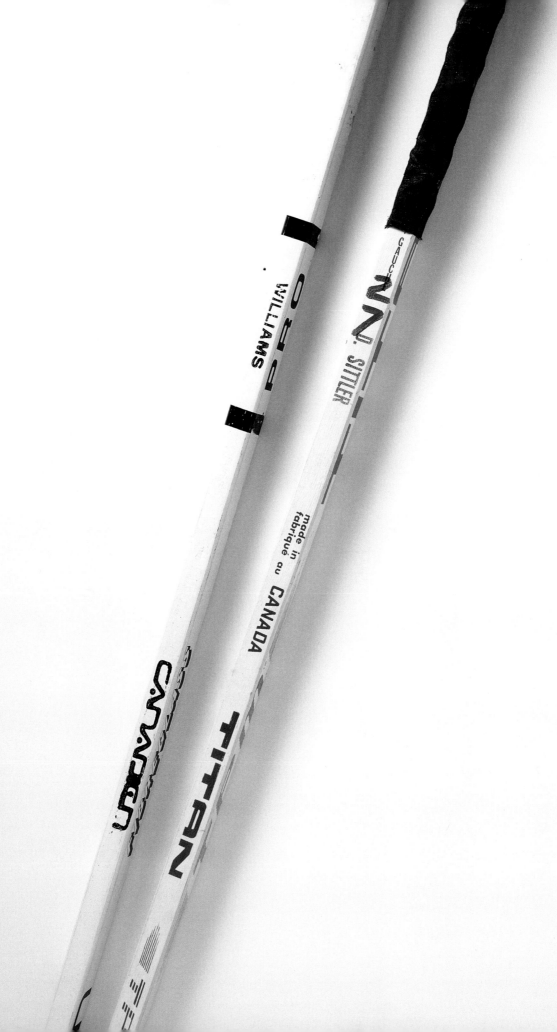

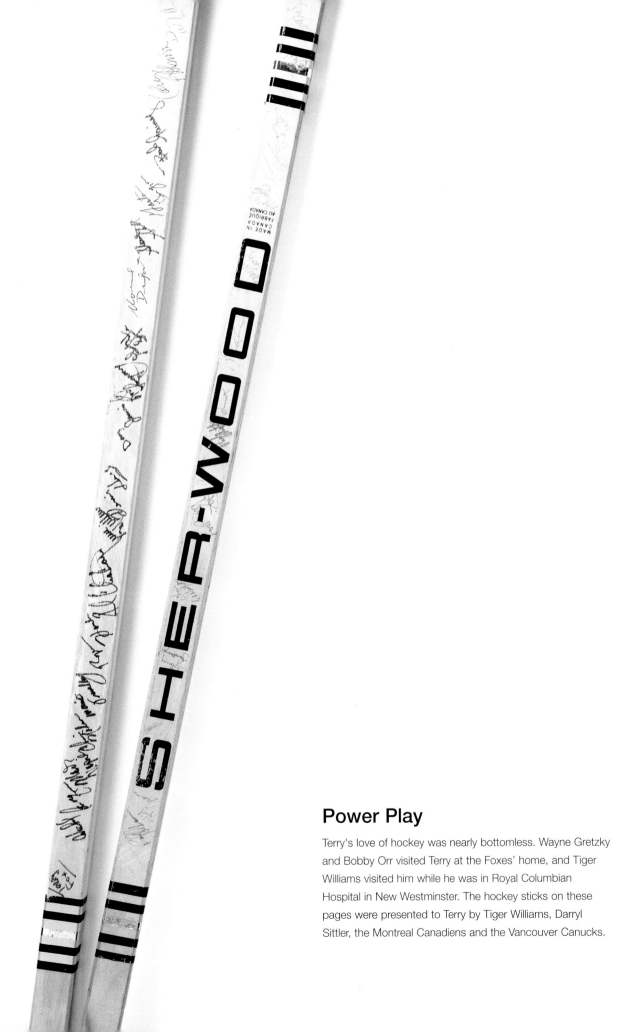

Power Play

Terry's love of hockey was nearly bottomless. Wayne Gretzky and Bobby Orr visited Terry at the Foxes' home, and Tiger Williams visited him while he was in Royal Columbian Hospital in New Westminster. The hockey sticks on these pages were presented to Terry by Tiger Williams, Darryl Sittler, the Montreal Canadiens and the Vancouver Canucks.

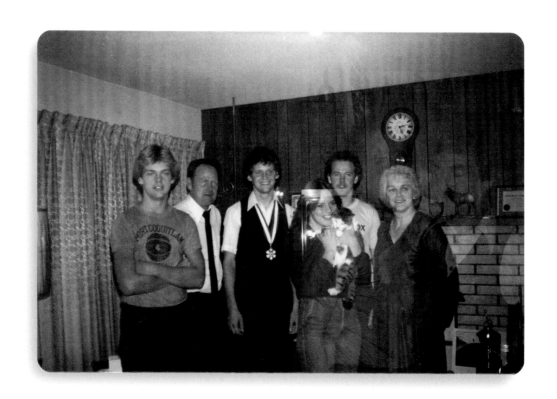

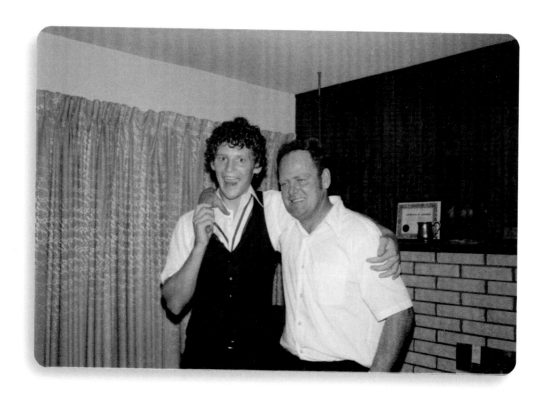

Companion of the Order of Canada

September 18, 1980

The highest civilian honour the nation can bestow on its citizens is the Companion of the Order of Canada, but by late September, Terry wasn't in good enough shape for a flight to Ottawa to receive this award, so the ceremony came to him—it was held in Port Coquitlam, a thirty-minute drive east of downtown Vancouver. The ceremony itself was structured, dignified and civilized and was given front full-page treatment by most of the country's newspapers. But afterwards, snapshots taken by family members back at the house show the Fox family's high spirits and dislike of formality. On such an important occasion, most families might have hired a photographer for complicated sit-down portraits. The Foxes took their own snaps and had them developed at the local drugstore. Some of them are double-exposed and many have flares, but the happiness and love for each other is abundantly evident.

However, the most startling thing about these photographs is that they were taken just over four years after Terry stood in the same corner of the same living room wearing his graduation tux (page 14). In just four years this guy from a typical Canadian suburb changed the world. If any of us are ever in need of reminding that life has surprises in store for us, these photos offer more than enough testament.

I wish the best in the life
Alejandra Larios M.

Good luck Jerry!

Good Work Jerry

We're all hoping you You Jerry'd you

You'll come thru!
Love, Maureen Tegart

Calvin #36

Cheryl Lady

Robbie Robinson

Heather Miller

Debbie Bowling

Debbie Mackie

Ann-Marie Blaker

Cheryl Rutvege

Wendy Anderson

Doug Lee

Penny Gabruch

Kevin Toews

Jean McIntosh

Sandie Amanda

Audrey Sheppard

Brad Mattock

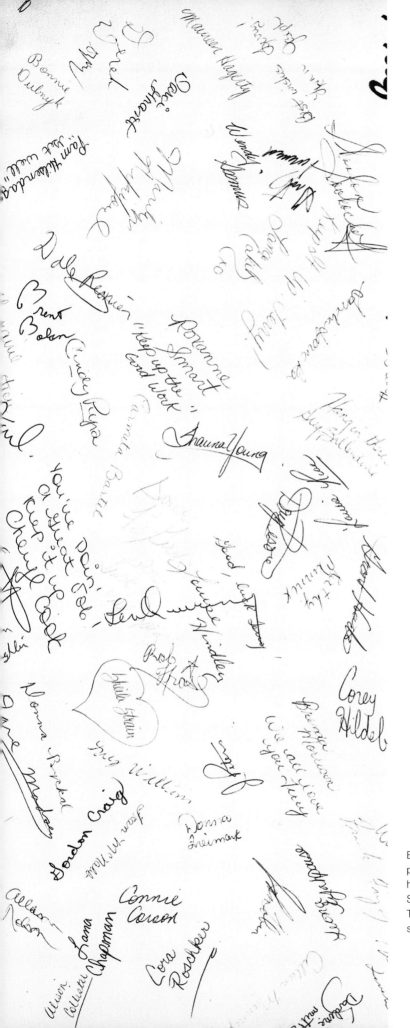

Before there was e-mail there was simply the mail, and Terry probably received more mail than anybody in Canadian history. The signatures shown here are on a jumbo card from Saskatchewan's North Battleford Comprehensive High School. This was just one of hundreds of jumbo cards sent to him from schools, offices and churches across the nation.

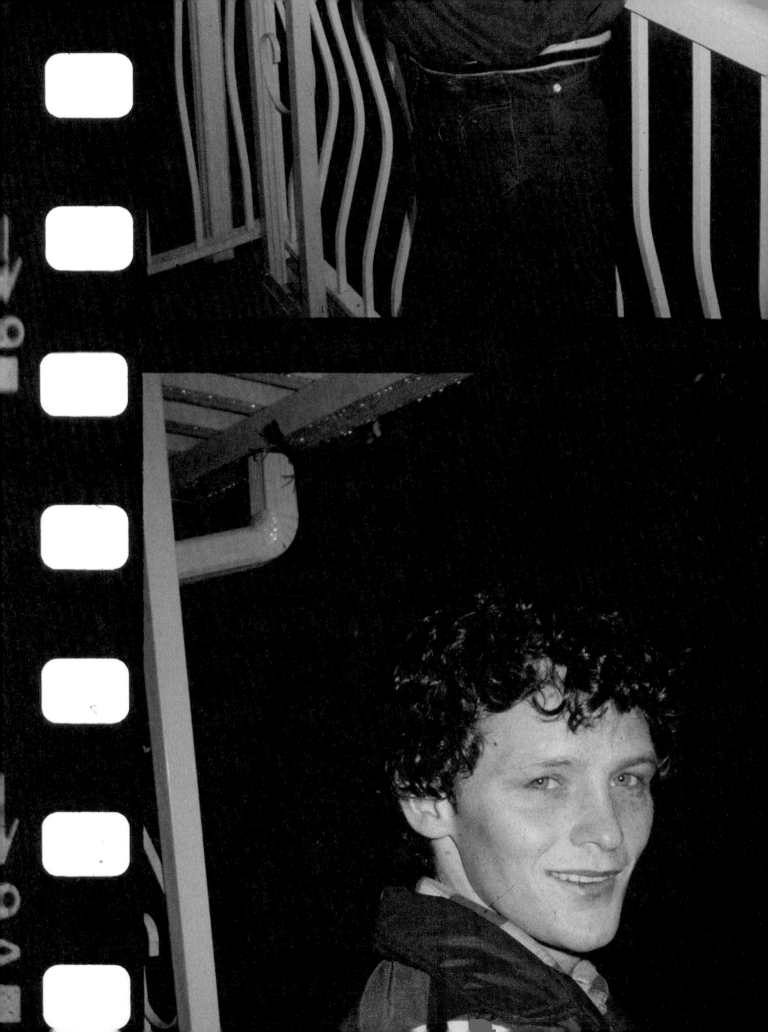

December 22, 1980

Photographers all agree that it was pretty hard to take a bad picture of Terry: bad photos of him look better than most people's good ones, and then some. This one comes from a session on December 22, 1980, the last photos of Terry publicly released. It shows a very thin Terry putting on a brave face at Christmas. He knew things weren't going well—neither of the two new chemotherapy treatments, cis-platinum and interferon, was working, and both had ghastly side effects. With his shrinking body and pale skin, Terry looks more like he was fifteen than twenty-two. It was during this photo shoot that Terry said out loud the words, "Even though I die of cancer my spirit didn't die and that should influence a lot of people."

129

Christmas 1980

A strange thing to realize is that around the same time as the photo on page 128 was taken, Terry was, in addition to being very ill—and in spite of everything else that had happened in his life—*unemployed.* He had not taken a cent of the money raised during the run, and Christmas was looming and he was flat broke.

Darrell remembers Terry panicking—*What can I get people? What do I get Mom?* In the end he was able to cobble together a few dollars to buy gifts. For his mother, he bought this pink wastepaper basket, which matched a hamper she had in her bathroom and which she uses to this day. And while Terry had been deluged with mail since the day the run ended, there came a huge spike as Christmas greetings overwhelmed the local post office. Come Valentine's Day and Easter, Terry was inundated by more mail than was received by his entire town of Port Coquitlam.

This example of the many letters sent to Terry came from Darren Hardemann, an elementary school student in Salford, Ontario. The letter is typical in that Hardemann recognized a quality in Terry beyond the simple physical perseverance. He wrote:

Dear Terry,
Here is a story for you: Terry was a good boy, but he did not know Christmas was coming. When Christmas came he still didn't know Christmas was here. But when they gave Terry some candy, Terry said "I will give you some candy." And Terry gave them all his candy.
 The End.

This beaver doll was sent to Terry from the workers at a Toronto office supply store.

He Was Dying

Leslie Scrivener was a twenty-seven-year-old *Toronto Star* reporter who covered Terry's run almost from the start. What began as an ongoing human-interest feature for the newspaper eventually became the biography of Terry that was published in the fall of 1981. Revised and updated editions have followed. *Terry Fox: His Story* is a well-researched and fully fleshed biography that is the definitive work on Terry. This book could certainly never have been done without it or Leslie's help and advice.

On the right is a page of the transcript of Leslie's interview with Terry as they sat on his family's floral-print sofa. "We were completely alone and it was nice and quiet. It was fall—raining outside mostly—and Betty made sure there were no interruptions. Terry, in spite of being very sick, was determined that the truth be told. On his good days he'd take me for a drive and show me his old stomping grounds—where he trained and the places that were important to him."

Today, a quarter of a century later, Leslie says: "I wish I could have done more. I wish I could have done better. But I was so young and he was dying."

TERRY FOX INTERVIEW

TAPE 1

Like I didn't know, you didn't know, when
I was in Newfoundland that I would do that,
did you?

M-M.

Well, neither did I. But first of all, just
the fact of being able to, of trying, attempting
to do something like that, the physical
achievement of doing it itself was a reward.
To be able to ~~figure~~ say I could do it, to run
across Canada on one leg was something that
nobody else in the world has ever come close
to doing and even near approached. Right?
Okay, that was one thing.

IS THAT IMPORTANT TO YOU, THAT SENSE OF
PHYSICAL ACHIEVEMENT?

Yeah.

DO YOU KNOW WHY?

I'm competitive. I've always been competitive.

Standard
AUTO GLASS

The Glassmen of Canada

Dear Terry!

I work at Forest City Plymouth Chrysler Ltd. as a cashier in Parts and Service Depts., doing filing and answering the phone as well as waiting on customers.

The day you passed by the doors of our dealership at 1835 Dundas St. E, London, Ont., our General Manager who is one of the owners of the company, gave us the opportunity of going to the front of the building to cheer you on. When I saw you

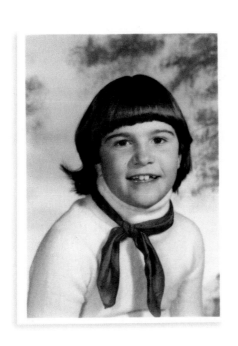

The Lost Girl

This photo of a young girl was found in the bottom of a box in the Fox archives—it had become detached from its original letter. Her name is unknown, as is her hometown, but she looks like a typical Canadian schoolgirl from 1980, one of the tens of thousands of children who sent Terry cards, letters and gifts. As no book is big enough to contain all of the photos and the names of children who sent in mail to Terry, this Lost Girl is here to represent them all.

Left: A note to Terry from a woman, Diana Coish, of London, Ontario. It conveys the sense of wonder people experienced when Terry was approaching, as though he were a tornado or a rare animal.

The Lost Boy

Many people had ongoing conversations with Terry in their minds, and many people still speak with Terry as if he were in the room with them. In February of 1981, Denise McGovern of Ontario began writing letters to Terry every few days. She never mailed them and sent them as a bundle to the Fox family only after Terry had died. In her thirty-five letters, McGovern talks about her life over the years with her two daughters and with her husband; they ran a Children's Aid Society group home for boys. She had a large supply of stories of what "her boys" had been up to, and the letters make for moving reading. This letter is the last one that McGovern wrote:

June 25, 1981

Dear Terry,

We heard the sad news that you were getting weaker and in great pain. I wish that I could take some of that pain away from you to give you a good rest, but as it is impossible, we'll just keep on praying for you, hoping that the pain will not take your fighting spirits away and that it will become more bearable with each new day.

I'm afraid I'm all out of funny stories that happened with the boys. I spent all day yesterday trying to remember one but I failed, and the only ones I could remember are not printable.

The only thing I could think of was the time we took four of the boys to the farm with us. The first night was so dark that we couldn't see where the sky or the sides of the road or the road itself was. Since the farm was in the middle of nowhere there was no light of any kind, and that night, there was no moon, stars, or anything else to light the road. Have you ever been in a situation where there's no light and nothing but darkness all around you?

We all decided to go for a walk and that was the weirdest thing I've ever experienced in my life. The boys thought it was hilarious—you had to feel the road with your feet first so that you wouldn't fall down. We were completely out of balance and even the sound of voices seemed to come from different directions. It was unnerving and spooky. I did find myself in a ditch a couple of times and didn't like it one bit. After about half an hour we decided to turn back.

To my surprise there were only three boys with us when we got back. I just about panicked. My husband hurried out with the flashlight and started looking and calling for the lost boy, but there was no answer. We then all went outside near the house and started looking around, and I was just about to push the panic button when the kid jumped out from behind some bushes, scaring the life out of me. I don't think I ever will hear my husband yell like that again. The poor kid thought he was playing a real funny joke, but with woods all around us and the nearest neighbour two miles away, we sure didn't find it funny.

We are praying for you and your family,

Denise McGovern and family.

June 25, 1981

Dear Terry,

 We heard the sad news that you were getting weaker and in great pain. I wish that I could take some of that pain away from you to give you a good rest, but as it is impossible, we'll just keep on praying for you hoping that the pain will not take your fighting spirits away, and that it will become more bearable with each new day.

 I'm afraid I'm all out of funny stories that happened with the boys. I spent all day yesterday trying to remember one but I failed, and the only ones I could remember are not printable.

 The only thing I could think of was the time we took four of the boys to the

I'm not ready to leave this world.

June 28, 1981
4:35 a.m.

In June of 1981, Terry developed pneumonia, and on June 27 he went into a coma. He died on the 28th at 4:35 a.m., his favourite hour for running—a time free of traffic and noise and dogs and strangers, a time to enjoy the world newly born and filled with promise.

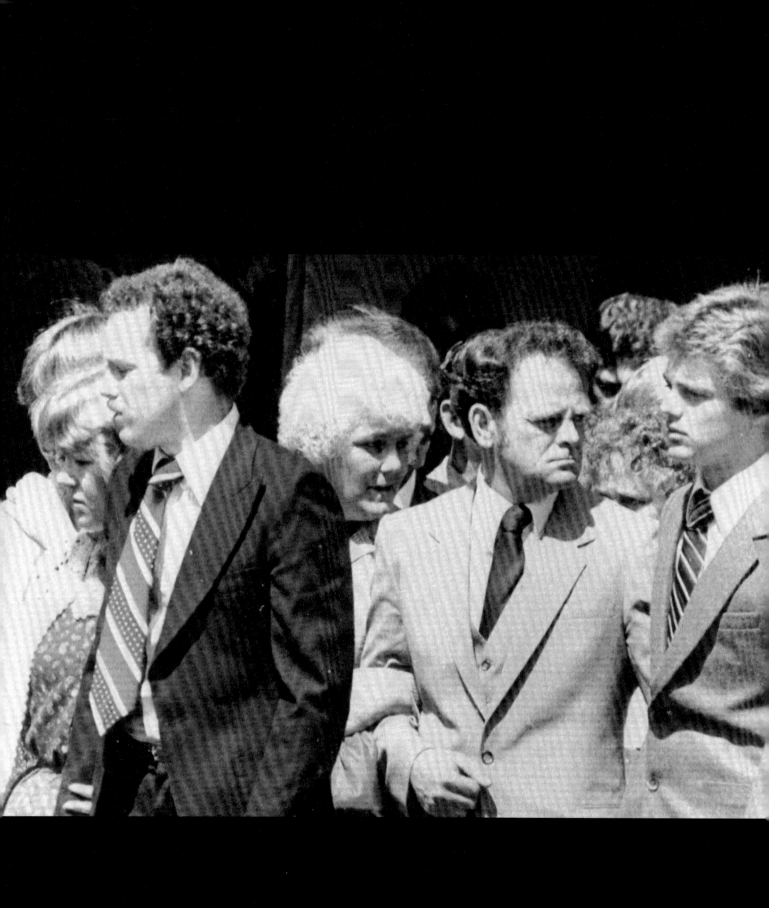

July 2, 1981

When someone close to you dies, nothing feels real for
days or weeks or months afterwards. The day of Terry's
funeral was unnaturally hot and muggy for Vancouver.
People who were there that day recall waves of steam
rising from the ground, making everything appear even
more unreal than it already did. Birds seemed to fly in slow
motion. Flowers looked like candy. The air was like syrup.

The funeral was large and was broadcast live on national
TV. For most Canadians, time slowed down and stopped
that day, if only for a little while.

Terry was buried not far from his favourite lookout,
which was just outside the cemetery gates. It was the spot
he visited when he had to think through important things. It
is a cool and grassy resting place that faces east, looking
out over all the rest of Canada.

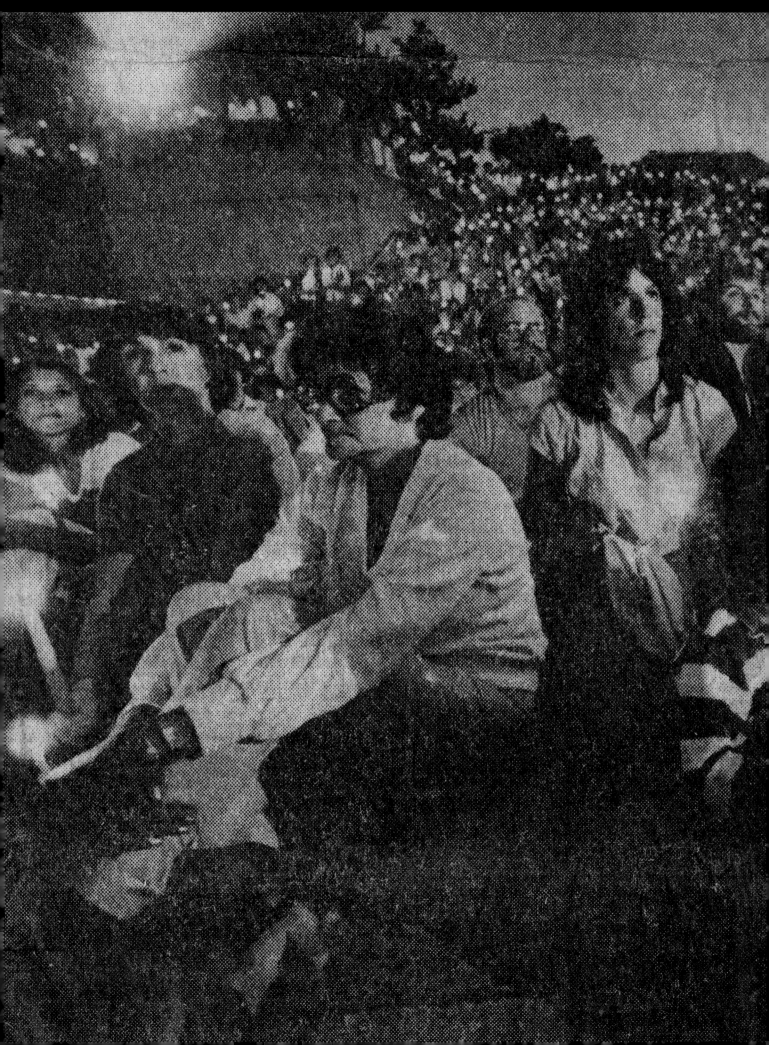

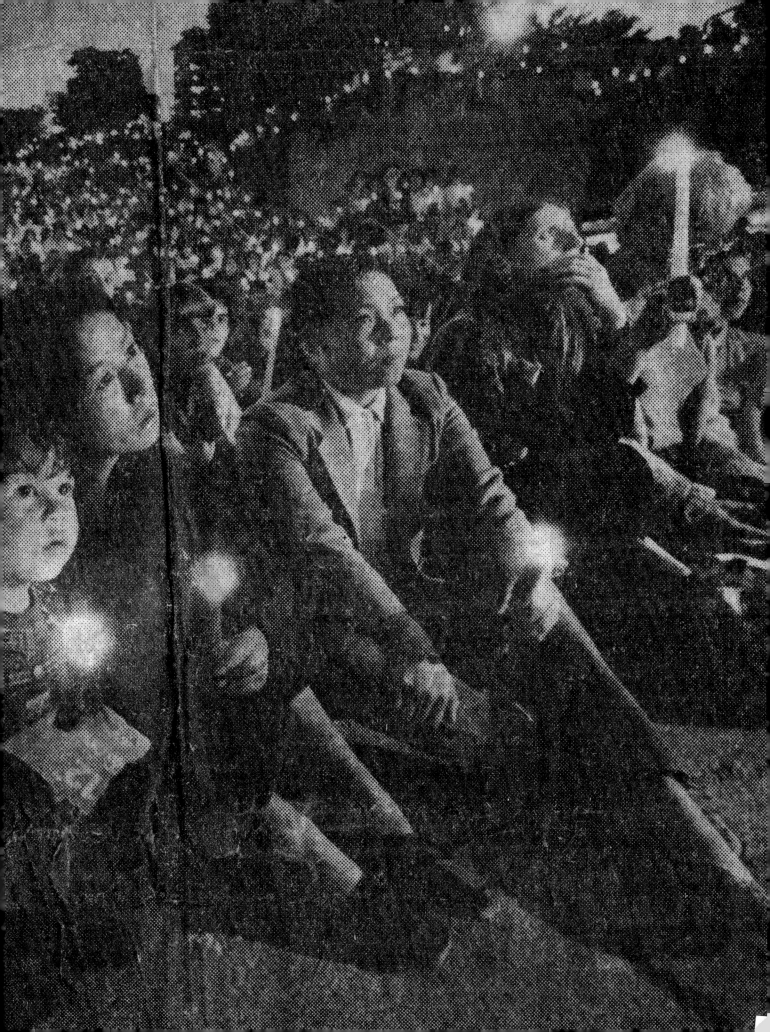

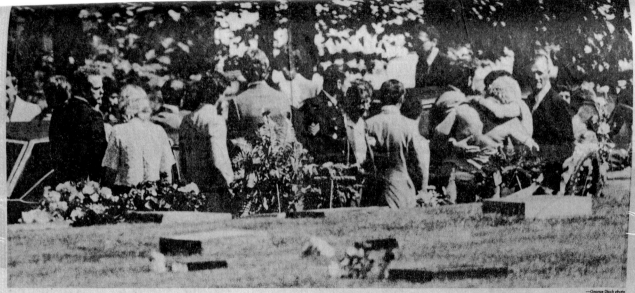

THE FINAL RESTING PLACE . . . Terry's mother Betty is comforted at the Port Coquitlam cemetery where a short ceremony was held after the church service
—George Diack photo

FINAL TRIBUTE TO OUR HERO

TIMES REMEMBERED . . . Family, including Terry's brothers Darrell (right) and Fred (left)
—CP photo

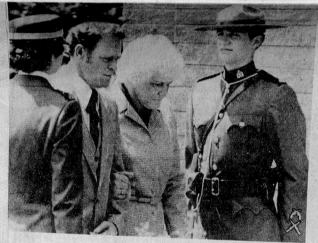

TRIBUTE IN THE SKY . . . Canadian forces jets (right) fly over the cemetery in symbolic "missing plane" formation

ARM IN ARM . . . Terry's parents Rolly and Betty arrive at the church for the service that was televised across the nation
—CP photo
—George Diack Photo

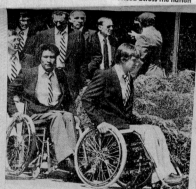

OLD COLLEAGUES . . . 'friends from Terry's wheelchair basketball team
—George Diack photo

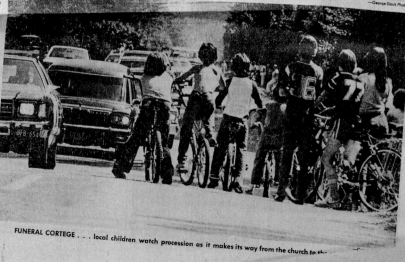

FUNERAL CORTEGE . . . local children watch procession as it makes its way from the church to the

Dear Mr. & Mrs. Fox,

We were most privileged to see Terry on his run, one hour before he stopped. A picture of Terry hangs in our dining room and will always be a reminder to us of his wonderful courage. Thunder Bay loved him.

Mr. & Mrs. J.K. Tucnik,
Thunder Bay, Ont.

......................................

He was a source of inspiration and hope to all Canadians. I hope this brings you a little comfort to know your son is shared by every Canadian.

Mr. & Mrs. Don Want
Glencoe, Ont.

......................................

Every mother, I'm sure, would like to have a son like Terry. If Canadians do their best as Terry did, we can't go wrong.

Mrs. Laidman and family
Hamilton, Ont.

......................................

Although we're miles apart our thoughts are with you. We went through the same ordeal just two years ago. May God bless and comfort you all.

Don & Margaret Hughes
Regina, Sask.

......................................

We loved him, too.

Neil & Dareen Grant
Lori & Heather McKay
Chatsworth, Ont.

......................................

Thinking of you with deepest sympathy.

Mr. & Mrs. R. Harris
Fort St. John, B.C.

......................................

Arthur & Audrey Grant and family
Winnipeg, Man.

......................................

Our thoughts are with you.

Jane Donaldson
Edmonton, Alta.

......................................

Mr. & Mrs. N. Taylor
Ajax, Ont.

......................................

Dear Fox Family

Eight years ago we lost a son to cancer. He was six years old. He fought a long battle. Therefore we can say we know how you feel and our prayers are with you.

Mr. & Mrs. Streen and family
St. Catharines, Ont.

......................................

Our sympathies.

Grant Vogel & Mrs. E. Vogel
Montreal, Que.

......................................

Dear Folks,

I hope you are well. I am going to visit my only brother who had cancer, too. He is a good brother to me. He and his family live in Calgary. I may move to Moose Jaw to live where my old time friends live.

Violet Ella Smith
(no address)

......................................

Norman & Mavis Gudlijactson
Gimli, Man.

......................................

Our family has been very proud of what Terry accomplished in his short life for himself, his family and cancer research. We're sure he will never be forgotten.

The McDonaugh Family, all 25 of us

......................................

We are thinking about your family.

Ken, Kathy and Shelley Adams
Meaford, Ont.

......................................

Love from the Proctor family.
North Vancouver, B.C.

......................................

Thinking of you with deepest sympathy.

Mr. & Mrs. R. Harris
Fort St. John, B.C.

......................................

A toute la famille.

Je vais envoie mes sympathies ainsi qu'une petite affronde à fin que l'on puisse trouver le remède contre le cancer. Bien à vous.

Michel Vachon
Québec, Qué.

......................................

The Langs
Oakville, Ont.

......................................

It's amazing how the folks of the East Coast where Terry started his run have loved and admired and respected him, and we mourn his passing.

Ruth M. Blakney
Hubbards, N.S.

......................................

Rod & Susan Taylor
Labrador City, Nfld.

......................................

Marilyn & Barney Daiter and Michael
Downsview, Ont.

......................................

I am a young adult 26 yrs. with cerebral palsy and confined to a wheelchair and do know and realize some of the suffering of your son and I will keep praying until his dream of conquering cancer is realized. Sincerely hoping everyone strength and courage to carry on the fight.

Laureen Dey
Hemmingford, Que.

......................................

John, Kaaren & B.J. McGlinchey
Nanaimo, B.C.

......................................

We feel as though we've lost a good friend.

Morris & Heather Brock
Burford, Ont.

......................................

Mr. & Mrs. B. Stepak and sons
Toronto, Ont.

......................................

Pages 142/143 and 144 are two yellowed newspaper clippings from the scrapbook of Mary Ann Wark, Terry's grandmother: one shows Vancouverites at a silent vigil in downtown Robson Square the night of Terry's funeral, and the other shows events the day of the funeral.

Silence

We like to speak to the dead because, in a way, they're perfect. We here on earth can only grow weaker and worse for wear, but the dead remain pure—not only pure but they do not judge those who still live.

We tell the deceased things we don't dare tell anybody else, because they know the worst that can happen. And if they died young, they never had a chance to lose the fine and wonderful parts of themselves.

Maybe you're young, and maybe you're old. If you're old, you know that as life goes on, we do lose a part of ourselves along the way. And maybe the parts we lose are the ones we once considered our best. But the thing about Terry is that he never lost the finest parts of himself, and because he left us the way he did, he's always there. To many people, Terry never stopped running. Day or night he's still near us, passing by the outskirts of the cities we live in: he's out there in the Rockies and out there amidst the fields, out there on the Canadian highways, with his strange hop-click-thunk step, forever fine and forever keeping the best parts of ourselves alive, too.

What If?

On a fundamental level, Terry's life makes us ask "What if?"

What if Terry had never lost his leg to cancer? Or what if he'd thought about doing the run but then decided not to do it after all? He might have survived, but also maybe not.

And if he had survived he'd probably have found a good job, gotten married and had a family—his life would have had the dignity and importance that all of our lives share. Sure, he might have wondered *What if?* for the rest of his life—but that's what many of us do. The world would have kept spinning. Everything would have been the same, and yet nothing would have been the same. You and I wouldn't be the same. The way we view life and death and courage and strength wouldn't be the same.

Sometimes we all feel like we're just one person here on earth. Why does anything matter? Why do any of us bother going on? But the fact is that we do go on, and that all of us matter, and just maybe if we follow Terry's example of going for the more difficult choice over all the other ones, our lives will take on a meaning greater than we ever might have dared hope.

Peak

In July of 1980, Marion Dahlberg of Valemount, British Columbia, mailed in a photo of the town's post office flag, flying at half-mast on the day of Terry's funeral. In 1981, not far from Valemount and 80 kilometres (50 miles) west of Jasper, Alberta, a 2639-metre (8,658-foot) peak in the Rocky Mountains was named Mount Terry Fox in Terry's honour.

The Run

Part of being Canadian is that we always have to find ways to deal with the fact that everything and everybody in this country is just so darn far away from everything and everyone else. One part of Terry's genius was that he gave Canadians a new way of looking at distance that made it exciting and fresh. He made people fall in love with the map of Canada the same way that he'd fallen in love with it. He transformed distance into something that joins us instead of something that divides us.

Another part of Terry's genius was knowing that sure, people do give to charity, but they want to participate—to feel as if they've done something, too.

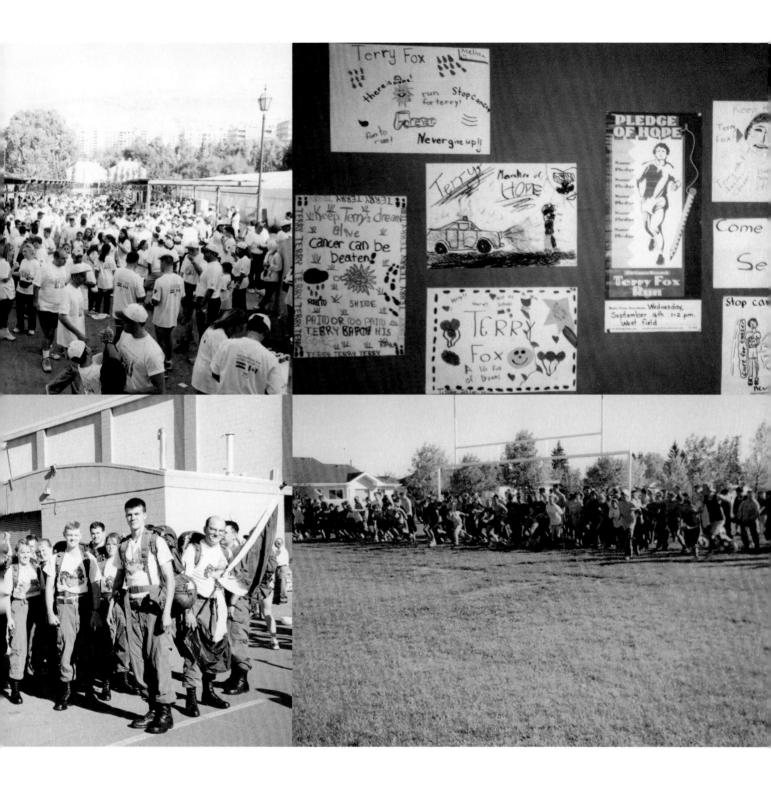

After the run's end, when Terry was in a hospital back home, Isadore Sharp phoned and the two discussed a run to be held in Terry's name once every year. Sharp, chairman and CEO of Four Seasons Hotels (certainly a man who knows about distances) had lost a teenaged son, Chris, to cancer, and had been extraordinarily helpful throughout the run. After the call, Sharp sent a follow-up telegram suggesting to Terry that he continue the marathon's goals with an annual fundraising event to be called the Terry Fox Run. And that's how it all began.

The most important aspect of the run is that it's non-competitive—no winners, no awards, just people joining together to raise money for cancer research.

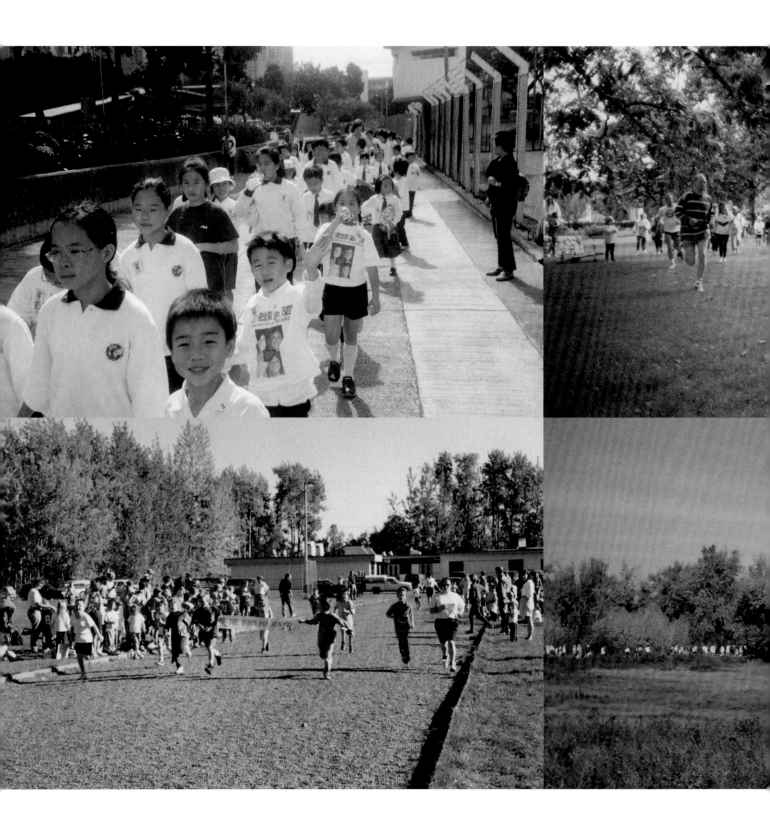

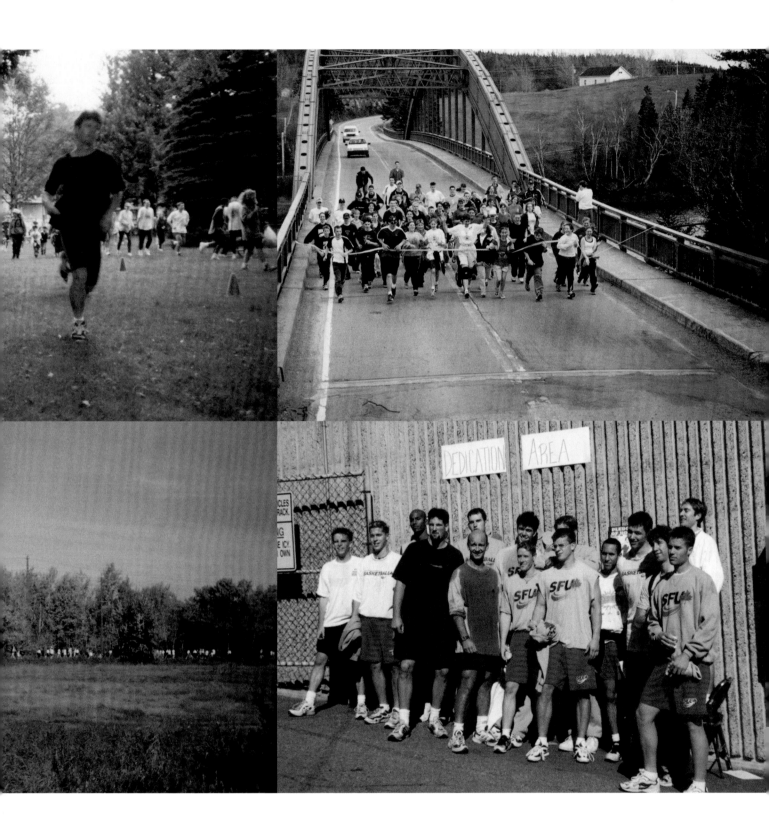

Champagne?

Had Terry never run those daily marathons, would he still be alive? That's a good question. Doctors agree that the cancer might have lodged itself in Terry's lungs long before the run (in a process technically known as pulmonary seeding). The run might have sped up the growth of the tumours—but on the other hand, the run also might have sped up Terry's metabolism, boosting his system's fighting power and hence delaying the cancer's recurrence.

Since 1980, cancer research—thanks very much in part to Terry—has leapt ahead several generations. Were he to have the same cancer today, not only would he keep his leg but he'd probably be alive and well. Terry got it right—research equals hope. More research equals more hope.

This bottle of champagne was to have been used to toast Terry on the evening he received the Order of Canada. The bottle wasn't opened that night, so Terry's mother decided she would open the bottle only once a cure is found for cancer.

No Small Change

We must never forget that Terry's 1980 Marathon of Hope run, right from its inception, had one reason only: it was an athletic event aimed at raising money for cancer research. Although it became much more than that in the end, it's important to remember that core mission. Terry wanted a dollar for every Canadian, and in his mind the equations were always:

RESEARCH MONEY = HOPE.
MORE MONEY = MORE HOPE
24 MILLION CANADIANS = 24 MILLION DOLLARS

Darrell Fox remembers when Terry was running along Highway 11 north of Toronto. By that time, the run had entered its biggest phase and there was a certain craziness that followed the young men in the van wherever they went. One afternoon, people in cars driving in the opposite direction slowed down and tried to donate money. The situation could have become dangerous, so Darrell crossed the four lanes to collect their donations. As it turned out, the buckets normally used for accepting money were all full, so Darrell had to pass around a used cardboard bucket from a chicken take-out, and everyone thought it was funny, grease stains and all.

People didn't always put just money into the buckets and bags. They sometimes gave flowers and teddy bears and small precious items. In the end, Canada pretty much placed its collective soul into that fried chicken bucket and continues to do so to this day.

As of 2005, Canada's population topped 30 million. Terry's equations remain as true now as they were then:

RESEARCH MONEY = HOPE
MORE MONEY = MORE HOPE
30 MILLION CANADIANS = 30 MILLION DOLLARS … OR MORE

The Loonie

Terry's goal in 1980 was to get a dollar from every Canadian. Twenty-five years later in 2005, Terry's image now appears on Canada's one-dollar coin, the loonie. Terry's is the first Canadian circulation coin ever struck that shows a person other than the king or queen. It features Terry running against a background of the stone and trees of the Canadian Shield, and comes from a shot taken by photographer Gail Harvey.

The day before the shoot for these photos in Vancouver, Darrell Fox flew to Winnipeg to pick up this coin—the very first Terry loonie, one struck specifically for this book. Darrell joked that he'd have to place the coin in a suitcase and travel with it handcuffed to his wrist. In actuality, the coin was kept inside a small clear plastic container which rattled in Darrell's pocket, and he joked that he might accidentally forget how valuable the coin was and use it in a parking meter.

What was interesting was how scuffed even the shiniest untouched coin is when viewed up close. When magnified, a coin's shiny patches actually resemble the surface of a frozen lake on which people have been skating for a few hours. Forget metal polishes and hot water. Most coins could use a few minutes with a Zamboni.

But what a strange and amazing journey for Terry—from gathering coins to being on a coin. You can't help but wonder what he might have made of it all.

Where the Money Goes …

For many people, the words "cancer research" conjure up fuzzy images of shiny buildings in a part of town they never visit. The researchers all wear white lab coats and sport movie-star tans, and once a week they shout *Eureka!* and hop into their Corvettes and go out for a martini. In reality, researchers spend half their time filling out forms and trying to raise enough money so that they can continue to do what they do. Their hallways tend to be crammed with specimen-cooling freezers and fridges bought from the newspaper's want ads. They're usually on the brink of being broke, and it's frustrating. Ironically, they also have to fight a common perception that cancer research is well funded.

This is a listing of where the just over $17-million-dollar allotment from the Terry Fox Foundation went in 2004/2005. It's written in clean technical prose and is worth the extra effort to read. As you'll see, the research is of breakthrough quality and international in its scope and every penny spent on funding is a very realistic penny towards cures. None of the research described here would be underway if Terry had never begun his run—multiply these pages by twenty-four years and you can see how wonderful Terry's legacy is and the legacy of everybody who joins in the annual Terry Fox Run.

Below are lists of where the money goes in the form of New Research Grants, Continuing Research Grants, New Research Personnel Awards and Continuing Research Personnel Awards.

There is a difference between grants and awards. Grants are for the direct costs of doing research, such as test tubes, chemicals, etc., and the grants go to the principal investigator via his/her institution. Awards are stipends that are paid to individuals in the form of training awards: studentships and post-doctoral fellowships.

Grants support the research, and awards support the competitively awarded stipends of trainees.

The grand total of funds disbursed in 2004/2005: $17,163,801.

New Research Grants in 2004/2005
$6,431,143

The research grants for new investigators are given to individuals or a team of individuals working on a single project. The program project grants are larger grants given only to integrated teams of investigators working on multiple related projects in a coordinated program.

Archer, Michael
University of Toronto, Toronto, ON
TFF Research Grant for New Investigators

Mechanisms linking insulin resistance and colon carcinogenesis

Relevance: Risk factors for the development of colon cancer include obesity, low levels of physical activity, and diets high in calories, saturated fat and simple carbohydrates. These are very similar to the risk factors for insulin resistance, a precursor to type 2 ("adult-onset") diabetes, and various studies suggest a relationship between insulin resistance and colon cancer. Dr. Archer's group is investigating this relationship and why it occurs. Their results will show the effects of various specific risk factors on the development of colon cancer and thus suggest more effective ways to prevent this disease.

Description: Insulin resistance leads to high blood levels of a molecule called insulin-like growth factor-I (IGF-I), as well as high levels of insulin and changes in cholesterol levels and certain hormones. However, it is not clear which of these responses is related to colon cancer. Dr. Archer's team is using genetically altered mice to find out how low levels of IGF-I, obesity and high levels of a hormone called leptin each affect the development of colon cancer.

Category of Research: Fundamental
Cancer Site Relevance: Colon/rectum

2004/2005	$100,916
2005/2006	$104,821
2006/2007	$82,000
Grant total:	$287,737

Bell, John
TFF New Frontiers Program Project Grant
Ottawa Health Research Institute, Ottawa, ON

Canadian oncolytic virus consortium

Relevance: Oncolytic viruses—viruses that can kill cancer cells—are exciting new anticancer treatments that are just beginning to be tested in cancer patients. Several Canadian research groups have been pioneers in developing these viruses. This project aims to unite them in order to maximize their results and get the new treatments into patient testing more quickly. Dr. Bell and this new research group will work together on different viruses to determine which is best for certain kinds of cancer, and will begin studies in cancer patients to learn how best to give these viruses and at what doses.

Description: The group will carry out a number of linked projects to fulfill their goals. One is a basic science project aimed at understanding how oncolytic viruses interact with cells. Its results will be incorporated into the other projects, which will test known and new viruses in laboratory-grown cells to see which is the most effective at killing cancer cells, study which dosages are best, and begin tests in cancer patients.

Category of Research: Fundamental & intervention
Cancer Site Relevance: Multiple cancer sites

2004/2005	$850,602
2005/2006	$850,602
2006/2007	$660,900
Grant total:	$2,362,105

Benchimol, Samuel
TFF New Frontiers Program Project Grant
Ontario Cancer Institute/Princess Margaret Hospital, Toronto, ON

Molecular determinants of death and survival in mammalian cells

Relevance: Apoptosis is the term for a type of cell death that happens to all normal cells if they are damaged. However, one characteristic of cancer cells is that they do not undergo apoptosis, because they carry altered genes that allow them to avoid it. Many cancer treatments work by causing apoptosis in cancer cells, but not all cancers are susceptible to this approach. Dr. Benchimol's group, now consisting of five researchers and their staff, is studying apoptosis and its relationship to cancer from a number of angles with the goal of not only understanding how cancer cells avoid apoptosis, but also stopping these cells from doing so.

Progress During the Previous Grant: The group's research during the past few years has focussed on a group of proteins that help to control apoptosis and are overactive or underactive in cancer cells. They have learned how the Myc protein encourages cells to die while also being required for cell growth. They have shown that the Flip protein helps cancer cells to survive by blocking the effects of two other proteins that encourage apoptosis. They have also started to identify the death-promoting genes controlled by the p53 protein and have learned some of the functions of the BRCAI protein in repairing DNA and preventing apoptosis.

Current Proposal: The five researchers involved in this project are continuing to study different aspects of apoptosis and cancer. One is examining how apoptosis induced by the Myc protein works. One is studying the p53protein's relationship to cell death. One is looking at the effect of certain cell signals on the control of apoptosis and DNA repair. One is investigating the role of loss of control of apoptosis in cancer. Finally, one is breaking down the molecular pathways that lead to or prevent apoptosis.

Category of Research: Fundamental
Cancer Site Relevance: Breast, hematopoietic, liver & various other sites

2004/2005	$1,143,274
Grant total:	$1,143,274

Bouchard, Maxime
TFF Research Grant for New Investigators
McGill University, Montréal, QC

Tumours of the kidney: the role of Pax2

Relevance: More than 4,000 Canadians are diagnosed with kidney cancer every year. The most frequent types of kidney cancer are renal cell carcinoma and Wilms' tumour and both are known to be caused by abnormalities in a number of different genes. Dr. Bouchard's group is studying the genes involved in normal kidney development, since these are likely to be among the ones that are abnormal in kidney cancer cells. Their results will improve our understanding our how kidney cancers develop and may lead to new ways to diagnose or treat these diseases.

Description: Several genes involved in normal development have been found to be abnormally active in cancer cells, including one that appears to cause about 10% of Wilms' tumour cases. Dr. Bouchard's team has recently identified the most important genes for the formation of the kidney in mice. These genes are normally active only during two stages of kidney development, but have been discovered to also be active in renal cell carcinoma and Wilms' tumour cells, suggesting that they play a role in these cancers' development. The team now plans to see whether activating these genes in mice causes kidney cancers to develop, and to discover how these genes normally function.

Category of Research: Fundamental
Cancer Site Relevance: Kidney & various other sites

2004/2005	$118,807
2005/2006	$118,807
2006/2007	$110,407
Grant total:	$348,021

Bouchard, Maxime
TFF Equipment Grant for New Investigators
McGill University, Montréal, QC

Tumours of the kidney: the role of Pax2 (Equipment)

2004/2005	$71,728
Grant total:	$71,728

Cheung, Peter
TFF Research Grant for New Investigators
Ontario Cancer Institute/ Princess Margaret Hospital, Toronto, ON

Functional analysis of apoptosis- and proliferation-associated histone modifications

Relevance: Although many different genetic alterations can cause cancer, they all have the same eventual result: the altered cell multiplies out of control. In order for this to happen, the cell must either maintain signals that are telling it to grow, or block signals that would normally cause an out-of-control cell to die. Dr. Cheung's team is studying these signals and how they are controlled, to better understand what happens when that control is gone. Their results may lead to new cancer treatments that can "reset" cell controls to stop cancerous cells from multiplying.

Description: In human cells, circumstances outside a cell can send signals to the cell nucleus (where the genes are) so that the cell can respond appropriately. In order for the genes to receive these signals, they must be translated into a language that they can understand. The machinery that controls this translation process includes proteins called histones, which are physically joined to the genetic material (DNA). Dr. Cheung's group is studying the interactions between the histones and the DNA to determine whether different kinds of interactions tell the cell to do different things.

Category of Research: Fundamental
Cancer Site Relevance: Various cancer sites

2004/2005	$127,900
2005/2006	$127,900
2006/2007	$127,900
Grant total:	$383,700

Choi, Keith
TFF Research Grant for New Investigators
BC Research Institute for Children & Women's Health, Vancouver, BC

Mechanisms of ovarian carcinogenesis in novel knockout mouse models

Relevance: Ovarian cancer kills more than 1,500 Canadian

women every year. Some of these cancers have been found to be caused by alterations in two genes, called BRCA1 and BRCA2, and women with these gene alterations have a much higher risk (up to 60%) of developing ovarian cancer within their lifetimes. Dr. Choi's team is investigating how these altered genes cause ovarian cancer to develop. Their results will improve our understanding of ovarian cancer and help in the development of new ways to diagnose, treat and prevent this disease.

Description: A common way to investigate the purpose of specific genes is to create a strain of mice without those genes and observe the effects. However, BRCA1 and BRCA2 have not been studied this way, since removing either gene is fatal to the mice. Dr. Choi's group is testing a new way to block the effects of these genes in mouse ovary cells. They will then use these mice to determine the effects of the BRCA genes on the development of ovarian cancer.

Category of Research: Fundamental
Cancer Site Relevance: Ovary

2004/2005	$96,500
2005/2006	$96,500
2006/2007	$96,500
Grant total:	$289,500

Choi, Keith
TFF Equipment Grant for New Investigators
BC Research Institute for Children & Women's Health, Vancouver, BC

Mechanisms of ovarian carcinogenesis in novel knockout mouse models (Equipment)

2004/2005	$75,000
Grant total:	$75,000

Gratton, Jean-Philippe
TFF Research Grant
Clinical Research Institute of Montréal-IRCM, Montréal, QC

Molecular basis of tumour vessels hyperpermeability

Relevance: Attacking a cancer by destroying the blood vessels that feed it is an idea that many researchers have investigated. Unfortunately, blood vessels in cancers have been found to be difficult to target without damaging normal blood vessels. Dr. Gratton's group has taken advantage of a known difference of cancer blood vessels and discovered a new way to slow the growth of cancers in mice. They plan to study this process more closely in the hope that a better understanding of it will lead to the development of new anticancer treatments.

Description: It is well known that blood vessels in cancers are abnormal in several ways. One of these is that cells lining the cancers' blood vessels have larger spaces between them than normally occur in blood vessel linings. Dr. Gratton's team blocked the production of a molecule that is necessary for blood vessels to have these holes in their linings, and found that it slowed cancer growth in mice. They now plan to further investigate this molecule and how it affects the cells lining blood vessels.

Category of Research: Fundamental
Cancer Site Relevance: Various cancer sites

2004/2005	$105,595
2005/2006	$105,595
2006/2007	$105,595
Grant total:	$316,785

Hill, Richard
TFF New Frontiers Program Project Grant
Ontario Cancer Institute/ Princess Margaret Hospital, Toronto, ON

Hypoxia in tumours: clinical and experimental studies

Relevance: Most cancers have a poorly organized blood supply that results in regions of hypoxia (low levels of oxygen) within the cancer. Most cancers also contain very few lymphatic vessels, which are responsible for removing excess fluid in normal tissues. This leads to increasing levels of fluid in the cancer and therefore increased fluid pressure. Cervical cancers with larger hypoxic regions or higher fluid pressure have been found to be less curable with current anticancer treatments. Dr. Hill's group is investigating why this might occur. Their results have already improved treatments for some cervical cancer patients and are expected to produce further improvements over the next five years.

Progress During the Previous Grant: Dr. Hill's team recently completed a study in cervical cancer patients looking at the effects of hypoxia and increased fluid pressure on treatment outcome. They discovered that in patients whose cancers had not spread, the degree of hypoxia in the original cancer predicted how likely that cancer was to spread in the future. Increased fluid pressure levels predicted both cancer spread and the likelihood of treatment failure in the original cancer. These results have already led to treatment changes for some patients. The team also developed new imaging techniques that allow them to look at the activity of certain proteins in different parts of a patient's cancer. Finally, they created a strain of mice that allows them to study the effects of hypoxia and increased fluid pressure on cancer spread.

Current Proposal: The research group is now using laboratory-grown cells and lab animals to investigate the underlying cell changes that occur in cells exposed to hypoxia or increased fluid pressure. They will examine whether these changes can be reversed with drugs that target some of the molecules involved. They will also use new techniques to study the changes in blood flow that occur in a cancer during its treatment, as well as changes in factors that affect fluid pressure. Finally, they will test new drug combinations to see whether they can overcome the limitations of current treatments.

Category of Research: Fundamental & intervention
Cancer Site Relevance: Uterus/cervix & various other sites

2004/2005	$1,231,428
2005/2006	$1,190,676
2006/2007	$1,211,363
2007/2008	$1,150,808
2008/2009	$1,150,808
Grant total:	$5,935,082

Johnston, Brent
TFF Research Grant for New Investigators
Dalhousie University, Halifax, NS

Natural killer T (NKT) cell homing and activation

Relevance: Natural killer T-cells (NK or NKT cells) are white blood cells that can destroy cancer cells. They circulate in the blood and normally accumulate in the liver, the lungs, the spleen and the bone marrow. However, we still don't entirely understand how NK cells are sent to different parts of the body and what tells them to become active. Dr. Johnston's team is investigating these questions. If we can identify the molecules that tell NK

cells where to go and when to become active, we may be able to use this information to develop treatments that direct NK cells to destroy cancer cells more effectively or prevent the spread of cancer cells to other parts of the body.

Description: Dr. Johnston's group has been investigating a molecule called CXCR6, which occurs at high levels on NK cells and may be responsible for controlling their distribution. Using mice that lack CXCR6, the group will determine the role that CXCR6 plays in sending NK cells to different organs or activating them to destroy cancer cells.

Category of Research: Fundamental
Cancer Site Relevance: Liver, lung & various other sites

2004/2005	$114,450
2005/2006	$113,050
2006/2007	$113,050
Grant total:	$340,550

Johnston, Brent
TFF Equipment Grant for New Investigators
Dalhousie University, Halifax, NS

Natural killer T (NKT) cell homing and activation (Equipment)

2004/2005	$14,032
Grant total:	$14,032

Ling, Hong
TFF Research Grant for New Investigators
University of Western Ontario, London, ON

Carcinogenic benzo[a]pyrene adducts, anticancer cisplatin adducts and the Y-family DNA polymerase Dpo4

Relevance: Benzo[a]pyrene is a common environmental pollutant that contributes to the development of cancer. When it is taken into a cell, it causes changes in the cell's genetic material (DNA), which can lead to the cell becoming cancerous. Dr. Ling's group is studying this process, which is also related to a way in which cells learn to resist the effects of anticancer drugs. Their results will increase our knowledge of how pollutants cause cancer and may suggest ways to prevent cancer cells from resisting anticancer drugs.

Description: When benzo[a]pyrene makes genetic changes to a cell, they are carried out by a newly discovered family of enzymes called Y-polymerases. These enzymes are also involved in a process by which cancerous cells become resistant to the widely used anticancer drug cisplatin. Dr. Ling's team plans to use state-of-the-art techniques to study the interactions between one of the Y-polymerases and the genetic changes caused by both benzo[a]pyrene and cisplatin.

Category of Research: Fundamental
Cancer Site Relevance: Lung, pancreas, skin/integument & various other sites

2004/2005	$133,850
2005/2006	$133,850
2006/2007	$133,850
Grant total:	$401,550

Ling, Hong
TFF Equipment Grant for New Investigators
University of Western Ontario, London, ON

Carcinogenic benzo[a]pyrene adducts, anti-cancer cisplatin adducts and the Y-family DNA polymerase Dpo4 (Equipment)

2004/2005	$70,688
Grant total:	$70,688

Nam, Robert
TFF Research Grant for New Investigators
Sunnybrook & Women's College Health Sciences Centre, Toronto, ON

Prospective evaluation of prostate biopsies for prostate cancer detection

Relevance: Doctors usually test for prostate cancer by examining the prostate during a physical examination and by doing a blood test. If either of these tests is abnormal, the patient undergoes a prostate biopsy, in which a needle is inserted into the prostate to extract tissue samples that are tested for the presence of cancer. Unfortunately, if cancer is actually present, the first biopsy misses it about 30% of the time. Yet many men do not receive a second biopsy. Dr. Nam's group is studying a new test that may identify which men should undergo a second biopsy if their first is negative. If this test works as hoped, it could allow more accurate and earlier diagnosis of patients with prostate cancer.

Description: Dr. Nam's team has discovered that high blood levels of a protein called hK2 are associated with an increased risk of prostate cancer. They now plan to test the levels of hK2 in the blood of a thousand men who had abnormal physical exams or blood tests and underwent a prostate biopsy that was negative for cancer. They will then perform a second biopsy on these men to see whether hK2 levels, or some other factor, might predict which men are likely to have prostate cancer despite a negative result on a first prostate biopsy.

Category of Research: Program delivery/evaluation, surveillance & monitoring
Cancer Site Relevance: Prostate

2004/2005	$130,800
2005/2006	$130,800
2006/2007	$130,800
Grant total:	$392,400

Nam, Robert
TFF Equipment Grant for New Investigators
Sunnybrook & Women's College Health Sciences Centre, Toronto, ON

Prospective evaluation of prostate biopsies for prostate cancer detection (Equipment)

2004/2005	$17,670
Grant total:	$17,670

Nielsen, Torsten
TFF Research Grant for New Investigators
University of British Columbia, Vancouver, BC

Synovial sarcoma: translating gene expression into patient care

Relevance: Sarcomas are cancers that arise in the muscles, bones, joints, nerves and other connective tissues. Synovial sarcomas typically affect young adults and are treated with surgery, radiation

therapy and sometimes anticancer drugs; however, despite all treatments, about half of all synovial sarcoma patients die. There is a pressing need for better treatments for this disease. Dr. Nielsen's group has done important work on the genetic alterations that appear to cause synovial sarcoma, and they now intend to translate their results into actual treatments. If successful, they could significantly improve survival rates for synovial sarcoma patients.

Description: Dr. Nielsen's team recently identified a set of genes that are unusually active in synovial sarcoma cells. Some of these genes make proteins that can be blocked by known drugs that have never been used to treat this cancer. The team now plans to confirm their earlier results and to test these drugs against synovial sarcoma in animals. If the drugs work, they will immediately begin a study to see whether they are as effective in humans.

Category of Research: Fundamental & intervention
Cancer Site Relevance: Musculoskeletal

2004/2005	$109,672
2005/2006	$111,788
2006/2007	$108,788
Grant total:	$330,248

Nielsen, Torsten
TFF Equipment Grant for New Investigators
University of British Columbia, Vancouver, BC

Synovial sarcoma: translating gene expression into patient care (Equipment)

2004/2005	$6,508
Grant total:	$6,508

Paige, Christopher
TFF New Frontiers Program Project Grant
Ontario Cancer Institute/ Princess Margaret Hospital, Toronto, ON

Molecular biology of hemopoietic progression and function

Relevance: Every blood cell in the body develops from the same kind of basic cell in the bone marrow, called a stem cell. When stem cells divide, the resulting cells mature and specialize into various types of blood cells. However, a few of these cells do not mature, but instead remain copies of their parent cells in a unique process called "self-renewal." Evidence is accumulating that the same principles apply to cancers: most of the cancer cells have relatively short lifespans and it is the activity of a few self-renewing cancer stem cells that keeps the cancer alive. This means that a drug that blocked this self-renewal would theoretically cure the cancer. Dr. Paige's research group is studying stem cells and self-renewal, and their relationship to cancer, with the goal of understanding these processes and applying that knowledge in the fight against cancer.

Progress During the Previous Grant: Dr. Paige's group had two main goals during the previous research period: to improve the experimental systems that would allow them to observe in detail the development of blood cells, and to test the effects of certain genes and proteins on developing blood cells. They made significant progress on both fronts. They devised new techniques that allow them to pluck a single cell out of the bone marrow and put it into a test tube to develop. They then used these techniques to observe many of the stages of blood cell development and discovered a number of new checkpoints that make sure the developing cells

are on track. Finally, they identified several genes and proteins that play a role in these checkpoints by promoting either the survival of healthy cells or the elimination of cells that are developing badly.

Current Proposal: The team is continuing to investigate the processes by which stem cells mature into specialized cells or self-renew and how these processes can go astray and lead to the development of cancer. They will use genetically engineered mice, laboratory-grown cells and state-of-the-art techniques to study the specific genes and proteins in cells that control cell development, self-renewal, cell survival and cell death in both healthy bone marrow cells and cancerous cells.

Category of Research: Fundamental
Cancer Site Relevance: Breast, hematopoietic & various other sites

2004/2005	$1,380,194
2005/2006	$1,380,194
2006/2007	$1,380,194
2007/2008	$1,380,194
2008/2009	$1,380,194
Grant total:	$6,900,969

Petruk, Kenneth
TFF Research Grant
University of Alberta, Edmonton, AB

Molecular signalling and therapeutic targeting of TRAIL-induced apoptosis in malignant glioma cells

Relevance: Malignant gliomas are the most common brain cancers, and the most difficult to treat. Traditional anticancer treatments such as drugs, surgery and radiation do not significantly help these patients. The group is investigating a new kind of therapy involving a normal protein found in human cells, which may improve survival in malignant glioma patients.

Description: The team has been studying a protein called tumour necrosis factor-related apoptosis-inducing ligand (TRAIL). They have shown that it can kill laboratory-grown malignant glioma cells without affecting nearby healthy cells. In animals, TRAIL prevents cancers from growing with few side effects. Unfortunately, many glioma cells can resist its effects. The team has learned how TRAIL kills glioma cells, and they now plan to discover how glioma cells can resist TRAIL. They will also test various anticancer drugs in combination with TRAIL to see whether the combination can overcome the glioma cells' resistance.

Category of Research: Fundamental
Cancer Site Relevance: Brain/neurological

2004/2005	$109,040
2005/2006	$109,040
2006/2007	$109,040
Grant total:	$327,120

Rak, Janusz
TFF Research Grant
McMaster University, Hamilton, ON

Tissue factor in tumour progression and angiogenesis

Relevance: In order for a solid cancer to grow and spread, it needs a blood supply. Cancers achieve this by triggering the formation of blood vessels within themselves to feed their cells, a process called angiogenesis. If this process could be blocked,

cancers could not grow. Dr. Rak's team is working on ways to block angiogenesis by studying a protein that appears to be involved in the process. A better understanding of how angiogenesis occurs will suggest new ways to stop it from happening.

Description: Both cancer cells and the cells of the blood vessels they create produce unusually high levels of a protein called tissue factor. The more tissue factor a cancer makes, the worse its outcome is likely to be for the patient. Dr. Rak's team is investigating why cancer cells produce tissue factor and what it does. Their previous research has suggested that the same abnormal genes that turn a normal cell into a cancerous cell might also trigger the production of tissue factor. The team now plans to confirm this finding and to analyze how tissue factor helps cancer cells to grow or form blood vessels.

Category of Research: Fundamental
Cancer Site Relevance: Colon/rectum & various other sites

2004/2005	$142,600
2005/2006	$142,600
2006/2007	$142,600
Grant total:	$427,800

Rosen, Kirill
TFF Research Grant for New Investigators
Dalhousie University, Halifax, NS

IAP family members as mediators of three-dimensional tumour growth

Relevance: The cells that line our organs are called epithelial cells. Normally, these cells form a single layer, and any cells that become detached from this layer die. Most cancers originate from epithelial cells, but they grow in three-dimensional masses and their cells do not die when they are detached from their original locations. Dr. Rosen's group is studying this difference and how one protein helps the cancer cells to accomplish this. Their results could eventually lead to a new type of anticancer therapy based on blocking cancer cell's ability to grow in three-dimensional masses.

Description: Dr. Rosen's team is investigating a protein called Ras, which is normally activated by signals from outside the cell, and then triggers other cell events. Genetic alterations in cancer cells can make Ras active all the time, and this contributes to the cancer's progression. One of the important abilities of Ras is that it can stop cells growing outside their original single layer from dying. Dr. Rosen's team is trying to learn how it does this. They are studying the various effects of Ras activity to see which is related to keeping three-dimensional cancers alive.

Category of Research: Fundamental
Cancer Site Relevance: Colon/rectum & various other sites

2004/2005	$115,536
2005/2006	$115,536
2006/2007	$115,536
Grant total:	$346,608

Rosen, Kirill
TFF Equipment Grant for New Investigators
Dalhousie University, Halifax, NS

IAP family members as mediators of three-dimensional tumour growth (Equipment)

2004/2005	$73,853
Grant total:	$73,853

Roy, Richard
TFF Research Grant
McGill University, Montréal, QC

Novel effectors of Notch signalling in C. elegans

Relevance: Cells receive information from their environments and use it to make "decisions" such as whether to grow or to produce necessary molecules. Part of the decision-making process is a series of events called the Notch pathway. When parts of this pathway are altered by genetic changes, the result can be cancer or other diseases. Dr. Roy's group is studying the Notch pathway to learn what it does in normal cells, with the goal of discovering a way to disrupt Notch activity in cancer cells without harming healthy ones.

Description: Dr. Roy's team has observed that the Notch pathway is active during an unusual developmental stage in microscopic worms. When growth conditions are unfavourable, this worm "hibernates"—its cells stop multiplying and it changes its shape to conserve energy. When conditions improve, the worm resumes its normal activity. The team plans to use this worm to identify the genes that the Notch pathway activates in order to send the worm into hibernation.

Category of Research: Fundamental
Cancer Site Relevance: Various cancer sites

2004/2005	$90,500
2005/2006	$81,500
2006/2007	$81,500
Grant total:	$253,500

Continuing Research Grants in 2004/2005 $8,772,880

Grants that were newly given in 2004/2005 are considered to be new. Grants that were given in any year prior to 2004/2005, but because of their multi-year nature were still being funded through the 2004/2005 grant year, are considered continuing. So, for example, a three-year grant given in 2002/2003 would show up as a new grant in 2002/2003 but also as a continuing grant in 2003/2004 and also in 2004/2005.

Bally, Marcel
TFF Research Grant
British Columbia Cancer Research Centre, Vancouver, BC

Combining conventional therapeutics with molecular targeting strategies for the treatment of breast cancer

Relevance: Breast cancer is the most commonly diagnosed cancer among women and leads to more than 5,000 deaths each year. Although prevention and early detection have improved treatment results, patients whose cancers come back still do not fare well. Dr. Bally believes that these "aggressive" breast cancers can be

treated with a combination of drugs aimed at specific molecules that are present on hard-to-treat cancer cells. His team is working at developing such drug combinations in the hope that they can better treat the most difficult breast cancers.

Description: Dr. Bally's team has been studying a protein called HER-2/neu, which occurs on the surface of aggressive breast cancer cells. A number of other proteins have also been found to be associated with particularly aggressive breast cancers. The team will now investigate combinations of regular anticancer drugs and drugs that target these proteins. They will test these combinations in laboratory-grown breast cancer cells, then create genetically altered mice for further testing.

Category of Research: Fundamental
Cancer Site Relevance: Breast, ovary & various other sites

2004/2005 $108,740

Beattie, Tara
TFF Research Grant for New Investigators
University of Calgary, Calgary, AB

RNA-protein interactions within human telomerase

Relevance: Telomerase is an enzyme that is responsible for adding genetic material to the ends of our chromosomes. This does not occur in normal cells, but telomerase has been found to be active in 90% of cancers. Previous research has suggested that stopping telomerase activity might stop the growth of cancer cells. Dr. Beattie is studying the structure and function of telomerase, as well as the interactions with other molecules required for it to function. Her research will help us discover regions of the telomerase molecule that can be targeted by new cancer drugs to slow down or stop the activity of this enzyme.

Description: Dr. Beattie has discovered two molecules that are needed in order for telomerase to function in laboratory-grown rabbit cells. She will now study the interactions between these molecules and will use various biochemical techniques to determine the three-dimensional structure of the telomerase molecule.

Category of Research: Fundamental
Cancer Site Relevance: Multiple cancer sites

2004/2005 $107,725

Brill, Julie
TFF Research Grant for New Investigators
Hospital for Sick Children, Toronto, ON

Phosphoinositide control of cytokinesis in Drosophila

Relevance: All the cells that make up our bodies are enclosed in a cell membrane, which is mainly composed of fats. The composition of these fats must be carefully controlled to prevent cells from growing out of control. In fact, imbalances in a class of fats called phosphoinositols (PIs) are linked to the development of cancer. Dr. Brill's team is studying the effects of PIs on cell growth in fruit flies. Their research will increase our knowledge of the role of PIs during the development of normal and cancerous cells.

Description: Dr. Brill's group has been studying fruit flies with changes in a key enzyme called PI4Kß, which controls the production of PIs. They have shown that PI4Kß is needed in order for cells to divide, and their research suggests that it encourages cell division by assisting cell membranes to grow.

The team will now study the exact role of PI4Kß in cell growth and division and how this enzyme controls PI production.

Category of Research: Fundamental
Cancer Site Relevance: Various cancer sites

2004/2005 $123,300

Coomber, Brenda
TFF Research Grant
University of Guelph, Guelph, ON

Heterogeneous tumour vasculature: implications for therapy and consequences for cancer progression

Relevance: In order to grow and spread, cancers require a blood supply to provide oxygen and nutrients. To achieve this, the cancer cells produce molecules that attract blood vessels into the growing cancer. Because cancers are so dependent on these blood vessels, it has been suggested that drugs that block or damage these vessels would be useful anticancer drugs. However, early studies have found that such drugs are not always effective—they work in one patient but not others, or on some cancers but not all. Dr. Coomber's group is trying to determine why this occurs. If this obstacle could be overcome, it could make the new drugs much more effective at curing cancer.

Progress During the Previous Grant: Dr. Coomber's team has been studying blood vessel growth within cancers in genetically altered mice. They have discovered that the blood vessels in certain cancers are not as similar as would be expected. The mice were created with a "label" on one of the molecules on certain blood vessel cells. However, when the team looked at the blood vessels in cancers, not all the vessels were labelled, indicating that the molecule (which is called tie-2) didn't occur on the cells of all blood vessels.

Current Proposal: The team will now use the same mice to determine whether the tie-2 molecule occurs in various organs and various types of cancers. They will also analyze the differences between those blood vessel cells that carry this molecule and those that don't. Finally, they will test drugs that act against a cancer's blood vessels in these mice to determine whether they work better in cancers whose blood vessels carry the tie-2 molecule.

Category of Research: Fundamental
Cancer Site Relevance: Multiple cancer sites

2004/2005 $114,800

Craig, Andrew
TFF Research Grant for New Investigators
Queen's University, Kingston, ON

Role of Fps/Fes and Fer kinases in regulating inflammation and tumourigenesis

Relevance: Scientists are becoming increasingly interested in the role of inflammation in triggering cancer. In fact, drugs that block inflammation have already been shown to prevent cancer growth. Dr. Craig's team is studying several of the mechanisms that start or control inflammation in the hope that a better understanding of them will contribute to the development of treatments that control both inflammation and cancer growth.

Description: Using genetically altered mice and laboratory-grown cells, Dr. Craig's group will study the contribution of various

inflammation-related cells and molecules to the development of cancer. One focus is the role of two proteins called Fps and Fer, which appear to be involved in the process by which a cell becomes cancerous. The team will investigate their functions in a type of white blood cell that plays a large part in the development of inflammation. They hope to determine how these proteins affect the white blood cells' ability to move toward a site of inflammation, their role in the control of inflammation, and whether they have a role in the development of a particular kind of cancer that involves these white blood cells.

Category of Research: Fundamental
Cancer Site Relevance: Various cancer sites

2004/2005 $110,587

Davey, Scott
TFF Research Grant
Queen's University, Kingston, ON

Uve1-mediated DNA repair

Relevance: All living organisms must keep their genetic material from developing errors and have therefore developed "repair systems" to correct any errors that occur. One characteristic of cancer cells is that genetic errors are not corrected, leading to abnormal cell behaviours such as uncontrolled growth. Dr. Davey's team is studying a protein that plays a key role in one genetic repair system. Their results will lead to a better understanding of how genetic errors are repaired and how defects in this process can lead to a cell becoming cancerous.

Description: In previous studies, Dr. Davey's group found that a protein called Uve1 can attach itself to DNA, near where an error has occurred, remove the incorrect material and replace it with correct DNA. They have also learned that yeast cells deprived of Uve1 develop errors in a similar way to cancer cells. The team will now investigate other aspects of Uve1 in more detail and will identify other proteins that interact with it and participate in the repair process.

Category of Research: Fundamental
Cancer Site Relevance: Skin/integument & various other sites

2004/2005 $95,067

Eaves, Allen
TFF Research Grant
BC Cancer Agency, Vancouver, BC

Disease mechanisms in chronic myeloid leukemia (CML)

Relevance: The gene that, when altered, causes one type of leukemia (chronic myeloid leukemia or CML) was identified 15 years ago and is fairly well understood. It was believed that drugs that blocked the activity of this altered gene would be effective treatments for the disease. Unfortunately, this has not been the case and better treatments for this leukemia are still needed. Dr. Eaves' team is studying CML stem cells ("parent" cells from which other leukemia cells develop), since controlling or destroying these cells is necessary if CML is to be cured. They hope to discover new ways to suppress these cells and thus treat CML more effectively.

Progress During the Previous Grant: Dr. Eaves' research group has been gathering cells from patients with CML and using them to investigate a newly discovered growth process that appears to

explain many of the properties of CML stem cells. They learned that this growth process is going on even before the leukemia becomes apparent, making it a good target for new drugs since they could eliminate even the earliest leukemic cells. They also identified a drug that blocks the growth of normal stem cells but not CML stem cells, and created a way to genetically alter CML cells for further studies.

Current Proposal: The team now plans to continue gathering cells from CML patients and to learn how the speed of CML cell multiplication is controlled; what properties of these cells cause leukemia to develop or a relapse to occur; and whether new drugs developed from their results can be effectively tested.

Category of Research: Fundamental
Cancer Site Relevance: Alimentary tract & hematopoietic

2004/2005 $150,000

Gallie, Brenda
TFF Research Grant
University Health Network, Toronto, ON

Oncogenes and tumour suppressor genes active in retinoblastoma tumour progression

Relevance: Retinoblastoma is a rare cancer affecting the retina (part of the eye) in infants. This disease is the result of genetic alterations, some of which have been identified. However, additional genetic changes are needed in order for retinoblastoma to develop. Dr. Gallie's team is studying several genetic changes that may be the ones responsible. Knowledge of these culprit genes might provide a basis for future prevention and new treatments for retinoblastoma, as well as for other cancers.

Description: Cancer-causing genetic changes generally involve either the loss of a gene that would otherwise prevent cancer (called a tumour suppressor gene) or the gain of a gene that stimulates cancer growth (called an oncogene). Dr. Gallie's team has identified two potential tumour suppressor genes and one potential oncogene and now plans to determine whether these are the genes responsible for causing retinoblastoma. They will also study the activity of these genes in mice and in laboratory-grown cells.

Category of Research: Fundamental
Cancer Site Relevance: Head & neck

2004/2005 $150,000

Harrington, Lea
TFF Research Grant
University Health Network, Toronto, ON

Probing the role of human telomerase in tumourigenesis using a genetic switch for hTERT expression

Relevance: Most normal human cells can only divide a limited number of times, but cancer cells can often divide indefinitely. This ability is mainly due to an enzyme called telomerase, which keeps chromosomes from growing shorter each time the cancer cell divides. Dr. Harrington's group is studying telomerase and the proteins that help it to operate. Because normal cells do not need telomerase in order to grow, but most cancer cells contain active telomerase, blocking telomerase activity might be the basis for new treatments of many types of cancer.

Description: Dr. Harrington's team plans to find out whether

blocking telomerase activity will lead to cell death in human cells that have been genetically altered to become cancerous. They will do this by inactivating telomerase in these cells (by "turning off" a protein it needs to function).

Category of Research: Fundamental
Cancer Site Relevance: Various cancer sites

2004/2005 $98,700

Henkelman, R. Mark
TFF New Frontiers Program Project Grant
Sunnybrook & Women's College Health Sciences Centre, Toronto, ON

Medical imaging for cancer

Relevance: Medical imaging (the use of techniques such as x-rays or ultrasound to see inside the body) is vital in both detecting cancer and determining whether cancer treatments have been successful. Dr. Henkelman's group is developing new technologies to provide clearer, more informative images of cancers and the blood vessels that nourish them. They intend to apply these technologies in a variety of ways: to improve diagnostic accuracy, to improve treatment effectiveness, to guide surgical procedures, and to assist in the gathering of information about the genetic basis of cancer.

Progress During the Previous Grant: In the past five years, the team has begun a program to incorporate imaging directly into patient treatment. They built a new MRI (magnetic resonance imaging) system to guide surgeons operating on brain tumours; the system has already been used in the treatment of more than 70 patients. They also worked on better ways to study the blood vessels within cancers and investigated several possible technologies for creating clearer, more informative images.

Current Proposal: The group is currently developing approaches to the imaging of breast cancers using various techniques: new digital detectors, measurements of blood flow, and MRI. They are also adapting the digital technologies to monitor prostate cancers and improve the way radiation therapy is used to treat them. In addition, they are further developing their surgical guidance system and adapting the system to guide the removal of breast tissue samples for examination. Finally, they plan to determine how to accurately apply medical imaging to mice, so that imaging can help scientists who are working on the genetic changes that occur in cancer cells.

Category of Research: Fundamental & intervention
Cancer Site Relevance: Breast, prostate & various other sites

2004/2005 $1,398,702

Humphries, R. Keith
TFF New Frontiers Program Project Grant
BC Cancer Agency, Vancouver, BC

Normal and leukemic Hematopoiesis

Relevance: The overall goals of this project are to determine how normal blood cells become leukemia cells and to apply that infor-mation to develop new leukemia treatments. Dr. Humphries and four other researchers are using a number of innovative approaches to identify the mechanisms controlling the growth and division of stem cells, the bone marrow cells from which all blood cells develop. Their results will increase our understanding of how cancer develops, and may also suggest new approaches to the treatment of leukemia or other cancers.

Progress During the Previous Grant: This project has resulted in several important discoveries in the past few years. The team has established new procedures for analyzing the blood cells that leukemia can develop from, and has defined many of the key changes that turn a normal stem cell into a leukemic stem cell. They have discovered the role played by a large family of genes in both normal and leukemic cells and have determined the importance of molecules that help to control how often a cell can divide before dying. Finally, they have continued to improve their basic understanding of how stem cells multiply, specialize and how these processes are controlled.

Current Proposal: Dr. Humphries' team will continue to combine their expertise to explore the mechanisms that control the growth of both normal and cancerous blood cells. They will use a variety of approaches to develop and expand their previous findings and to combine their results to make the best use of their discoveries.

Category of Research: Fundamental
Cancer Site Relevance: Hematopoietic & various other sites

2004/2005 $1,031,205

Irwin, Meredith
TFF Research Grant for New Investigators
Hospital for Sick Children, Toronto, ON

Functional analysis of p73: roles in chemosensitivity and apoptosis

Relevance: Researchers know that a gene called p53 plays a critical role in preventing cells from becoming cancerous. In more than half of all human cancers, the p53 gene has been altered so that it will not function normally. Dr. Irwin's group is studying a related gene called p73. They and others have shown that an active p73 gene can kill even those cancer cells that lack a functioning p53 gene. As well, blocking p73's activity gives cancer cells the ability to withstand the anticancer effects of some cancer drugs. An increased knowledge of the role of p73 in preventing the development of cancer may lead to the design of better treatments or new ways to combat cancer cells' resistance to anticancer drugs.

Description: Several anticancer drugs have been shown to "activate" the p73 gene and Dr. Irwin's team is studying the process by which this occurs. They will also investigate how specific alterations in the p53 gene affect the ability of the p73 gene to become active and destroy cancer cells. Finally, they will identify other proteins that are related to p73.

Category of Research: Fundamental

Cancer Site Relevance: Brain/neurological, colon/rectum, musculoskeletal & various other sites

2004/2005 $146,931

Jean-Claude, Bertrand
TFF Research Grant
McGill University, Montreal, QC

The combi-targeting concept: novel molecules "programmed" to target tumour cells with disordered signalling

Relevance: Anticancer drugs form an important part of treatment for many cancers. However, the drugs currently being used attack

both cancer cells and normal, healthy cells. This causes many side effects, which often lead patients to stop taking the drugs before they have finished their treatment. Dr. Jean-Claude's team is designing drugs that would destroy only cancer cells. It is hoped that their research will lead to the development of safer and more effective anticancer drugs.

Description: Using a new approach called "Combi-Targeting," Dr. Jean-Claude's team has designed drugs with two active parts. One part seeks out and joins to a special molecule (called a receptor) on the cancer cell, and the other part then destroys that cell. The team has focussed on two receptors called EGFR and p185neu, which are commonly found on ovarian, prostate and breast cancer cells. The group now plans to develop the new drugs and study their abilities in laboratory-grown cancer cells of various types.

Category of Research: Fundamental
Cancer Site Relevance: Various cancer sites

2004/2005 $81,138

Masson, Jean-Yves
TFF Research Grant for New Investigators
Laval University, Ste. Foy, QC

Roles of the human RAD51 paralogs in DNA double-strand break repair and genome stability

Relevance: When a cell's genes are altered, that cell can become cancerous. Fortunately, human cells have built-in defence mechanisms: DNA repair proteins recognize genetic damage and fix it before it can make the cell cancerous. Dr. Masson's team is studying a class of DNA repair proteins that recognize and repair one of the most dangerous kinds of genetic damage by searching for undamaged identical DNA and using that as a template to repair the damaged DNA. Their findings will increase our knowledge of how cancer develops or is prevented, and may also help to increase the effectiveness of gene therapy in cancer treatment.

Description: Alterations in DNA repair proteins can themselves lead to cancer, since the cell becomes unable to fix its genetic damage. Dr. Masson's team will investigate how these proteins behave in a test tube (and what they need to function properly), then when and why they work in a cell. Finally, they will investigate what happens in a cell when these proteins are altered, something that has been observed to occur in some types of cancer.

Category of Research: Fundamental
Cancer Site Relevance: Breast & various other sites

2004/2005 $100,000

Ohh, Michael
TFF Research Grant for New Investigators
University of Toronto, Toronto, ON

Functional characterization of pVHL modification by ubiquitin-like protein NEDD8

Relevance: von Hippel-Lindau (VHL) disease is an inherited condition that makes affected people likely to develop multiple cancers in many parts of the body. It is caused by alterations in the VHL gene, which is involved in cell growth and the development of new blood vessels. Dr. Ohh's group is studying the activities of this gene and how they may lead to cancer. It is hoped that their results will lead to the design of new kinds of cancer treatments.

Description: Dr. Ohh's team has discovered that the VHL gene makes a protein that "tags" another protein for destruction. If the VHL gene is altered, the second protein is not destroyed, and its presence encourages inappropriate cell growth and the growth of new blood vessels (which are necessary for cancer development). Dr. Ohh's team is studying the VHL gene, how its activities are controlled, and the molecules that it affects, in order to better understand how cancers develop in VHL patients and how they can be prevented.

Category of Research: Fundamental
Cancer Site Relevance: Brain/neurological and kidney

2004/2005 $138,658

Pawson, Anthony
TFF New Frontiers Program Project Grant
Mount Sinai Hospital, Toronto, ON

Genetic analysis of signalling pathways in vascular development and tumour angiogenesis

Relevance: In order for cancers to grow and spread, they must have access to a supply of oxygen through the bloodstream. Many cancers have the ability to stimulate new blood vessels to grow in order to maintain their oxygen supply. Dr. Pawson's team is studying this process in order to find ways to block it. Their results may suggest new treatments that will stop cancers from growing or spreading.

Progress During the Previous Grant: In recent years, the members of this program project have focussed on understanding how cells communicate with each other and how cancer causes these communication pathways to break down. They have learned the functions of several molecules that play a part in cell communication; they have identified and cloned a gene that controls whether or not leukemia can be artificially induced; and they have produced a large number of genetically altered mice, which have helped the team to understand blood vessel development.

Current Proposal: The team will now continue to work toward a fuller understanding of how blood vessels develop, both in normal tissues and when stimulated by cancers. They will determine which molecular events start the process of new blood vessel growth, and how cancers activate this process.

Category of Research: Fundamental
Cancer Site Relevance: Brain/neurological, breast & lung

2004/2005 $1,178,856

Rennie, Paul
TFF New Frontiers Program Project Grant
University of British Columbia, Vancouver, BC

Program on prostate cancer progression

Relevance: Prostate cancer is the most common cancer in Canadian men, as well as the second most common cause of cancer death. Prostate cancer cells are usually dependent on the presence of male sex hormones called androgens to survive, so withdrawing these hormones is often an effective way of destroying these cancers. Unfortunately, this is usually a temporary cure, since surviving cancer cells become independent of the need for androgens. This project is focussed on the process by which prostate cancer cells become independent of androgens with the goal of understanding how it happens and using that information to improve the treatment of prostate cancer.

Progress During the Previous Grant: Since this team was formed, three years ago, the 10 scientists involved—leading Canadian researchers from a variety of specialties—have made progress in a number of areas. They have determined the effects of various environmental substances on prostate cells' responses to androgens, tested the combination of anticancer drugs and gene therapy, and provided the scientific background for the first test in humans of a new prostate cancer therapy, among other results. In addition, they have assisted in the training of several researchers, and the work they have done has encouraged more funds to be dedicated to prostate cancer research and the discovery of a cure for this disease.

Current Proposal: The 10 scientists in the team are carrying out seven individual but linked research projects. They are examining: genes that are related to prostate cancer development; the design of a virus that will destroy prostate cancer cells; whether certain genetic changes will make cancers more susceptible to radiation therapy; the roles of certain molecules in prostate cancer development and the processes by which cells become androgen-independent or resistant to anticancer drugs; and combinations of these approaches.

Category of Research: Fundamental & intervention
Cancer Site Relevance: Prostate

2004/2005 $1,275,100

Roy, Peter
TFF Research Grant for New Investigators
University of Toronto, Toronto, ON

A functional genomic investigation of guided cell migrations in C. elegans

Relevance: Guided cell migration (the ability of cells to find appropriate locations in order to carry out specific functions) is essential for the development of both normal animals, including humans, and cancers. When a cancer begins to grow, cell migration allows for the creation of new blood vessels to provide oxygen and nutrients, and also helps cancer cells to spread to other parts of the body. Many of the same factors are involved in cell migration whether it is being done for normal development or to help a cancer grow, but they are not well understood at present. Dr. Roy's group is trying to improve our knowledge of this process with the goal of eventually identifying new targets against which anticancer drugs can act.

Description: To better understand what factors control cell migration, Dr. Roy's team will study these processes in a type of worm. Within this tiny creature, muscle extensions called arms migrate directly to nerves and make connections with them. Using fluorescent molecules and various complex genetic techniques, the team will examine this process and identify the roles of new genes in guided cell migration. Because many genes in this worm have similar roles in humans, the genes discovered are likely to also be involved in cell migration in humans.

Category of Research: Fundamental
Cancer Site Relevance: Various cancer sites

2004/2005 $106,000

Stewart, A. Keith
TFF New Frontiers Program Project Grant
University Health Network, Toronto, ON

Molecular therapeutics of B cell malignancies

Relevance: Cancers involving abnormal B cells (a kind of white blood cell), including non-Hodgkin's lymphoma, chronic lympho-cytic leukemia and multiple myeloma, are often incurable, even though some of these diseases are becoming more and more common. Researchers are therefore hunting for better ways to treat them. One possibility is "gene therapy," in which altered viruses are used to deliver genes into cancer cells, thus causing the cells to stop multiplying or to destroy themselves. Dr. Stewart's team of four researchers is working on developing and testing gene therapies for these cancers.

Description: Although gene therapy is an attractive approach to cancer treatment, it is associated with several technical difficulties. The members of Dr. Stewart's group are working on defeating these challenges such that their combined work will allow the creation of successful treatments. Two researchers will create a virus that will selectively attack myeloma cells; one will study better ways to get gene therapies into the patient's body, as well as certain drug combinations; and one will create potent vaccines aimed against leukemia cells.

Category of Research: Fundamental
Cancer Site Relevance: Hematopoietic

2004/2005 $878,419

Tang, Damu
TFF Research Grant for New Investigators
McMaster University, Hamilton, ON

Studies of p53-independent tumour suppressing activities of p14ARF

Relevance: A protein called p53 is known to be vital in preventing cells from becoming cancerous. It works by stimulating the cell to repair cancer-causing damage to its genetic material. Another protein, called p14ARF, is known to protect p53 itself from being damaged. Dr. Tang and his team are studying p14ARF and have observed that it can block the development of cancer even when p53 isn't present. A better understanding of how p14ARF works to prevent cancer could lead to the development of an entirely new group of anticancer drugs.

Description: Dr. Tang's team has created a type of laboratory-grown kidney cancer cells that have no p53 protein but produce a controlled amount of p14ARF protein if they are exposed to an antibiotic called doxycycline. They will now use these cells to study p14ARF in great detail. The team will also identify other proteins that may affect the functions of p14ARF in the absence of p53.

Category of Research: Fundamental
Cancer Site Relevance: Various cancer sites

2004/2005 $92,300

Vanderhyden, Barbara
TFF Research Grant
Ottawa Regional Cancer Centre: General Division, Ottawa, ON

Role of the c-Kit protooncogene in ovarian tumourigenesis

Relevance: Almost 90% of ovarian cancers develop from a single layer of cells that cover the surface of the ovaries, called surface epithelial cells. However, how these cells become cancerous is not well understood. Dr. Vanderhyden's team has found that a

molecule called KIT is present in three-quarters of ovarian cancers but doesn't occur in normal surface epithelial cells. They now plan to determine the role of KIT in the development of ovarian cancers and test the effects of a drug that blocks its activity. Their results may produce an effective new treatment for ovarian cancer.

Progress During the Previous Grant: Dr. Vanderhyden's group has learned a great deal about KIT in the past two years. They discovered that many factors affect cell multiplication, but not KIT activity. They showed that in ovarian cancer cells, KIT appears to help the cell survive and specialize, and to block it from moving to another part of the body. They also developed two systems for studying KIT: by growing human ovarian cancer cells in mice, and by genetically altering mice to develop ovarian cancers that closely resemble human cancers.

Current Proposal: The team now plans to determine how KIT becomes active in surface epithelial cells, KIT's role in cancer cells' survival and ability to withstand anticancer treatments, and whether KIT becomes more active if cancer-preventing genes are missing. They will also develop another genetically altered mouse to test KIT's contribution to ovarian cancer development. Finally, they will test the effectiveness of a drug that blocks KIT activity in both mice and humans.

Category of Research: Fundamental & intervention
Cancer Site Relevance: Ovary

2004/2005 $139,592

Woodgett, James
TFF New Frontiers Program Project Grant
Ontario Cancer Institute/Princess Margaret Hospital, Toronto, ON

Molecular genetics of breast cancer development

Relevance: Although significant progress has been made in the detection and treatment of breast cancer, its survival rate is not as good as it could be. Dr. Woodgett's team of distinguished researchers is studying the genes involved in the development of breast cancer from a variety of perspectives. Their goals are to identify new targets for breast cancer treatment, to increase the accuracy of diagnosis and to improve early detection of this cancer.

Progress During the Previous Grant: In recent years, Dr. Woodgett's team has made significant discoveries in several areas. They have found a way that cancer cells stay alive when normal cells would self-destruct, and have identified the proteins involved in this survival mechanism. They have created new research tools to study normal and cancerous breast cell development in mice, and this has resulted in new information about how cell functions are controlled. They have discovered genetic changes that distinguish two kinds of early breast cancer in patients. They have added to our knowledge about the genes that cause inherited breast cancers. Finally, they have set up a system to study how thousands of genes function together to cause breast cancer.

Current Proposal: The group now plans to determine which genetic changes in breast cancer cells might help to predict how fast-growing a cancer is, or how likely it is to spread, or to return after treatment. They will investigate the roles of a number of genes in normal and cancerous breast cell development. They will examine a number of enzymes that may help cancer cells

to avoid self-destruction. Finally, they will combine information gathered from patients, mice and laboratory-grown cells to ensure that all the researchers have access to all the latest discoveries.

Category of Research: Fundamental & intervention
Cancer Site Relevance: Breast and various other sites

2004/2005 $1,019,560

Young, Paul
TFF Research Grant
Queen's University, Kingston, ON

Regulation of G2 cell size homeostasis

Relevance: Regulating cell size is an important function of all cells. When cell size regulation goes wrong, it can lead to genetic errors in the cell, which can cause the cell to become cancerous. Unfortunately, this series of events is not well understood. Dr. Young's team is studying how cells control their size during cell growth and multiplication. It is hoped that this knowledge will contribute to a broader understanding of how cells become cancerous, and thus how this development can be blocked.

Description: Dr. Young's group has been studying how cells control their size in yeast, in which the process is somewhat better understood. It appears that two enzymes called Cdc25 and Wee1 play important parts in cell size control in yeast. In this project, the team will try to identify the molecules that trigger these enzymes to act in response to cell size. They will also investigate the circumstances within the cell that make these unknown molecules carry out their triggering function.

Category of Research: Fundamental
Cancer Site Relevance: Various cancer sites

2004/2005 $127,500

New Research Personnel Awards in 2004/2005
$980,995

Research personnel awards that were newly given in 2004/2005 are considered to be new.

Ahmad, Khaja
TFF Research Fellowship: Biomedical
University of California (San Francisco),
San Francisco, CA, USA

Hijacking Actin Polymerization: The molecular mechanism of N-WASP activation by the IcsA protein of the pathogen Shigella flexneri

$36,400

Bacani, Julinor
TFF Post MD Research Fellowship:
Biomedical
Mount Sinai Hospital

Frequency of E-cadherin (cdh1) and mismatch repair (MMR) germline mutations in young gastric cancers in Southern Ontario

$46,838

Baltzis, Dionissios
TFF Research Studentship: Biomedical
Jewish General Hospital

Control of molecular mechanisms of tumour suppressor p53 by eIF2alpha kinases

$21,500

Bisson, Nicolas
TFF Research Studentship: Biomedical
Laval University

In vivo regulation of epithelial-mesenchymal transitions by the PAK and MLK signal transduction pathways

$21,500

Blais, Marie-Eve
TFF Research Studentship: Biomedical
Hopital Maisonneuve-Rosemont

Mechanisms of early apoptosis in extrathymic T cells

$21,500

Bock, Nicholas
TFF Research Studentship: Biomedical
Hospital for Sick Children

High throughput, longitudinal brain tumour screening in mice with magnetic resonance imaging

$21,500

Boucher, Lorrie
TFF Research Studentship: Biomedical
Mount Sinai Hospital

Systematic genetic dissection of the Mitotic Exit Network in saccharomycesn cerevisiae

$21,500

Burton, Teralee
TFF Research Studentship: Biomedical
University of Manitoba

Negative regulation of Bcl-2 nineteen kilodalton interacting protein (BNIP3) in glioblastoma multiforme tumours

$21,500

Chan, Sherwin
TFF Research Fellowship: Biomedical
Whitehead Institute of Biomedical
Research, Cambridge, MA, USA

Genome-wide analysis of epigenetic regulation

$36,750

Cote, Jean-Francois
TFF Research Fellowship: Biomedical
The Burnham Institute, La Jolla, CA, USA

Understanding the role of DOCK180 in Rac-mediated signalling

$43,562

Dehm, Scott
TFF Research Fellowship: Biomedical
Mayo Clinic, Rochester, MN, USA

Mechanisms of ligand independent androgen receptor activation in androgen refractory prostate cancer

$36,750

Ebos, John
TFF Research Studentship: Biomedical
Sunnybrook & Women's College Health
Sciences

Characterizing the role of soluble vascular endothelial growth factor receptor 2 (sVEGFR-2) in tumour angiogenesis

$21,500

Griffiths, Emily
TFF Research Fellowship: Biomedical
Hospital for Sick Children

Investigating the roles of ubiquitin ligase LNX and the related protein LNX2 in neuronal polarity and intracellular signalling

$38,770

Heath, Emily
TFF Research Studentship: Biomedical
McGill University

4D Monte Carlo investigation of organ motion in conformal radiotherapy for lung cancer

$21,500

Heath-Engel, Hannah
TFF Research Studentship: Biomedical
McGill University

Endoplasmic reticulum involvement in E1A induced p53 dependent apoptosis: regulation by BH3 only Bik

$21,500

Hojilla, Carlo
TFF Research Studentship: Biomedical
University Health Network

Mechanisms of breast cancer attenuation by the loss of TIMP-3

$21,500

Ivanova, Iordanka
TFF Research Studentship: Biomedical
University of Western Ontario

Mechanisms for E2F-1 regulation in epidermal keratinocytes

$21,500

Katz, Sigal
TFF Research Fellowship: Biomedical
Ontario Cancer Institute/PMH

The role of c-Myc in gene regulation

$36,400

Kazemi, Shirin
TFF Research Studentship: Biomedical
Jewish General Hospital

Control of translation initiation factor eIF2alph phosphorylation pathway by human papillomavirus E6 oncoprotein

$21,500

Leung, Genie
TFF Research Studentship: Biomedical
Mount Sinai Hospital

Structural and functional analysis of the
Sak polo box domain

$21,500

Louis, Isabelle
TFF Research Studentship: Biomedical
Hôpital Maisonneuve-Rosemont

What is the essence of a primary T
lymphoid organ?

$21,500

Mazroui, Rachid
TFF Research Fellowship: Biomedical
McGill University

Link between stress, cell death and
tumour growth

$43,353

Moisan, Annie
TFF Research Studentship: Biomedical
Université de Sherbrooke

Étude du mécanisme d'activation de la
transcription génique par le suppresseur
de tumeur BRCA1

$21,500

Mulholland, David
TFF Research Fellowship: Biomedical
University of California, Los Angeles, CA,
USA

Deciphering beta-catenin contributions in
androgen independent prostate cancer by
modulation of P13K signalling

$35,000

Robichaud, Gilles
TFF Research Fellowship: Biomedical
Universite de Sherbrooke

Antitumour therapy using engineered
delta-ribozymes targeted against the
inactivation of Pax-5/BSAP in lymphoma,
lymphocytic leukemia and testicular
cancer

$41,292

Sangwan, Veena
TFF Research Fellowship: Biomedical
McGill University

Role of dephosphorylation in the down-
regulation of the Met receptor tyrosine
kinase

$42,102

Semple, Jeffrey
TFF Research Studentship: Biomedical
University of Waterloo

Functional characteristics of the origin
recognition complex subunit Orc6p in the
budding yeast, Saccharomyces cerevisiae

$21,500

Singh, Sheila
TFF Post MD Research Fellowship:
Biomedical
Hospital for Sick Children

Molecular and cellular characterization of
a cancer stem cell in human brain
tumours

$47,500

Suriano, Gianpaolo
TFF Research Fellowship: Biomedical
University of British Columbia

E-cadherin germline missense mutations and
hereditary diffuse gastric cancer: a model
for the identification of the E-cadherin-
dependent signalling pathways pivotal for
cell invasion

$42,728

Walther, Rhian
TFF Research Fellowship: Biomedical
Cancer Research UK, London, UK

Mechanisms of directed cytoplasmic
transport of mRNA transcripts in the
drosophila embryo

$36,050

Wiggin, Giselle
TFF Research Fellowship: Biomedical
Mount Sinai Hospital

The role of polarity proteins in mammalian
cancer development

$36,925

Wyles, Jessica
TFF Research Fellowship: Biomedical
Queen's University

Protein-protein interactions of human
topoisomerase IIalpha and topoisomerase
IIbeta

$36,575

Continuing Research Personnel Awards in 2004/2005 $978,783

Awards given in any year prior to
2004/2005, but because of their
multi-year nature were still being funded
through the 2004/2005 award year, are
considered continuing. So, for example,
a three-year award given in 2002/2003
would show up as a new award in
2002/2003 but also as a continuing
award in 2003/2004 and also in
2004/2005.

Andrew, Scott
Queen's University, Kingston
TFF Research Fellowship: Biomedical

The effect of GFRx-1 variants on cell
growth in neuroendocrine tumours and
development

$19,663

Belanger, Simon
INRS-Institut Armand-Frappier, Laval
TFF Research Studentship: Biomedical

Étude de l'interaction entre les cellules
cancereuses et endotheliales lors de la
metastasie d'un modèle de lymphome T.

$21,500

Bernstein, Nina
University of Alberta, Edmonton
TFF Research Fellowship: Biomedical

Structural characterization of the DNA
repair enzyme, human polynucleotide
kinase

$30,235

Boisvert, Francois-Miche
Lady Davis Institute, Montreal
TFF Research Studentship: Biomedical

The functional role of Sam68 nuclear
bodies in cancer cells

$21,500

Cellot, Sonia
IRIC: U of Montreal, Montreal
TFF Post MD Research Fellowship:
Biomedical

HOX B4 as a mitogen for hematopoietic
stem cells

$47,500

Chan, Edmond
Imperial Cancer Research Fund, London, England
TFF Research Fellowship: Biomedical

Regulation of autophagy by beclin 1 and phosphatidylinositol 3-kinase

$3,682

Coulombe, Philippe
IRIC: U of Montreal, Montreal
TFF Research Studentship: Biomedical

Regulation of the cell cycle blocking activity of ERK3 by the ubiquitin/proteasome pathway

$21,500

Denicourt, Catherine
University of California at San Diego, La Jolla, CA, USA
TFF Research Fellowship: Biomedical

Role of cytoplasmic p27KIP1 in cell motility and metastasis

$38,955

Dunfield, Lesley
University of Ottawa, Ottawa
TFF Research Fellowship: Biomedical

The role of KIT expression in ovarian cancer chemosensitivity

$36,750

Dykstra, Bradford
BC Cancer Agency, Vancouver
TFF Research Studentship: Biomedical

Effects of cytokine stimulation and cell cycle activation on the functional properties of hematopoietic stem cells

$21,500

Elowe, Sabine
Mount Sinai Hospital, Toronto
TFF Research Studentship: Biomedical

Regulation of Ras specificity by membrane-bound receptorsE

$5,375

Emberley, Ethan
University of Manitoba, Winnipeg
TFF Research Studentship: Biomedical

The role of the psoriasin gene in breast cancer progression

$21,500

Forget, Marie-Annick
Boston Biomedical Research Institute, Watertown
TFF Research Fellowship: Biomedical

Rnd3: p190B interaction in epithelial cell transformation

$41,685

Galarneau, Andre
Lady Davis Institute, Montreal
TFF Research Studentship: Biomedical

Molecular and biochemical characterization of SLM-2, a RNA binding protein acting as an apoptotic inducer

$21,500

Jones, Nina
Mount Sinai Hospital, Toronto
TFF Research Fellowship: Biomedical

The role of atypical protein kinase C in cellular asymmetry and oncogenic transformation

$10,526

Kapoor, Priya
University of Toronto, Toronto
TFF Research Studentship: Biomedical

The analysis of the segregation mechanism of Epstein-Barr Virus (EPV)

$21,500

Laferriere, Julie
CNRS-Institut de recherche-INSERM-UNSA, Nice, France
TFF Research Fellowship: Biomedical

Role of hypoxia in cancer progression and metastasis

$36,750

Lukong, Kiven
Lady Davis Institute, Montreal
TFF Research Fellowship: Biomedical

Characterization of the SLM-1 protein and identification of its molecular pathology in transgenic mice and human tumours

$42,102

Mamane, Yael
McGill University, Montreal
TFF Research Fellowship: Biomedical

Regulation of cell growth, proliferation and translation initiation by the mammalian target of Rapamycin, mTor, in cancer cells

$39,150

McManus, Daniel
Children's Hospital of Eastern Ontario, Ottawa
TFF Research Fellowship: Biomedical

The roles of the human inhibitors of apoptosis proteins in cancer cell survival and tumour initiation and progression

$40,124

Meunier, Marie-Christin
Hopital Maisonneuve-Rosemont, Montreal
TFF Research Studentship: Biomedical

Cancer treatment by adoptive transfer of minor histocompatibility antigen-specific T lymphocytes

$21,500

Peschard, Pascal
McGill University, Montreal
TFF Research Studentship: Biomedical

The molecular mechanisms underlying the regulation of receptor tyrosine kinases by the Cbl ubiquitin-protein ligase and their implications in human tumours

$21,500

Piluso, David
McMaster University, Hamilton
TFF Research Studentship: Biomedical

Investigating the molecular mechanism of HCF-1-mediated cell cycle progression

$3,583

Roncagalli, Romain
IRCM: Clinical Research Institute of Montreal, Montreal
TFF Research Studentship: Biomedical

The role of EAT-2 in normal immune functions and oncogenesis

$21,500

Roy-Proulx, Guillaume
Hopital Maisonneuve-Rosemont, Montreal
TFF Research Studentship: Biomedical

Immunodominance and repertoire of the model B6dom1 anti-tumour antigen

$21,500

Rubinstein, John
University of Toronto, Toronto
TFF Research Fellowship: Biomedical

Structural analysis of the complexes of protein associated with Set1 and Set3

$40,506

Rundle, Natalie
Queensland Institute of Medical Research, Queensland, Australia
TFF Research Fellowship: Biomedical

Importance of dominant negative atm missense mutants in cancer susceptibility: a mouse model

$35,056

Sheng, Yi
Ontario Cancer Institute/Princess Margaret Hospital, Toronto
TFF Research Fellowship: Biomedical

Structural and functional studies of ubiquitin specific protease 7 (USP7) and its interaction with p53 and Epstein-Barr virus nuclear antigen 1 (EBNA1) using NMR spectroscopy

$36,050

Shepherd, Trevor
Dalhousie University, Halifax
TFF Research Fellowship: Biomedical

The role of BMP4 regulation of ID1 and ID3 helix-loop-helix genes in human ovarian cancer

$41,292

Simoncic, Paul
Hospital for Sick Children, Toronto
TFF Research Studentship: Biomedical

The role of T-cell protein tyrosine phosphatase in Tel-JAK2 and Bcr-Abln induced leukemia

$21,500

Smith, Christian
Hospital for Sick Children, Toronto
TFF Research Studentship: Biomedical

Characterization of mammalian Numb: a structure and function approach

$21,500

Surtees, Jennifer
Cornell University: Cornell Medical Center, New York, USA
TFF Research Fellowship: Biomedical

The roles for DNA mismatch repair proteins in maintaining genome stability

$42,519

Swan, Andrew
Princeton University, Princeton, NJ, USA
TFF Research Fellowship: Biomedical

Cell cycle regulation in the early drosophila embryo

$21,781

Truscott, Mary
McGill University, Montreal
TFF Research Studentship: Biomedical

The molecular basis of transcriptional activation by CDP/Cux

$21,500

Vongsamphanh, Ratsavarinh
Hopital Maisonneuve-Rosemont, Montreal
TFF Research Studentship: Biomedical

The mechanism by which PIR1 targets the DNA repair enzyme APN1 into yeast mitochondria to maintain genomic stability

$21,500

Woo, Michelle
University of British Columbia, Vancouver
TFF Research Studentship: Biomedical

The role of Mullerian differentiation in ovarian epithelial carcinogenesis

$21,500

Woolstencroft, Robert
Mount Sinai Hospital, Toronto
TFF Research Studentship: Biomedical

Regulation of the eukaryotic DNA damage response

$21,500